WATER MEDIA TECHNIQUES

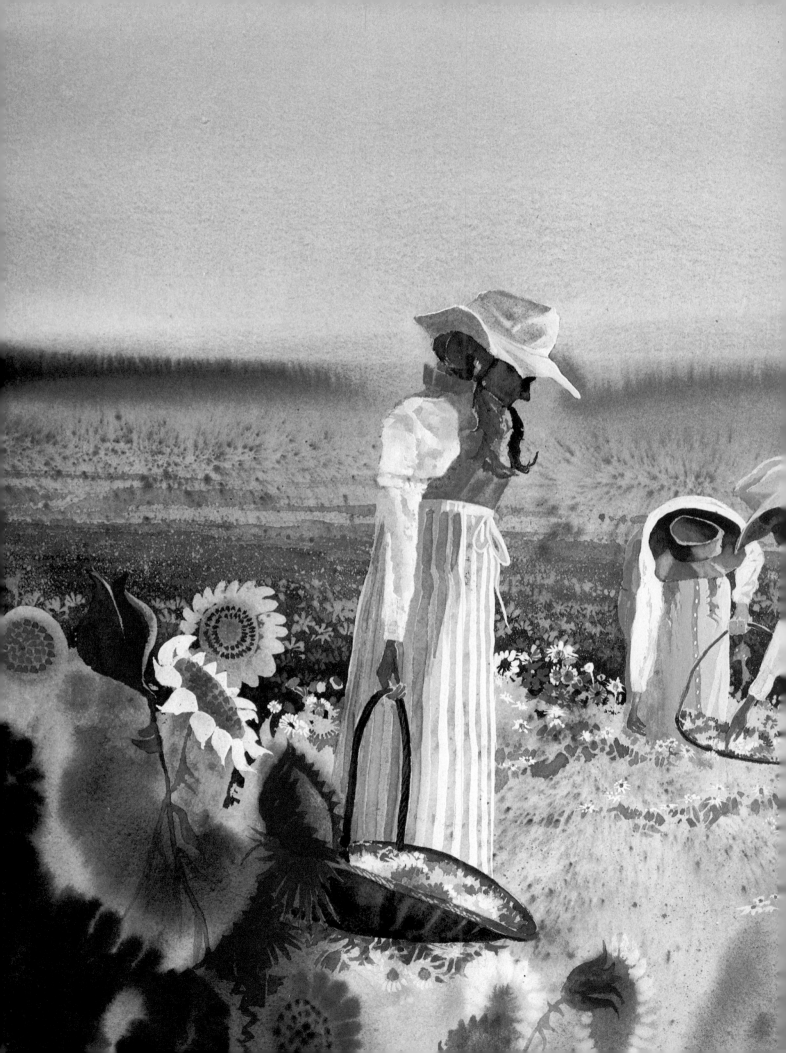

WATER MEDIA TECHNIQUES

by Stephen Quiller and Barbara Whipple

WATSON-GUPTILL PUBLICATIONS/NEW YORK

For Charlene
and my parents

For Grant

First published 1983 in New York by Watson-Guptill Publications,
a division of Billboard Publications, Inc.,
1515 Broadway, New York, N.Y. 10036

Library of Congress Cataloging in Publication Data
Quiller, Stephen.
 Water media techniques.
 Bibliography: p.
 Includes index.
 1. Water-color painting—Technique. I. Whipple,
Barbara. II. Title.
ND2422.Q5 1983 751.42'2 82-23784
ISBN 0-8230-5671-6

Distributed in the United Kingdom by Phaidon Press Ltd., Littlegate
House, St. Ebbe's St., Oxford

Manufactured in Japan.

First Printing, 1983

1 2 3 4 5 6 7 8 9 10 88 87 86 85 84 83

ACKNOWLEDGMENTS

We would like to thank Marsha Melnick for her good-humored and perceptive editorial directives; Candace Raney and David Lewis for editorial assistance; Grant Heilman and James W. Schaaf for photographic assistance and equipment; Cloyde Snook, Chairman of the Art Department at Adams State University, Alamosa, Colorado; and Tom and Marilyn Ross of the Saguache Hotel, Saguache, Colorado, who cheerfully provided us with space to work. Without them, this collaboration would have been impossible.

CONTENTS

INTRODUCTION

The idea for this book came to me while I was attending a national exhibition of works in water media. It struck me that only a few years ago, if a painting was not done entirely in transparent watercolor, it would have been disqualified from such an exhibition. Although there still are shows limited to watercolor, this type of restriction has become quite rare; so rare, in fact, that at this particular show of more than 125 works, I counted less than 50 paintings done entirely in watercolor. The majority were done in various combinations of the water media.

"Water media" is now an accepted term for describing a painting done in any combination of watercolor, gouache, casein, and acrylic. I've worked with all the water media, together and separately, for many years. I came to realize that nothing at all had been written about the way I was working. So this book is a way of sharing some of the discoveries and observations I've made and some of the techniques I've evolved.

This book will be useful to every painter. If you're a beginner, you can learn about each of the four water media step by step, by following the simple instructions. If you're an expert, you can select the information that holds the greatest interest for you.

The book is logically arranged to be useful as a reference source. Part one deals individually with the four water media, discussing their advantages, handling techniques and visual qualities. This section also covers the materials and special equipment unique to each medium. Some of these can be used in common with all the water media; others are special to a particular medium. Recommended paints, brushes, and papers are given, including some brand names. Then, eight typical uses of each medium are described and illustrated so that you will be familiar with what each of the water media can do when used alone. At the end of this first part, you'll find a chart designed for handy reference. It gives in capsule form all the information found in part one.

Part two presents a series of seven warm-up exercises in which each of the four water media is used in various combinations, working in transparent, translucent, and opaque techniques. By the time you've finished these exercises, you'll be able to combine the water media in a variety of interesting ways.

Part three consists of twelve of my finished paintings, each one of which uses two or more of the water media. Each demonstration begins with an introduction that describes where the idea for the painting comes from and why I selected the particular combination of media and support surface. Sketches and preliminary studies are illustrated, and then each painting is developed step-by-step.

As I painted and photographed each one of these steps, I described what I did. Everything is here for you, visually and verbally. I haven't held back any "secrets." If, halfway through a painting, I decide to cut part of it off, I'll tell you. Everything is explained so you'll know how I achieve the effects in each painting.

You'll find out about the color I like best when painting a night scene and why. You'll learn what's the best medium for painting snowbanks and why. You'll discover an unusual way of painting a misty seascape and interesting ways of applying paint for textures. You'll learn how staining colors can be lifted to leave a toned background and how a collage surface can be built up to enhance the twiggy texture of branches.

Part four is a visit to my studio/workshop, where a full-color gallery of fourteen of my finished paintings in shown. Here, each painting is presented, along with a number of greatly enlarged details that are taken from it; each detail reveals an in-depth and close-up look at the beauty and richness that can be achieved with water media.

This book is full of sound, technical information. I think you'll find it fun to read, too. No matter where you live or what your favorite subject may be, you'll find exciting techniques described that will open up whole new avenues of creativity for you. Once you familiarize yourself with each of the four media and have combined them as I show you, you'll go on to invent entirely new ways of putting them together. When that happens, you'll be on your way to creating your own unique way of painting.

Moonlight on Bristol Head. Watercolor, 29″ x 21″ (73 x 53 cm). Collection of Rick and Terri Inman.

Bristol Head is a legendary mountain near my home. In midwinter, when the moon is full, the nights are as bright as day. I used a limited palette of Prussian blue, alizarin crimson, and phthalo green watercolor, which I knew from long experience, was just right for this kind of scene. I enjoyed using transparent watercolor by itself because, used properly, it's a medium capable of great power and contrast, and it gave me just the effects I wanted for this painting.

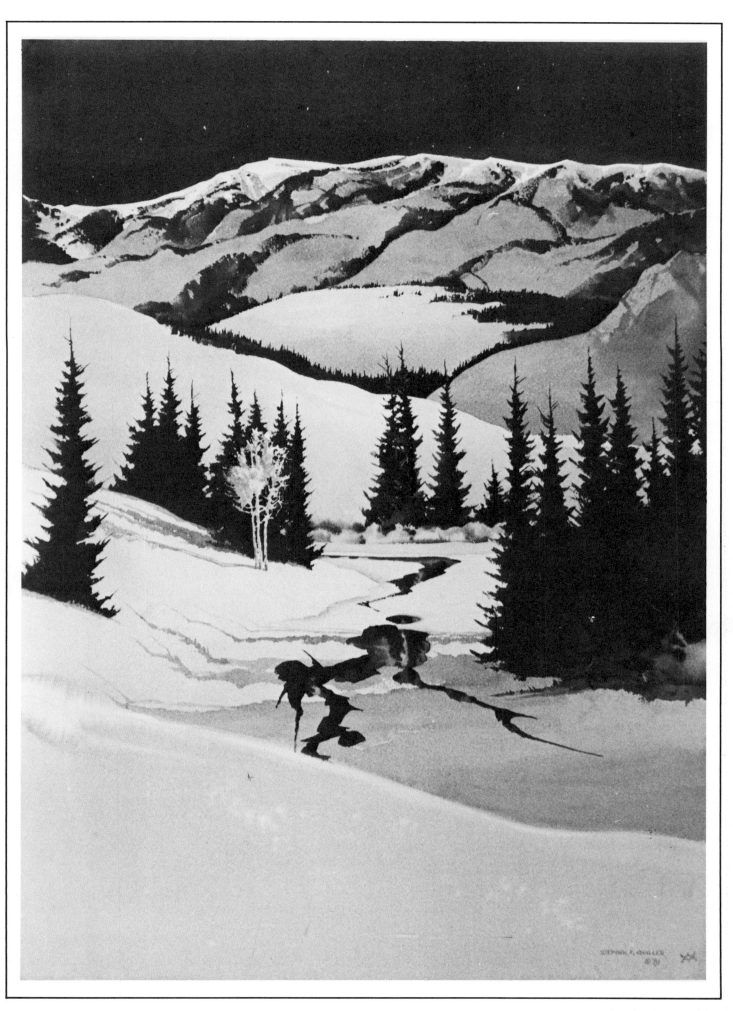

PART 1 THE CHARACTERISTICS OF THE FOUR WATER MEDIA

When I first began to paint seriously in high school and college, I worked exclusively with transparent watercolor. Then, for three years after graduating from Colorado State University, I continued to use it, at the same time developing my own style and choosing my own subjects. These years gave me an excellent foundation in the medium. I can't overestimate how important this is: technical facility is essential in order to use watercolor successfully. The medium is transparent and water soluble, and you can't hide your mistakes. Overwashes have a tendency to get blotchy, and if the painting is overworked, it's a failure. For this reason, I recommend beginning with transparent watercolor.

During these early years, I happened to see the work of a California artist who was working in a tight, magic-realist style that combined transparent watercolor with gouache. I was interested in some of these effects, so I bought some gouache paints and began experimenting. These early paintings were done using mostly transparent watercolor with only a few areas in gouache.

A transparent watercolor with some opaque accents of gouache can be unsuccessful because the gouache has a tendency to look "tacked on." So, to avoid this problem, I began doing some paintings that used gouache for the larger part of the painting, rather than transparent watercolor.

Because gouache is water soluble and will lift off even when it's dry, I began doing some experimental paintings with acrylics, which are insoluble when dry. I did a group using an underlayer of brilliant transparent acrylic with an overlayer of translucent and opaque gouache.

Finally, when I began wanting to add texture to my paintings, I added casein to the other three water media I was already using. After I'd used it for a time, I discovered that casein is best for the large, even washes of translucent or opaque paint I need for many of my paintings.

So, in a way, I turned to each new water media because of shortcomings in the ones I had been us-

ing. Each medium has its own characteristics, its own advantages, and its own disadvantages. Start with transparent watercolor because if you can handle watercolor, you can handle them all. Begin with each medium separately and become familiar with it, then begin combining two or more in various ways. Ultimately, you will know, as I do, what combinations will give you the results you want.

I really love working with transparent watercolor, just as I enjoy looking at a successful watercolor painting. There is a direct, spontaneous quality, and a reflective glow unattainable in any other medium. Its solubility means you can use fine sable brushes, because they rinse out easily. The paint can be stored and reused without a problem.

But watercolor has limitations. Its solubility and susceptibility to damage means the painting must be framed under glass. It's not a textured medium, and all the textures have to be created visually. Although the color is intense in the tube, it fades when it dries, so that color must be applied very densely to avoid a washed-out appearance.

Gouache handles much like transparent watercolor. It flows easily, although it is very opaque. It also can be used transparently and translucently, and the paint can be stored for reuse in a closed box with a damp sponge. I use gouache frequently for small preliminary studies, and intricate details can be painted light over dark with small brushes. There's no other paint better than Prussian blue gouache for the effects I want in my night paintings. Cleanup is easy because of its solubility and fine sable brushes can be used.

But gouache isn't the opaque paint that I use most frequently. Although it covers well, it is soluble even when dry, and colors have a tendency to lift. This muddies an overlayer of paint. Because of this, I don't use it for the large flat translucent or opaque areas of my paintings. When any kind of paint thickness is desired, it must be done in

thin successive layers, or the paint will crack. Also, if anything is done to hasten the drying, like using a hair dryer, the paint will crack, so I recommend letting the paint air dry naturally. If any thickness of the paint is desired, be sure to use a rigid support. And when a gouache painting is framed, it must be protected by glass.

Whenever I think of acrylic, I think of intense color, and I always use acrylic where color is important. When dry, the color maintains its intensity and becomes insoluble. It is very resilient and flexible, and its adhesive qualities means it bonds to nearly any support and to any successive layers of paint which follow. It also can be used as an adhesive. It produces heavy, textured impastos, or thin transparent washes. When working transparently, the pigment must be worked well into the brush at the beginning, otherwise there will be undissolved globules of paint in the wash. When working with a heavier load of paint for translucent or opaque effects, the paint has a different "feel" on the brush: it's slicker, and the paint slides, rather than flows, onto the surface, so it takes awhile to get used to.

Don't try to save acrylic paint; use a disposable palette and throw it away, or use a metal or glass palette that can be scraped clean. And be sure to clean your brushes with soap and water immediately. I use synthetic brushes for acrylics and casein as they're less expensive and give good results. Acrylic paints will streak if used translucently over a darker tone; gouache and casein are better for this. Acrylic also has a tendency to streak when used for large flat, opaque areas, so for this purpose, I use casein. Acrylic colors have a tendency to be garish if used unwisely. An acrylic painting can be framed just like an oil painting, without glass.

Casein is probably my favorite of all the water media, and I use it extensively. It seems to me that most painters use opaque acrylic for things that would be better handled in casein. Casein can be used trans-

parent, translucent, and opaque. A finished casein painting has a unique matte quality that I find extremely pleasant. It can be used to advantage as a translucent wash over an underlayer of intense acrylic color. I can use casein for large areas without streaking. It flows quite well and has good opaque coverage, far better than gouache for large areas. I also find it's better than acrylic for details. It can also be used to build up texture, using a brayer, combs, and similar tools. In fact, of all the water media, I find that casein has the most universal technical application. Finally, Shiva, which manufactures the brand of casein I use, has given the paint a delightful aroma.

Because casein becomes insoluble after a time, I clean my brushes with soap and water as I go. Be sure to use a rigid support if any impasto effects are desired. A casein painting can be framed as an oil; without glass.

All of the water media are direct, spontaneous, and dry quickly. For these reasons, they seem the ideal media for today's fast-moving society, where people have come to expect quick results. After studying this chapter, you'll be well acquainted with the characteristics of transparent watercolor, gouache, acrylic and casein.

Along with their characteristics, I've supplied you with the basic information about the materials and special equipment that are unique to water media. At the end of the chapter is a convenient chart that will enable you to see at a glance the similarities and differences, advantages and disadvantages of each of the water media. The chart summarizes the information contained in this chapter, and you can use it as a quick and easy reference guide. Following the chart are two full-page color illustrations of the brushes I use most frequently.

This chapter will serve as a guide and as a starting point for you when you begin acquiring materials, and I'm sure you'll have ideas of your own, as well as some individual preferences.

WATERCOLOR

I'll begin with transparent watercolor because it's the medium most of us are familiar with. Many of its properties are shared by the other water media, and it's the easiest, yet at the same time, the most difficult to handle. Once you're acquainted with transparent watercolor, it will be easier to move on to the other three water media.

All the water media use the same pigments, and the vehicle for all of them is water; only the binder is different. A binder keeps the pigment from dusting off the painting surface when the water evaporates. Transparent watercolor uses gum arabic—a vegetable gum—as the binder.

SOLUBILITY

Transparent watercolor is soluble, both wet and dry. This means that cleanup is easy, and that almost any brush, including expensive sables, can be used. Paint can be stored in a closed palette and reused. I keep a damp paper towel inside to keep the paint moist.

HANDLING CHARACTERISTICS

No other paint flows on quite as easily as transparent watercolor. It doesn't resist or drag on any paint surface. It looks twice as dark when it's wet as it does when dry, so it's necessary to use a lot of pigment to avoid a pale, washed-out appearance. If the paint is too thick, however, it will crack. Transparent watercolor is generally painted from light to dark. Washes can be built-up, but a wash must dry thoroughly before the next one is applied. These succeeding washes must be applied lightly and quickly to avoid picking up underlying color. Because watercolor is soluble when dry, paint can be lifted off with a damp brush and a variety of other tools. More than any of the other water media, watercolor needs a bold, confident approach.

VISUAL QUALITIES

Because of its transparency, water-color depends on the white of the paper reflecting light back up through the pigment for its effect. Therefore, the choice of support, whether rough or smooth, absorbent or nonabsorbent, will influence the final result. A properly done transparent watercolor has a freshness quite unlike any other kind of painting.

Transparent watercolor cadmiums and earth colors are of normal pigmentation. Others, such as alizarin crimson, phthalo blue, phthalo green, and sap green have staining qualities that dye the paper. Naples yellow and cerulean blue are so heavily pigmented they are almost translucent. Their pigment sinks into the pockets of rough paper to give an interesting granular effect.

All the transparent watercolor pigments can be made translucent, or even opaque, by the addition of Chinese white watercolor or permanent white gouache. The addition of this opaque pigment should be done with caution, however, because it will overpower transparent passages.

MATERIALS

Paint In selecting watercolor paint, I use Winsor & Newton Artists' Water Colours, and I always use the artist quality grade paints rather than the student grade. Watercolor paints are classified by degrees of permanence. *AA* is extremely permanent, *A* is durable, *B* is moderately durable, and *C* is fugitive. The paints that comprise my watercolor palette are taken only from the *AA* and *A* classifications.

Here is my watercolor palette:
cadmium lemon, new gamboge, cadmium yellow, cadmium orange, cadmium red, alizarin crimson, Winsor violet, cobalt blue, carulean blue, Prussian blue, Winsor emerald, Hooker's green dark, Hooker's green light, raw sienna, burnt sienna, brown madder alizarin, burnt umber.

Palette I recommend the Jones palette or any similar palette that has a heavyweight, white plastic surface with wells or depressions around the edges that are deep enough to hold plenty of paint. These palettes have tight-fitting lids and a brush holder. The lids are very useful for keeping the paint moist. Before leaving my studio for the day, I place a wet sponge or a damp paper towel inside the palette, and this prevents the paint from drying out for a week or more. If I am gone longer than a few weeks however, all I need to do to moisten the paint is to drop three or four drops of water on the paint. This will bring the paint back to a workable condition.

Painting Surface Always use the highest quality support that you can afford. For watercolor painting, you will want a non-yellowing paper. My favorite paper for watercolor use is Arches 300-lb., cold-pressed and rough. It is heavy enough to be cut to any size, taped down, and not buckle. This paper also responds well to wet-in-wet and drybrush techniques, and it is durable enough so that I can scar and scrape the surface without tearing the paper.

Paper and illustration boards generally have three surfaces, and each has its own distinctive quality: *Rough* paper has an uneven texture. When used with heavily pigmented paint, the granules settle out and create interesting effects. Because the paper has raised areas, it's particularly effective when used with drybrush techniques and for bold, expressive brushwork. *Hot-pressed* paper has very little texture, and washes can be floated over it in airy drifts. Detailed, flat renderings demand this surface. A smooth surface is excellent when lifting off color. *Cold-pressed* paper is neither very smooth nor very rough and is adaptable for most purposes. It's good when working wet-in-wet; and because of its suitability for a variety of effects, it is the surface I

use the most.

Paper is also classified according to its weight. A good rule to remember is that the higher the number, the heavier the weight of the paper. A 300-lb. paper, for example, means that a ream (500 sheets) of 22″ x 30″ paper weighs 300 pounds.

Lighter weight papers must be presoaked for fifteen minutes to a half hour, depending on their weight. I have sheets of plywood, ¼″ and ⅜″ thick, cut to various sizes, that I use as supports. With a staple gun, I staple the wet paper to the board, placing the staples about ¼″ in from the edge and about 1½″ apart, flattening and stretching the paper as I go. When the paper dries, I put 1½″ masking tape over the staples to seal the edges. Then, when I complete a wash, I use a paper towel for blotting up the edges, which prevents the wash from seeping back onto the paper, causing light-colored "balloons."

When using 300-lb. paper or heavier, there's less worry about shrinking and buckling, so it's easier to concentrate on technique. Heavy paper can be cut to size, taped to plywood, and you're ready to begin. While there may be some bowing, there isn't any annoying pooling or puddling, and it's easy to tilt the paper and get rid of any excess water. Papers do have a front side, although there may be only a slight difference, and sometimes I might even prefer the "wrong" side. If you are unsure, however, which side of the paper is which, look for the watermark; it indicates the right side.

Both Strathmore and Crescent make good quality illustration boards, and I prefer the heavyweight kind. Illustration boards, like paper, also come in rough, cold-pressed, and hot-pressed surfaces; I generally use the cold press, which has a semirough surface. There may be some slight bowing or buckling, and I always staple the four corners to plywood for convenience. The thickness of the illustration board eliminates the problem of water seeping back on the surface. Illustration board offers an inflexible

surface to the brush, and while this characteristic has some disadvantages, it's essential when working impasto.

Watercolor boards are also available in hot-pressed, cold-pressed, and rough surfaces. These are watercolor papers that are laminated to a board. They combine the qualities of both paper and illustration board.

Japanese papers are lightweight strong papers that can be directly painted on and they can also be laminated to illustration board with acrylic matte medium. Some are strong, smooth, and translucent, such as Hosho and Sekishu. Others, such as Kinwashi, have fibers. They can be used to build up a surface for a collage, or they can be painted on one side and laminated to the paint surface. The pigment showing through the filmy paper creates a misty translucent effect. Paint can then be applied directly, giving an interesting contrast of paint quality.

Brushes Although there are several natural-haired brushes used for watercolor painting (ox hair, squirrel hair, and boar bristles), I prefer the highest quality brush—the red sable—because of its great spring and perfect point. I keep a great variety of these red sables: the ¾″, 1″, and 1½″ (1.9, 2.5, 3.8 cm) single strokes are great wash brushes, and I use them for the majority of my paintings needs. For detail, I use the round sables, no. 1-8. For very large wash areas, I like to use the 2″ or 3″ (5.1 or 7.6 cm) squirrel hair or the oriental Hake.

Watercolor brushes should always be cleaned after use. I first rinse them out in cold water and then massage the brush on a hard cake of ordinary bath soap. I do this until no more color runs; then I shape the brush back to its natural point. When storing brushes, I always take care to put the brush in the container handle-first, which keeps the brush from touching anything. *Never* leave a brush soaking in water. This can ruin the shape, the handle, and shorten the brush's life.

SPECIAL EQUIPMENT

Scraping Tools I keep a supply of tools (pocket knife, palette knife, razor blade, scraps of mat board, the end of a brush, even my fingernail) to remove still-wet paint from the painting surface. Usually, this method is similar to spreading butter, using the tool in such a way as to not damage or scar the surface. However, certain tools, such as a razor blade or a knife can be used to intentionally cut and scar the paper.

Paper Towels and Tissues I use towels and tissues to blot areas with too much paint. They can also be crinkled-up and gently rubbed on the painting surface for a textured effect.

Toothbrush This is a spattering tool that I frequently use. It's done by dipping the toothbrush in paint and then dragging my thumb across the bristles. The spatter can then be applied to a dry, damp, or wet surface, all with different effects. This same procedure can also be used with clear water instead of paint. This creates clear pockets or a balloonlike texture in the damp area.

Stencils Torn paper, scraps of mat board, and masking tape can all be used as stencils to block out areas that are to be kept free from paint or spatter. Torn paper stencils will give an irregular, free-form effect, and mat board stencils will give a crisp, hard-edge look.

In addition to using masking tape to divide or protect areas of the painting surface from spatter, I also use it as a stencil by cutting out shapes from within a wide piece of tape. The tape can then be applied to the surface. When the tape is secured, a damp clear brush can be used to remove the paint from the cut-out area.

Masking Fluid A liquid rubber cement that can be applied with a brush to block out areas of paper. Color can then be washed over these areas; and when the passage is dry, the mask can be rubbed off exposing the unpainted area.

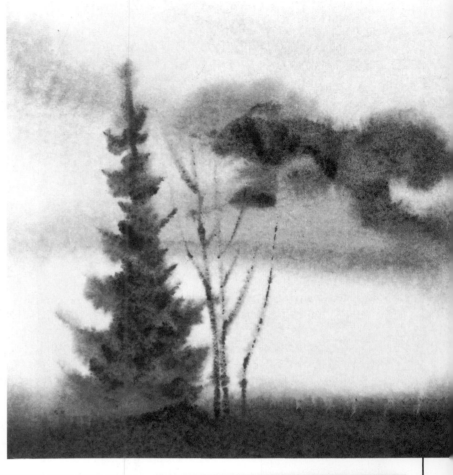

(above) Figure 1. Drybrush. Load a 1" single stroke sable brush with pigment and squeeze out most of the moisture. Fan it out and draw it across the left side of rough dry paper. Use the point of a # 6 round sable for the tree. Make the texture on the right by pressing the heel of the brush into the paper, then lift it up.

(right) Figure 2. Wet-in-Wet. On saturated paper apply a toned wash with a very wet ¾" (1.9 cm) single stroke sable brush. Add more pigment to make the cloud form and even more for the ground and spruce. Then use a # 2 round sable that is dryer than the paper and paint the sapling when the paper is only slightly damp.

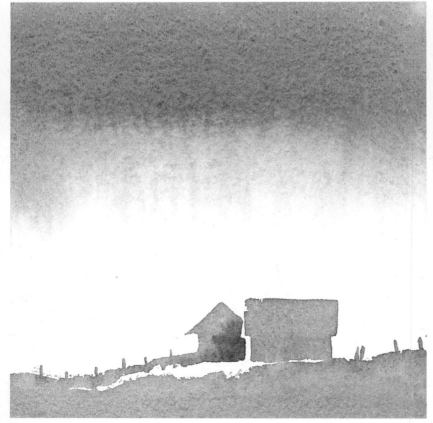

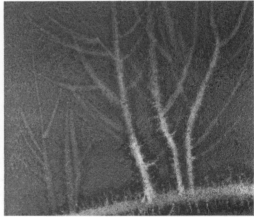

(above) Figure 3. Balloon Effect. Apply an even wash of color on damp paper. When the paper is nearly dry, paint with clear water, using a # 5 round sable for the horizon line and a # 3 round sable for the trees and branches. The clear water pushes the pigment aside.

(left) Figure 4. Fused and Controlled Wash. Wet the paper with clear water, then apply a mid-value wash to the upper part with a ¾" (1.9 cm) single stroke sable brush. Tilt the board until fusing is satisfactory, then lay it flat. When the paper is dry, paint the buildings and land with a ⅝" (1.6 cm) single stroke sable, painting around white areas for a silhouette effect.

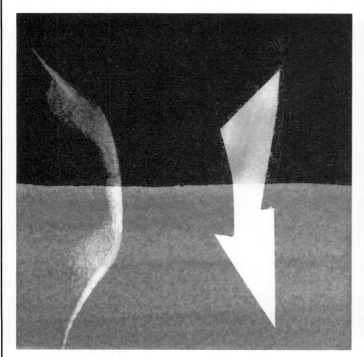

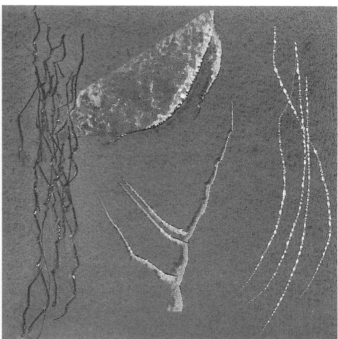

Figure 5. Stencil Lift. Apply a flat wash of alizarin crimson to the upper half of the paper and cerulean blue to the lower half. Allow these colors to dry. Then, using masking tape, from which some of the adhesive has been removed, cut out stencil. Press the stencil on the right side of the paper and lift off the pigment with a damp brush. Note how the blue lifts, but the alizarin crimson stains. The shape at left is done freely, with only the use of a damp brush.

Figure 6. Scarring and Scraping. Apply a flat wash to damp paper. While the paper is still wet, scrape lines into the left side of the paper with the corner of a mat knife and let the pigment sink in. For the middle area, use a mat knife as a squeegee for the top shape and a pocket knife for the twig forms. When the paper is completely dry, scrape white lines into the right side of the paper using the point of the mat knife.

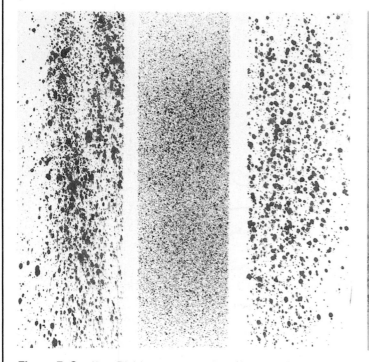

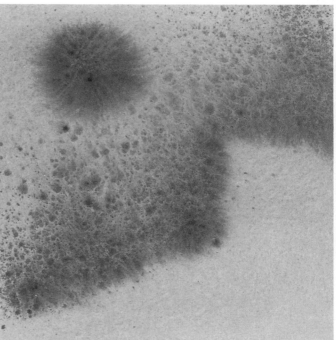

Figure 7. Spatter. Divide your paper into three vertical sections with masking tape. For the oblong spatter at left, tap your brush at an angle across the finger of your opposite hand. Make the fine spatter in the middle by drawing your thumb across a loaded toothbrush. Finally, to make the random spatter on the right, use a # 8 round brush held parallel to the paper and use the index finger of the opposite hand to hit the brush from below.

Figure 8. Wet Stencil. Apply an even wash. Make a torn paper stencil from heavy grade paper and hold it about ¼″ (.64 cm) off the damp paper. Then, using your other hand, apply the spatter using a toothbrush to the area above the torn-paper stencil. To make the sun shape, cut a circular stencil and hold it off the damp paper about ¼″ and apply a toothbrush spatter using a different color.

GOUACHE

Gouache means simply an opaque watercolor. It has other names, such as "tempera," "show card colors," and "designer's colors," in which the composition and durability of the product vary somewhat. The gouache paint we use today has been manufactured since the 1930s and is very reliable. It is an aqueous solution of pigment with a binder of gum arabic, to which has been added opaque white paint, precipitated chalk, or both.

More than any of the other water media, gouache has a long history of being combined with other materials. Since the Renaissance, artists have drawn on toned paper with ink lines and watercolor washes, adding highlights of opaque gouache. Gouache follows transparent watercolor very naturally, as the two have been combined for centuries and have many characteristics in common.

SOLUBILITY

As gouache is water soluble, wet or dry, cleanup is easy, and any type of brush can be used. While I store my pigments in a covered container with a damp towel ready for reuse, you may prefer to discard them, as they do tend dry out quickly.

HANDLING CHARACTERISTICS

Gouache handles almost as easily as transparent watercolor; it flows so easily on the brush. Because it's opaque and flows so well, it's excellent for details. For large areas of flat, opaque color, it's unbeatable. Fusing is possible wet-in-wet, but it's hard to blend if dry. Dry paint can be lifted with a clean damp brush, tissue, or sponge.

Gouache is brittle, and if used too thickly, it will crack. It's difficult to correct mistakes, as the water-soluble underlayer picks up and becomes blotchy. Keeping your brush as dry as possible helps. Another way is to make the first coat of gouache insoluble. Do this by adding a mixture of ten parts of water to one part acrylic matte medium to the gouache paint.

VISUAL QUALITIES

The characteristic opaque, chalky look of a gouache painting is most attractive. Gouache can be diluted with water for transparent washes that are softer and more diffuse in appearance than washes made with transparent watercolor. Although the visual differences between gouache and casein are not great, the way gouache flows from the brush makes the difference; and it can be used nearly transparent, as well as translucent and opaque. When used opaque, gouache looks thicker than it actually is. Light gouache colors will dry darker, while the dark colors will dry lighter.

MATERIALS

Paint I use Winsor & Newton gouache paints because I have had good results with them. These paints (just like the Winsor & Newton watercolors) are classified according to the degree of permanence: A colors possess a great degree of permanence, B colors are moderately fast, and C colors are fugitive. In addition, gouache is rated for its degree of opacity: O colors are completely opaque, R colors are reasonably opaque, P colors are partly transparent, and T colors are completely transparent.

I find that it is very important that the artist use this permanency rating when selecting colors because gouache is also a favorite medium of commercial artists who are not concerned with permanency; and some gouache colors have been specifically designed for commercial use.

Gouache is also catagorized according to its staining properties. Some gouache pigments are made from dyes and could bleed through a superimposed wash. The N colors are non-staining, M colors are moderately safe, but tend to bleed through the lighter colors, S colors will stain to some degree, and SS colors are strongly staining.

Here is my gouache color palette: All of the colors are A (permanent), O and R (opaque or reasonably opaque), and N (non-staining).

lemon yellow, cadmium yellow pale, cadmium orange, cadmium red pale, alizarin crimson, cerulean blue, cobalt blue, ultramarine blue, Winsor emerald, Winsor green, yellow ochre, raw sienna, burnt sienna, burnt umber, Prussian blue, zinc white, permanent white

Palette There are two different kinds of palettes that I use for gouache. Usually, I use the plastic palette with a covering lid, such as the one used for transparent watercolor. The paint can then be stored inside and kept moist by enclosing a wet sponge. If the paint does dry, I just add a few drops of water to each color and allow the water to soak in before starting to paint. At other times, I use a 10″ x 14″ (25 x 35cm) piece of glass with a white board secured underneath it. This is so that I can accurately gauge the colors of the paint. Also, because gouache dries so quickly, I use a single-edge razor blade for scraping away any excess paint on the palette. This means I am often squeezing fresh paint on the palette.

Painting Surface For most purposes ordinary watercolor paper can be used as a painting surface. Toned paper can also be used; the color of the paper supplies a middle value, and the gouache can be used for lights and darks. If any type of impasto is desired, a stiffer brush can be used, and the support should be heavy illustration board or something similar, in order to provide the necessary rigidity. Care must be taken when building up an impasto, which should be done in successive thin layers.

Brushes Because gouache is water soluble, brushes can be easily cleaned with ordinary hand soap or detergent and water. When using gouache I prefer red sable brushes because if sable is well taken care of,

it will have good spring, hold paint well, and keep a point for a long time. I use the red sable single strokes (sizes ½″ to 1½″ [1.3 to 4.8 cm]) for most of the washes and brushwork, the small, round red sables for detail work (no. 1-8), and the natural bristle "bright" (no. 4-20) works well for building up paint and to drag and scumble the paint over a textured surface.

SPECIAL EQUIPMENT

Scraping Tools Although scraping tools can be used to remove paint just as they are in watercolor, I am much more likely to use them to apply paint when using gouache. For example, various scraping tools (such as mat board scraps, razor blades, palette knife, or even a finger or fingernail) can be dipped in paint and applied directly to a wet or a dry surface, rendering effects that cannot be duplicated with a brush.

Some tools are very useful in building up texture. A coping saw blade or a file can be dragged through wet opaque gouache, thereby creating a textured, lined surface. Once this surface is dry, another layer of paint can then be applied over the textured surface.

Paper Towels and Tissues Just as in watercolor application, the paper towels or tissues can be wadded or crushed, then gradually rolled over a damp surface, leaving a crinkled texture on the painting surface.

Toothbrush The toothbrush is a very useful tool that I use to spatter gouache paint onto a surface. I do this by means of dragging my thumb over the loaded bristles. Soft, medium, and hard bristles will spatter the paint differently. Gouache can be spattered either transparently or opaquely on a wet or a dry surface. Opaque light-toned colors spattered over dark washes create an interesting effect.

Stencils Stencils can be used in the same variety of ways as they are for watercolor paint. However, gouache can also be used opaquely.

Masking Fluid I use masking fluid when using gouache to block out light areas that I don't want touched by paint. However, care must be taken when removing the mask, because even though the paint is dry, gouache smudges easily. To remove the mask, I use a kneaded eraser or a clean tissue, and I keep changing to a clean tissue or eraser as soon as any pigment begins to rub off or collect.

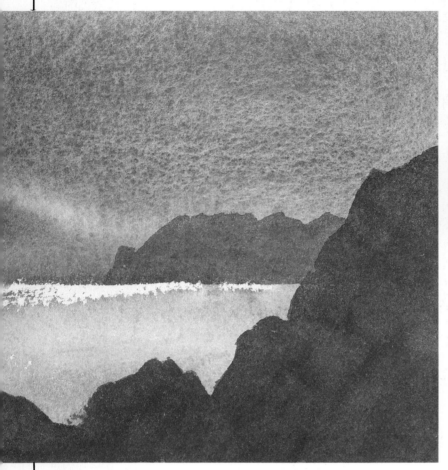

(left) Figure 1. Transparent Washes. Using a ¾″ (1.9 cm) single stroke sable brush, wet the paper, except for a small horizontal area in the middle. Apply a middle-value wash in the foreground and a somewhat deeper wash for the sky. When the paper is dry, paint the distant headland and foreground rocks with a middle-value controlled wash. Let it dry and repaint the foreground rocks with the deepest value.

(above) Figure 2. Translucent Gouache over Dark Acrylic. With a 1″ (2.5 cm) single stroke synthetic brush, wash on a dark tone of acrylic and let it dry. Rewet the surface and raise the upper margin. Float a mixture of zinc white and cerulean blue across the top, letting it fuse downward. When the layer of gouache is dry, lift off the circular area with the point of a clean, damp #5 round brush.

(above) Figure 3. Stencil Lift. Apply a flat opaque coat of gouache with a ¾″ (1.9 cm) single stroke. When this coat is dry, use a clean damp #5 round brush to lift off the pigment in random shapes. Cut out a stencil from masking tape and press it to the dry paint surface. Remove the color with a clean damp brush.

(right) Figure 4. Wet-in-Wet Opaque. Saturate an illustration board with a ¾″ (1.9 cm) single stroke sable and cover the surface with permanent white gouache. Flow color on top of the damp white paint, creating unusual feathery swirls as the white paint rises through the color.

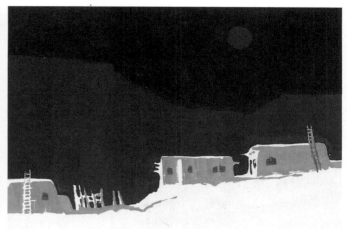

Figure 5. Opaque White Spatter: Wet-in-Wet and Drybrush. Using a ¾″ (1.9 cm) single stroke sable brush, paint the surface with opaque Prussian blue, and while the surface is damp, mask the lower half and apply a controlled spatter over the upper half with permanent white. When dry, cover this upper area and apply a graded opaque white spatter over the lower half by drawing your thumb across a loaded toothbrush.

Figure 6. Flat Opaque Washes. Using a ¾″ (1.9 cm) single stroke sable, apply an off-white wash to the foreground. When this wash is dry, apply a middle-value wash above the building forms and to the edges of the paper. When this middle-value area is dry, use a ½″ (1.27 cm) single stroke sable and paint the negative and positive forms of the buildings, fences, and ladders. When dry, paint the sky and around the moon with the deepest value.

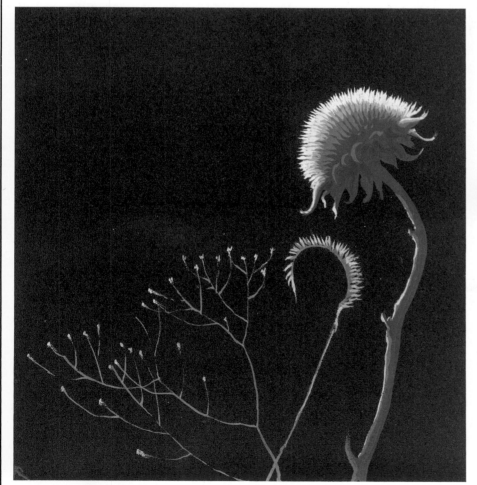

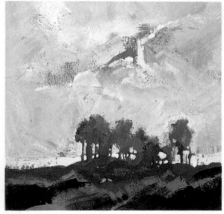

(above) Figure 7. Juicy Opaque. Using a "bright" brush and very little water, cover the surface with a textured warm tone. With a lighter value, scumble over the sky area and around the tree forms. Paint in the light area along the horizon. Then build up the textured foreground shapes with a variety of darks.

(left) Figure 8. Fine Opaque Detail. With a ¾″ (1.9 cm) single stroke sable, cover the board with opaque Prussian blue. When dry, paint in the weed forms with the tip of a #5 round sable and a warm middle value. Develop the forms with darker and lighter touches.

ACRYLIC

Acrylic paint is the result of years of chemical research into a variety of synthetic resins. First used as a house paint because of its durability, it became available for fine artist's experimentation in the 1950s.

Acrylic paints use either an acrylic polymer emulsion or a plastic resin as a binder. These particles of resin are suspended in water, and when the water evaporates, a clear, strong, flexible paint film remains, which is both waterproof and highly adhesive.

Because acrylic paint is water soluble until it dries, is fast drying, nontoxic, binds to nearly any surface, extremely flexible, and won't crack or harden with age, it's not surprising that many artists use it with the greatest enthusiasm.

SOLUBILITY

Because acrylics dry quickly and are hard to wash out, I use a different set of brushes from those I use for transparent watercolor and gouache. There are several good brands of synthetic brushes on the market. Whatever brushes you decide on, it's absolutely essential to wash them immediately after use, because acrylic paint is totally insoluble once dry.

HANDLING CHARACTERISTICS

Because acrylics adhere to nearly anything and are flexible, nearly any painting support can be used. Acrylic can be used for transparent washes or heavy impasto. It can be used for both transparent and opaque spatter. The adhesive qualities of acrylic make it excellent for adhering collage materials and for mounting paper.

Acrylic dries quickly to insolubility and won't lift off, so that succeeding transparent washes of color can easily be applied, producing effects of great depth. Both translucent and opaque applications have a tendency to streak, and acrylics lack real covering power except when used impasto. The paint has a tendency to glob and slide, and its unusual plastic feel gives some people difficulty. Because it lacks a flowing quality, acrylic is less satisfactory for fine detail work. Impastos can be built up with brush or palette knife and can be manipulated to create a variety of textures. Heavy impastos do not need a rigid support and should dry overnight.

VISUAL QUALITIES

Acrylic paints do not change color when dry, and they possess great brilliance. But if not used with care, acrylic paints have a garishness that some people find unpleasant. The appearance of acrylic paint is somewhat difficult to describe. A film or sheen seems to cover the opaque paint, lending a plastic appearance that is quite distinctive.

MATERIALS

Paint When using acrylic paints, it's important to stay with the same brand, as each company has a different formula. Once dry, acrylic paint is water insoluble and exceedingly durable. In addition, they dry rapidly and do not yellow with age. The paint film thus created is very permanent and brilliant in color.

Here is my acrylic color palette:
cobalt blue, dioxazine purple, emerald green, Hooker's green, permanent green light, phthalo blue, raw sienna, yellow oxide, titanium white, Acra violet, burnt sienna, burnt umber, cadmium orange, cadmium red light, cadmium yellow light, cadmium yellow medium, carulean blue, chromium oxide green

Palette Acrylic palettes should be either disposable or easily cleaned. Usually, I use the disposable palette, but sometimes a white scrap of mat board or a rectangular piece of glass with a white board taped underneath works well. The glass solution is appealing to me because I can scrape the paint off easily with a single-edge razor blade. Similary, white enamel trays also work.

However, be warned—the plastic watercolor palettes with the tight-fitting lids do not work well. Acrylic paints dry so quickly that it becomes nearly impossible to throughly clean out the paint wells and they scrape away much more easily on a flat surface such as glass.

Painting Surface Because acrylics adhere to practically anything, almost any paper or board can be used. It is the most durable and flexible of all the water media so it is not necessary that a rigid support be used, even when working in heavy impasto. A lighter weight watercolor paper will work with no fear of the paint cracking.

My chief concern when selecting a support for acrylic paint is that the paper or board lends itself to the technique that I intend to use. For example, when I am working rather small and am using wet-in-wet washes followed by more washes, I choose Arches 300-lb. cold press. For larger paintings, I would choose a heavier paper, such as the Arches 555-lb. rough; or if I'm using washes meant to express a splashy, energetic brush texture, I like the Arches 300-lb. rough.

Recently, I have begun to use rice paper for my acrylic paintings—a new direction that is exciting to me. This is accomplished by laminating the rather delicate rice paper to illustration board, using one part water and one part acrylic matte medium. Sometimes, I will have already applied a transparent acrylic wash to the illustration board, so that when the rice paper is superimposed on the board, the brilliant acrylic underlayer shows through underneath, although much subdued. Then the acrylic or watercolor paint is applied directly on the rice paper.

My favorite rice papers for this purpose are Hosho and Unryu, and I use the Strathmore Series 240-1 and the Crecsent #100 heavyweight cold press for illustration boards. I buy both of these boards in a large size (30" x 40" [76 x 102

cm]) and cut them to size.

Brushes When selecting brushes for use with acrylic, it is most important to remember that the medium is completely insoluble. This characteristic makes it imperative to keep brushes clean and in good condition. If a brush is not thoroughly cleaned, it's response will definitely lessen: the paint will begin to build up in the heel of the brush, making the brush stiff and thereby losing its spring. For these reasons, I always clean my brushes immediately, even if I intend to use them again in the next twenty minutes.

To clean brushes that have been used with acrylic paint, I put ordinary hand soap or a little detergent in the palm of my hand and massage or work the brush into the soap until all traces of paint have been removed.

I never use my red sable brushes when working with acrylic paint. They are just too expensive to risk the chance of lessening their response. Instead, I use the synthetic brushes that are developed specifically for use with water media. These synthetics are inexpensive, and in general their response is good, especially the wash brushes. My favorites are the ½″ to 1½″ (1.3 to 4.8 cm) single stroke synthetics. These are very good for washes and for the majority of my brushwork. For detail, I use the round synthetics, (no. 1-8), although the small round synthetics do not hold a point well. For "juicy" painting with a textural build-up, I have found that the synthetic "brights" (no. 4-20) are very good.

SPECIAL EQUIPMENT

As with brushes, it is especially important to clean your tools thoroughly when using acrylic paints. The paint will adhere as well to a metal surface as it will to a brush.

Scraping Tools The special tools (razor blades, pocket knife, mat board scraps, palette knife, fingernail) that I use with acrylic can be used either to remove paint in wet transparent areas or to apply paint with opaque techniques. I like to work into a rich transparent wash by taking a razor blade or pocket knife, charging it with thick, opaque acrylic paint, and then sliding the tool across the wet surface.

A palette or a pocket knife can be effectively used to build up a textured surface. Once this built-up surface is created, an inking brayer or a coping saw blade can add further texture by dragging or rolling it through the thick paint. When this layer has completely dried, I lay in a thin wash over the textured surface, letting some of its color show through underneath.

Toothbrush Toothbrush spatter can create an exciting and unusual effect in acrylic paint, especially when an opaque spatter is applied to a wet transparent wash. The effect of opaque paint seeping into the wet is very dramatic. Another option here is to alter the procedure and spatter the acrylic on dry or opaque areas.

Paper Towels and Tissues I use paper towels and tissues to blot and remove damp transparent acrylic paint. Textured effects can also be created by crinkling the tissue and gently blotting and rolling it on a damp surface. Towels can also be used to apply paint directly by dipping the paper towel in a basin with a wash of acrylic and then applying the color-soaked paper to the painting surface.

Stencils All types of stencils can be used when working with acrylic paints. However, it is important to note that acrylic paint can also be applied opaquely.

Masking Fluid Masking fluid can be used very effectively with acrylic paints because acrylic will not smudge. When the paint has dried over the mask, the masking fluid is easily removed with an eraser or a paper towel. Because acrylic doesn't smudge, batiklike results can be obtained by masking out areas and then washing on a layer of transparent acrylic paint. By letting each layer dry completely, this process can be repeated several times. When the mask is finally removed, a very unusual patterning effect is achieved.

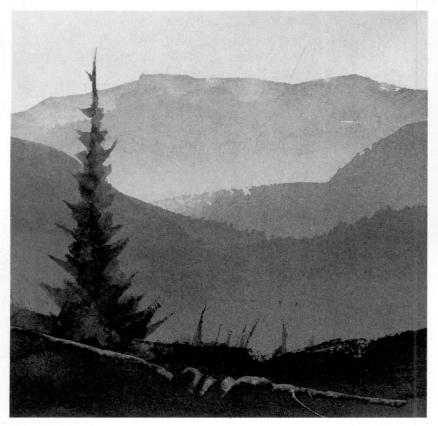

(above) Figure 2. Clear Spatter and Wipe. Lay a dark wash on dry paper. When the wash is semidry, apply a controlled spatter of clear water by tapping the wet brush with the index finger of your opposite hand. When the background color is dry, wipe off the spattered area with a clean damp brush.

(above) Figure 1. Transparent Washes. Dampen the entire surface and apply an even, light wash of Hooker's green with a ¾″ (1.9 cm) single stroke synthetic brush. When the wash is dry, use deeper colors to make the succeeding mountain ridges, allowing each wash to dry before applying the next. The tree and foreground are of the deepest value, and while the surface is still wet, make the shape suggesting a horizontal log by scraping the paint off with a mat knife.

(above) Figure 3. Brush Texture on Wet and Dry Paper. Using a ¾″ (1.9 cm) single stroke synthetic, apply opaque pigment to dry paper on the left in a variety of strokes. On the right, wet the paper with clear water and apply the loaded brush in the same way: soft brush textures are created; no other medium produces quite these same effects.

(left) Figure 4. Transparent and Opaque Spatter. Dampen the paint surface with clear water. Load a toothbrush with Hooker's green. Hold the bristles downward and rub your thumb across them. Touch the loaded brush to the surface several times, then drag it across the paper for a different effect.

(above) Figure 5. Translucent Wash over Dark, with Masking Fluid. Apply a dark opaque wash with a ¾'' (1.9 cm) single stroke synthetic brush. When the wash is dry, use masking fluid and paint out the bottom area, making circles of various sizes with an old brush. When the mask dries, cover the paper with a translucent wash of white and cerulean blue. Although it streaks when dry, the acrylic wash makes an insoluble layer that holds a crisp edge when the masking fluid is rubbed off.

(below) Figure 7. White Texture with Transparent Overlay. Apply titanium white heavily, and when it begins to harden, work various textures into the surface with a coping saw blade, a comb, or your fingers. When the paint is completely dry, apply a transparent wash of intense acrylic color.

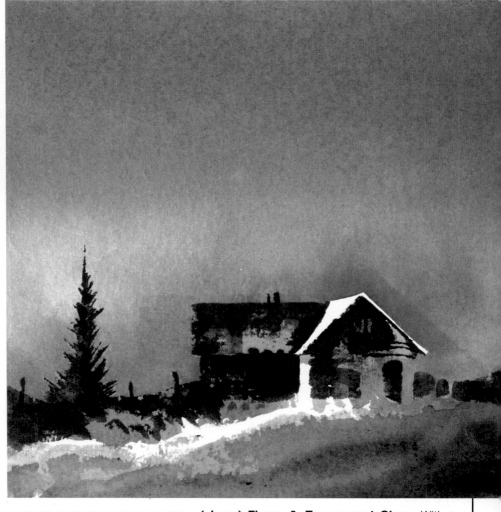

(above) Figure 6. Transparent Glaze. With a ½'' (1.27 cm) single stroke synthetic, paint in the building, tree, and foreground with a mixture of Hooker's green and burnt umber, leaving white areas untouched. When this is dry, wash transparent Acra violet over the entire painting, except for the white areas. A total change of mood results.

(below) Figure 8. Impasto. Mix a middle value of paint and apply it heavily over the whole surface, using a #16 ''bright'' and a palette knife. When the impasto is thoroughly dry, apply a thick, textured middle value for the headland. When this is dry, apply a heavy layer of various darks to the foreground and pure white for the line of surf.

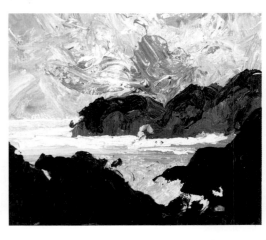

CASEIN

The binder for casein is milk curd made from pot cheese, one of the strongest adhesives known. Artisans of the eleventh century used it, and many medieval frescoes were painted in casein. These early users of casein were plagued with difficulties pertaining to proper blending and spoilage. However, because of the many good qualities inherent in casein, paint and chemical companies began experimenting in the 1930s to improve its quality. Today, casein paints are a consistent and durable product, meeting the highest requirements of the most demanding artist.

Casein paints still use a binder that is a milk derivative. This is mixed with water, heated, preserved, and deodorized. Various oils are emulsified into this milk-protein-water base, and stabilizer is added to hold the emulsion. Blending this emulsion with color requires a different process for each pigment. Because of this complex process, it's wise to stay with one brand.

SOLUBILITY

Casein is soluble when first applied, but it gradually becomes more impervious to water, and within a month it is totally insoluble. Casein paint will also build up on a brush, so always dip your brush in water before putting it into paint and always clean your brushes thoroughly with soap and water after each use. I use the same brushes for casein that I use for acrylic.

HANDLING CHARACTERISTICS

Casein can be used for transparent, translucent, and opaque effects. As a transparent wash, it's far less brilliant than transparent watercolor. It's similar to gouache, but harder to lift off. When used as an opaque wash, it's excellent for large areas because of its covering power. The paint flows very easily on the brush, so it's good for fine details. Casein can be built up in succeeding layers, as the undercoats don't pick up as easily as gouache. Glazing and overpainting will give very rich effects. If freshly painted, casein can be lifted with a wet brush, although not as easily as watercolor and gouache. "Brights" and palette knives can be used for impastos. A rigid support is recommended when using a heavy layer of paint, as casein is a brittle medium and might chip or flake if it is used thickly on a flexible surface. An added bonus when working with casein is its unique and pleasant aroma.

VISUAL QUALITIES

When thoroughly dry, a casein painting has a natural matte or semimatte finish. The surface can be polished to a dull luster with a ball of soft cotton. The look of a well-painted casein painting can't be matched by any other medium. This is one of the reasons that casein is a favorite of mine.

MATERIALS

Paint Casein paints are not readily available in most local art stores. However, they can usually be found in large art material centers in the larger cities and can be obtained through art supply mail-order catalog.

Shiva casein paints are my favorite brand and in my experience the most widely available. They have good coverage and brush flow, and they are permanent. Because I live in an isolated area, I try to keep on hand at least three tubes of each color in my palette. In addition, if a final gloss is desired, I use the Shiva brand finish varnish.

Here is my list of casein colors:
alizarin crimson, burnt sienna, burnt umber, cadmium orange, cadmium red extra pale, cadmium yellow light, cadmium yellow medium, cerulean blue, cobalt blue, golden ochre, Naples yellow, raw sienna, Shiva green (phthalo), permanent green light, Shiva violet, terra verte, titanium white

Palette When working with casein paints, I always use a palette in which the paint can be scraped away and cleaned after each use. Typically, my casein palette consists of a rectangular piece of heavy glass with protective tape around the perimeter. I also tape a sheet of white paper or mat board underneath the glass to set off the colors.

An enamel white tray is also an excellent palette for casein use. Casein paints left exposed to the air will dry out, so I keep the pigment moist by occasionally adding a few drops of water. Or, if I'm leaving the studio for any period of time, a damp cloth can be placed over the tray. This will keep the casein moist until I get back to work.

Painting Surface Most painting surfaces will work for casein. Because the casein binder is rather inflexible, I find that when working with thicker applications, either a rigid painting surface is necessary or that a lighter-weight paper (such as rice paper) will need to be mounted on a rigid support. This is done by laminating the paper to the board with one part acrylic matte medium to one part water.

Brushes When it comes to choosing brushes, casein is very similar to acrylic. I never use my expensive red sable brushes when working with casein. Instead, I use the synthetics, which are specifically designed for the water media. They are not costly and their performance is good, especially the wash brushes.

For the majority of my casein brushwork—wet-in-wet and drybrush techniques—I prefer the single stroke synthetics, sizes ½" to 1½" (1.3 to 3.8 cm). For detail areas, I use the synthetic round brushes, no. 1-8, although the smaller round brushes do not hold a point well. And for the "juicy" opaques and textural build-ups, I use the synthetic "brights," no. 4-20. Casein brushes must be cleaned immediately after each use because the

paint will build up, and, when dry, become very difficult to remove. However, I have discovered that if a brush is soaked in ammonia, some of the paint will eventually loosen.

SPECIAL EQUIPMENT

Scraping Tools The scraping tools (razor blade, pocket or palette knife, scraps of mat board, or my finger or fingernail) can be used either to remove or add paint to the painting surface. I like to load up a single-edge razor blade with opaque casein and apply it to a wet transparent wash. The combination of the intense transparent acrylic and the matte look of the translucent and opaque casein is exciting.

Brayer An inking brayer, which is normally used for relief printmaking, can also be used to apply casein to the paint surface. This technique is especially effective with casein because of its unique buttery consistency. To do this, I squeeze the casein onto a glass surface. Then, I roll the brayer into the paint, working it up over the glass. The loaded brayer is then applied to the painting surface, creating a tacky, textural effect. After this textured layer dries, subsequent overlays of paint can be brushed on, leaving some of the textured color showing through.

Toothbrush This useful tool can add opaque casein spatter to wet or dry areas. The casein can be spattered in lighter tones over dark areas and in dark tones over light areas. I like the soft effect of an opaque white or light-toned spatter over a thin wash of transparent watercolor.

Paper Towels and Tissues Opaque textural passages can be achieved by crinkling the paper towels or tissues and rolling it into some casein color on the palette. The paper can then be gently rolled over the wet or dry surface.

Stencils All types of stencils can be applied with casein paint. In addition, casein can also be used opaquely.

Masking Fluid Masking fluid can be used with casein. However, when the paint is dry, it will smudge easily if you are not careful when lifting the mask. I use a kneaded eraser or clean paper towel to remove the mask; and, as the pigment starts to transfer to the lifting tool, I immediately look for a clean area on the paper and continue the process.

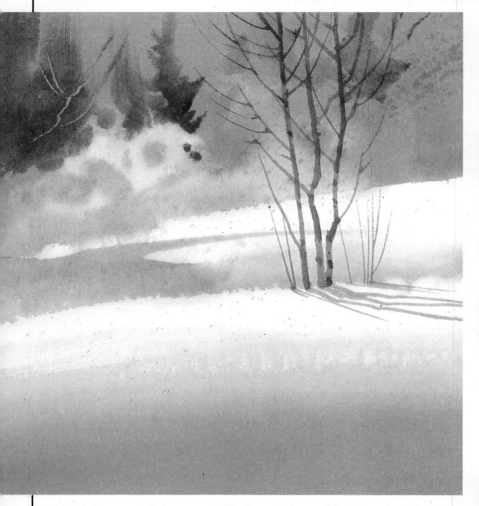

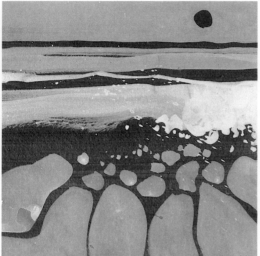

(above) Figure 1. Transparent Washes. Using a ¾″ (1.9 cm) single stroke synthetic brush, wet the background area with clear water and wash in a middle value of blue. Add green to the mixture and brush in the background trees. Lift off branch shapes by scraping with a knife. Then, using a ⅝″ (1.6 cm) single stroke synthetic, wash in the middle ground and foreground, leaving a drybrush edge to the foreground and white areas to indicate snowbanks. Paint the trees, saplings, and their shadows with a # 5 round brush on dry paper.

(top) Figure 2. Translucent Casein over Dark Acrylic. Apply a wash of dark green acrylic. When the acrylic is dry, use a ¾″ (1.9 cm) single stroke synthetic and apply a mixture of blue and white casein in various tones. Try to control the transparency of the paint by the amount of water added.

(above, center) Figure 3. Opaque White Wash. Paint the surface with titanium white. While this is still wet, raise the board at the upper margin and apply color to the upper area so that it flows downward. Lay the board flat, and when the paint becomes a bit dryer, apply dark paint across the foreground. This produces the feathery effect.

(left) Figure 4. Opaque Spatter into White. With the paper flat, cover it with titanium white. While this wash is damp, hold a torn paper (cut from heavyweight paper) stencil ¼″ (.64 cm) from the surface and apply a toothbrush spatter of blue to the upper area. When the white paint dries completely, use the same stencil, holding it in the same way, and apply another toothbrush spatter of the same color to the lower half of the paper.

(above, left) Figure 5. Opaque White Spatter. Paint the surface with a dark casein paint and let it dry. Mix titanium white with enough water to make it translucent, load up a toothbrush, and apply spatter while holding a torn paper stencil about ¼'' (.64 cm) from the surface of the paper. Then, do another area of the paper using a different stencil, this time loading the toothbrush with more pigment and less water.

(above, right) Figure 6. Opaque Flat Washes. Cover the surface with an opaque warm tone using a ¾'' (1.9 cm) single stroke synthetic. Then, with a lighter, more opaque wash, paint the mesa shapes at the horizon and bring the paint to the bottom of the paper. Create additional mesas and ridge shapes with opaque washes, each one gradually becoming lighter. Remember that each layer should dry before adding the next one.

(left) Figure 7. Opaque Detail. Paint the surface with a dark translucent shade of blue. While the paint is still damp, use opaque white for the snow. Let that dry. Paint the tree with a ¼'' (.64 cm) single stroke synthetic, beginning with the darkest value and progressing to the lighter. The deep value becomes the shaded side. Paint the more delicate branches and bark detail with a #3 round synthetic.

(right) Figure 8. Juicy Opaque. Using synthetic ''brights,'' paint the mountains with a heavy application of dark paint. When dry, paint the buildings by working dark on light, and then light on dark. Use the paint thickly throughout scumbling lightly over the dark areas of sky and foreground.

WATER MEDIA REFERENCE GUIDE

	WATERCOLOR	GOUACHE	ACRYLIC	CASEIN
PAINTING BINDER	Gum arabic, a vegetable gum made from the Acadia tree family	Gum arabic	Plastic resin particles suspended in water	Milk protein base (curd) and oils (oils in water emulsion)
BINDING CAPACITY	Excellent when applied in thin washes	Excellent with thin and medium applications; very poor with thick application	Excellent with any type of application: thin, medium, or thick	Excellent with thin and medium applications, very poor with thick applications
SOLUBILITY WHEN PAINT IS DRY	Completely soluble; paint can be lifted and removed at any time; some colors will stain surface	Completely soluble; paint can be lifted and removed at any time,	Completely insoluble; paint can be applied without disturbing the underlayer	Partially soluble; paint can be lifted, but not easily. The longer it sets, the harder the film; with time becomes impervious to water.
TRANSPARENT VISUAL QUALITY	Soft luminous glow	Chalky matte finish	High intensity, brilliant	Soft matte finish
TRANSLUCENT VISUAL QUALITY		Soft, cloudy	Cloudy, hard look; streaks easily	Soft, cloudy
OPAQUE VISUAL QUALITY		Chalky matte; colors are lighter because of addition of white chalk	High intensity; plastic sheen	Blond matte; polishes to a soft sheen with a cotton ball
GENERAL BRUSH HANDLING	Very easy and free flow	Very easy and free flow	Sticky resistance when applied translucent or opaque	Free and easy flow; some resistance with opaque application
BRUSH HANDLING FOR FLAT OPAQUE WASHES		Smooth, easily handled; great coverage power; excellent opacity	Hard to handle on brush; paint does not have extreme opacity; paint can streak and glob	Free and easy flow; great coverage power; good opacity

	WATERCOLOR	GOUACHE	ACRYLIC	CASEIN
BRUSH HANDLING FOR OPAQUE DETAIL		Extremely fine detail can be achieved; great brush flow	Hard to achieve fine detail; paint tends to thicken on tip of brush	Fine detail can be achieved; good brush flow
PAINT QUALITY WITH OPAQUE BUILD-UP		Can be applied in thin or medium layers; thick layers of paint will crack	Can have great impasto effects; paint can be applied in layers or in one application	Can be applied in thin or medium layers: a thick layer of heavy impasto will crack and chip
PAINTING SURFACE	Any paper or illustration board; for best results, use quality permanent brands	For thin and medium applications, any paper will work; for opaque build-up, use surface with a rigid backing or mount paper to board	Any paper or illustration board; for best results, use permanent brands	For thin and medium applications, any paper will work; for opaque build-up, use surface with a rigid backing or mount paper to board
SPECIAL CARE	No special care necessary; brushes easy to clean with water	No special care necessary; brushes easy to clean with water	Brushes must be cleaned thoroughly with mild soap and water	Do not freeze or expose paint to extreme heat; brushes must be cleaned thoroughly with mild soap and water
PERMANENCE AND FRAMING CARE	Permanent when using artist quality pigments; frame under glass and avoid long exposure to direct sunlight	Permanent when using artist quality pigments; frame under glass and avoid long exposure to direct sunlight	Permanent when using artist quality pigments; frame with or without glass and avoid long exposure to direct sunlight	Permanent when using artist quality pigments; frame with or without glass and avoid long exposure to direct sunlight

BRUSHES

These are the brushes I use for all the water media. They are basically interchangeable, but I use one set for watercolor and gouache and another set for casein and acrylic. This is because casein and acrylic don't wash out easily, so I use the less expensive synthetics, which have been designed for the purpose. Brushes sized by numbers use higher numbers for the larger sizes. All these brushes can be kept clean with soap and warm water, reshaped and set upright in a jar to air dry.

Oriental Hake brush. This wash brush comes in three sizes: 1", 1¾", and 3" (2.54, 4.5, 7.6 cm). Although not as soft and flexible as the squirrel hair, it covers a large area with a minimum number of strokes and so is ideal for washes.

Aquarelle. This brush is made by Grumbacher and is designed specifically for water media. The bristles (available in red or synthetic sable) are somewhat shorter than the single stroke brushes and give more control in restricted areas. The end of the handle has a convenient chisel edge that is useful for scraping paint.

Single stroke brush. This is the brush I use more than any other. It comes in sizes from ⅛" (.32 cm) to 1½" (3.8 cm) and is available in red sable, ox hair, and synthetic materials. The bristle material determines the price. Single strokes have long bristles that hold a lot of pigment, so they're good for working wet-in-wet and for covering large areas. The sharp edge can be used on its side for linear strokes. Single strokes can also be used for drybrush techniques.

Synthetic "bright" brush. This brush is made of a patented synthetic material, designed especially for acrylic and casein. The sizes run from #28, the largest, down to the smallest, #00. This is a stiff brush, with shorter bristles that have more snap than the single stroke. I use either the tip or the heel of the brush loaded with lots of paint and very little water for opaque, juicy effects. I use "brights" for everything except transparent watercolor.

Single stroke synthetic brush. This brush ranges in size from ⅛'' (.32 cm) to 1½'' (3.8 cm). It is inexpensive, has excellent handling qualities, holds large quantities of paint, comes to a good edge, and can be used for nearly everything.

Japanese Sumi brush. This brush is used for Sumi painting and oriental calligraphy. It comes to a fine point and can hold a lot of paint. The bristles don't have the resilience of a ''round,'' but it wears better than the round. It can be used for thick or thin lines, depending on how it's held.

Traditional ''round'' watercolor brush. This versatile brush can be made of red sable, synthetic sable, or camel hair and can be used for everything from washes to detail. It comes to a needle point but wears out quickly, especially in the smaller sizes. A resilient brush, it springs back after a stroke. Size 00000 has only a few tapered hairs, and the size #12 is almost ⅜'' (.95 cm) in diameter.

2'' squirrel hair brush. This brush was designed to be used by photographers for dusting off equipment. It's extremely soft, making it ideal for soaking down paper and applying large washes.

PART 2 COMBINED MEDIA EXERCISES

In part two I'll demonstrate various combinations of the four different water media: watercolor, gouache, acrylic, and casein. In each exercise I'll show you how to combine two of the media in a different way. I'll give you detailed information about the different painting surfaces, as well as the brushes and pigments that I use. I'll tell you about other tools you can use to create unusual effects. By following these instructions, step by step, at your own pace, you can achieve the same results that I do.

When you've completed the series of seven exercises, you'll be on your way to becoming familiar with all the water media combinations. Secure with the knowledge you've gained, you'll probably have ideas of your own, and will want to continue your own experimentation. That's the point at which your own creative expression can take flight.

So get set up at your work space.

EXERCISE 1. TRANSLUCENT CASEIN AND OPAQUE ACRYLIC

Crescent #100 cold-pressed, heavyweight illustration board

This exercise is based on hundreds of sketches I've made on the Oregon coast and makes use of a combination of media I find ideal for creating atmospheric effects. I'm using an underlayer of titanium white casein because of its excellent covering power. When followed by succeeding wet washes of casein colors, the underlying white paint bleeds up through the color, giving the effect of rainy clouds. You may want to experiment using gouache in this way. Gouache looks more opaque and comes to the surface more readily than casein, but for this particular purpose I prefer to use casein, followed by acrylic for its opacity and brilliance. This exercise requires a totally saturated illustration board. Illustration boards have a tendency to look as though they're wet, but then the water will totally disappear, soaked up by the layers of cardboard. It takes several successive washes of water before the illustration board is saturated to the point where it will hold an evenly damp surface for any length of time.

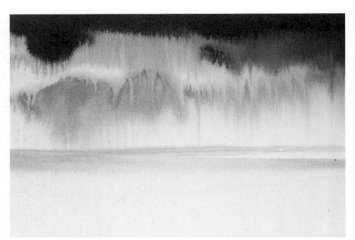

(left) Step 1. My illustration board is stapled at the corners to a piece of plywood. Using a 2″ (5 cm) squirrel hair brush, I give the board repeated washes of clear water until it is totally saturated. Next, using a 1″ (2.5 cm) single stroke synthetic, I flood titanium white casein over the entire surface. Mixing lighter tones of cadmium orange and burnt sienna casein, I wash over the sky area, adding more burnt sienna and alizarin crimson where I want darker values. Now I tip the board up and let the colored washes bleed down the page. The white casein underneath percolates up, creating fine streaks and lighter areas reminiscent of rainy, misty clouds. When I've gotten the effect I want, I lay the board flat and dry it quickly with a hair dryer. Just before the board is totally dry, I hit the horizon line with a stroke of cerulean blue to offer a suggestion of the ocean and pull the color down toward the bottom of the page, fading it out as I go. Then I let it dry.

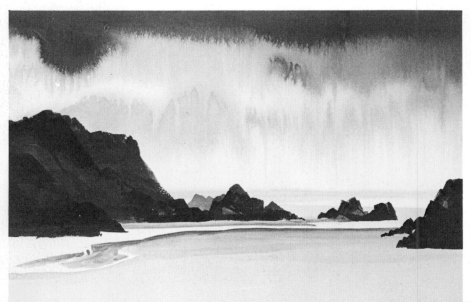

(left) Step 2. For this step, I am using acrylic paint and a ¾″ (1.9 cm) single stroke synthetic brush. Mixing burnt sienna, cadmium orange, and cadmium red light with varying amounts of titanium white, I paint the sand in the foreground. When this passage has dried, I complete the sketch by painting in the rock forms, adding Acra violet and a little phthalo blue to the orange and red for the darker tones.

EXERCISE 2. TRANSPARENT WATERCOLOR AND OPAQUE GOUACHE

Arches 300-lb., cold-pressed paper

This exercise is based on familiar shapes I see everywhere outside of my studio: the dark silhouettes of spruces, the delicate aspen, and jagged rock forms. Transparent watercolor in a graded controlled wash is excellent for creating atmospheric effects. This background color also helps to unify the study and is used in the middle foreground to suggest a pond or perhaps a stretch of ground that reflects light from the sky. Gouache is used for the tree and rock forms, both dark and light. Because of the opacity of gouache, it isn't necessary to save the white paper; highlights can be added later. Gouache when dry has a pleasant dull surface that provides a nice contrast with the luminous watercolor.

(left) Step 1. The paper is taped to a piece of plywood and propped up about 4″ (10 cm) at the upper margin. I wet it down completely with clear water using a 1″ (2.5 cm) single stroke sable brush. I mix some rose madder with a little Prussian blue watercolor and let it flow in along the top of the paper. Because the paper is wet and at an angle, the color gradually bleeds down over the entire surface, creating a graded wash, darker at the top and lighter toward the bottom. I let the paper dry.

(below, left) Step 2. I mix burnt umber, alizarin crimson, and a little Prussian blue gouache with water to a creamy, opaque consistency. Using a ¾″ (1.9 cm) single stroke sable, I paint in the background spruce trees and the foreground rocks. With a somewhat drier brush, I paint the passage just below the spruces, allowing the rough texture of the paper to create a sparkling effect. More drybrush touches are added in the foreground and for the outer branches of the spruces. I leave the transparent area in the middle ground untouched to create depth and to provide contrast between the transparent and the opaque passages.

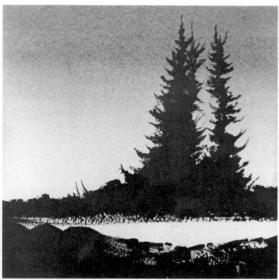

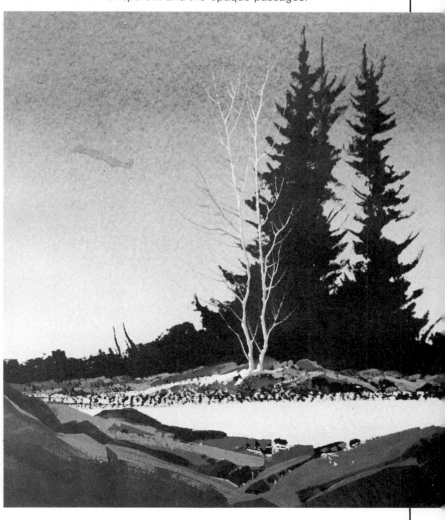

(right) Step 3. Using raw sienna, cadmium orange, rose madder alizarin, and burnt sienna mixed in varying combinations with the addition of permanent white gouache, I render the rocks in front of the spruce trees and the aspen tree. Permanent white gouache is the most opaque white I can use. I use somewhat brighter mixtures of raw sienna, cadmium orange, and white for the aspen trunks; and when dry, I add touches of pure permanent white gouache. With a ¾″ (1.9 cm) single stroke sable and somewhat freer strokes, I model the foreground rocks. Using cerulean blue gouache and a #5 round sable, I add texture to the rock forms and the shadows under the sapling.

EXERCISE 3. THE BATIK APPROACH: ACRYLIC AND MASKING FLUID

Crescent #100 cold-pressed, heavyweight illustration board

The batik approach to water media painting is similar to the technique used by fabric artists. Just like the fabric artist who blocks out areas of color before dyeing parts of the fabric to create brilliant pattern effects, so too the water media artist can adapt this technique to block or white out areas of his painting.

Acrylic is used for this approach because it is totally insoluble when dry and will not pick up when the masking fluid is rubbed off. You can work from sketches or from a still life, but don't get too rigid. It's important to remain flexible, even though you may want to do some preplanning in order to know how

much darker you want each succeeding wash to be. This exercise shows you the basic sequence of steps. You can continue these steps endlessly in your own paintings depending on how complex you want the effect to be. The batik approach can be used for very bold effects or very subtle ones.

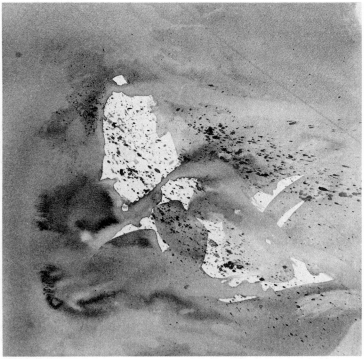

(left) Step 1. The illustration board must be totally dry. Using a 1″ single stroke synthetic, I lay in a light transparent wash using Hooker's green and phthalo blue acrylic. It's an irregular wash, and I leave some dry areas untouched in the central area. I apply a directional spatter of Acra violet, which blurs on the wet board and stays crisp where the board is dry. This will give me some variation in the areas I will white out with the masking fluid. I allow this wash to dry thoroughly.

(below, left) Step 2. First, I stir the masking fluid thoroughly and carefully. I want it evenly mixed and without bubbles. During this time I'm studying the painting, visualizing the areas I want to be the lightest in the composition. Using an old flat brush, I fill it with soap and water before putting it in the masking fluid. (This insures that the brush will wash out easily later.) Then I mask out the forms I have decided I want blocked out and let the masking fluid dry.

(below) Step 3. Mixing a middle-value wash of Hooker's green and phthalo blue acrylic and using a 1″ (2.5 cm) single stroke synthetic, I paint an irregular wash over the entire painting. This will emphasize the shapes of the leaves and ferns previously painted out with masking fluid, which will be the lightest value in the completed study. This paint layer is then allowed to dry.

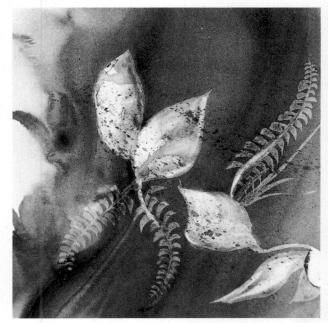

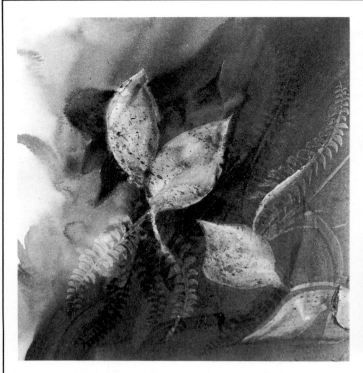

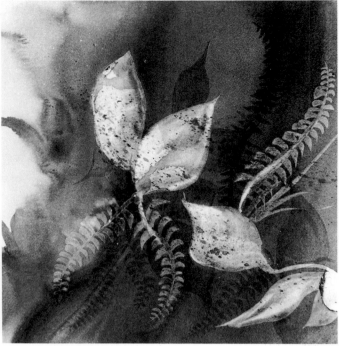

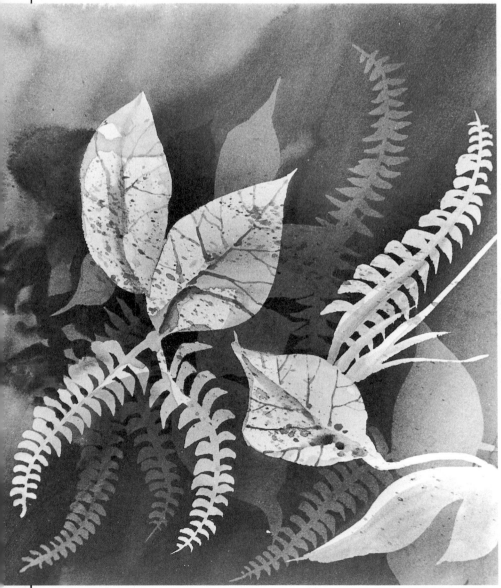

(above, left) Step 4. Using the same old flat brush dipped in masking fluid, I paint out the fern and leaf shapes that will be in the middle-value range. In effect, I'm blocking out these areas just as I did the lightest areas in step 2. I let this dry.

(above, right) Step 5. Once again I apply another irregular wash over the entire painting, this time using an even darker version of the basic color mixture of Hooker's green and phthalo blue acrylic. This wash is also allowed to dry.

(left) Step 6. With the same 1″ single stroke synthetic, I lay in a final deeper wash of the Hooker's green and phthalo blue acrylic to give even stronger contrast to the shapes that will be exposed when the mask is removed. With the deepest value of these same two colors, I paint fern shapes directly in the composition. After the paint has completely dried, I remove all the masking fluid gently using my finger. Finally I paint in the details of the leaf shapes with a # 3 round sabeline brush.

EXERCISE 4. TEXTURAL OPAQUE ACRYLIC AND OPAQUE GOUACHE

Crescent # 100 cold-pressed, heavyweight illustration board

My studio always has a collection of different kinds of weeds lying around for immediate reference. They're a favorite subject of mine, and I use them frequently in my paintings. This study of a milkweed pod makes use of a textured acrylic underpainting using colors complementary to the final layer of paint. Textured underpainting with complementary colors is a traditional oil painting technique; here's an example using water media. Acrylic is ideal for creating texture and is insoluble when dry. Gouache is used for the second step because of its opacity and because it is excellent for fine details.

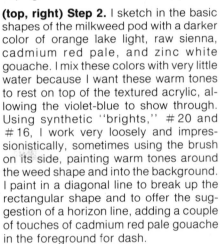
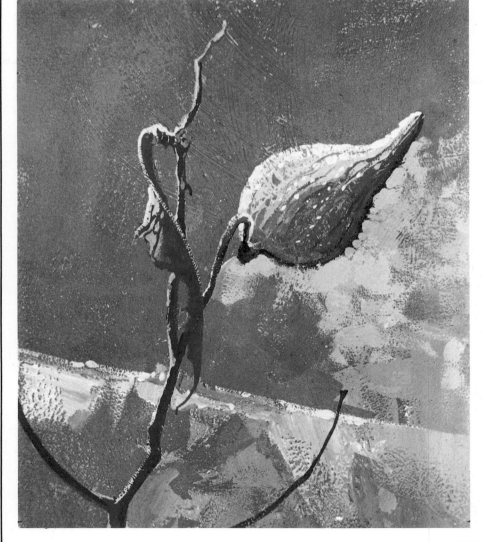

(top, left) Step 1. I've laid out my acrylic paints on a glass palette with white paper taped underneath to set off the colors. Using a brayer, I roll up and mix on the palette titanium white, cobalt blue, dioxazine purple and Acra violet acrylic. I then apply this mixture quite heavily to the surface of the board, creating an interplay of red and violet-blue in lighter and darker tones. When the acrylic is a bit sticky or tacky, I scratch in some texture using a coping saw blade. Then I let it dry.

(top, right) Step 2. I sketch in the basic shapes of the milkweed pod with a darker color of orange lake light, raw sienna, cadmium red pale, and zinc white gouache. I mix these colors with very little water because I want these warm tones to rest on top of the textured acrylic, allowing the violet-blue to show through. Using synthetic "brights," # 20 and # 16, I work very loosely and impressionistically, sometimes using the brush on its side, painting warm tones around the weed shape and into the background. I paint in a diagonal line to break up the rectangular shape and to offer the suggestion of a horizon line, adding a couple of touches of cadmium red pale gouache in the foreground for dash.

(left) Step 3. For this step I use # 8 and # 4 synthetic "brights" and a # 5 round sable brush. With the milkweed pod directly in front of me, I study the way the light creates the forms. I use raw sienna, cadmium red pale, and orange lake gouache, to which I add spectrum yellow and zinc white gouache for the lighter tones and ultramarine blue and burnt sienna gouache for the darker tones. Paying particular attention to the irregularities that give a milkweed pod its own character, I paint in these shapes, using very little water and a lot of pigment. Although I apply the paint heavily, I take care to allow some of the underlying violet-blue texture to remain visible.

EXERCISE 5. TEXTURAL OPAQUE ACRYLIC AND TRANSPARENT WATERCOLOR

Crescent #100 cold-pressed, heavyweight illustration board

Here's a process that offers limitless possibilities. I urge you to roll up your sleeves, clear your work surface, and collect everything you can find that might produce an interesting texture. You can use almost anything: screens of varying sizes, blades of all types, brayers or paint rollers of different sizes, combs, brushes, including shaving brushes, spatulas and scrapers, knives and forks, even your own fingers. Just remember to wash everything out thoroughly after use, because once acrylic hardens it's virtually non-removable. I'm using titanium white acrylic to build up the texture because of its adhesive qualities as well as its plasticity. Watercolor is best for glazing as it's the most transparent of all the water media. It settles into the hollows in the textured acrylic and enhances the variations. It's also easy to lift off for highlights.

(above) Step 1. I begin building up the textured surface with titanium white acrylic, which has been rolled up on a glass palette with a brayer. I roll this thick mixture across the lower part of the illustration board. Next, using an old brush, I apply textured daubs for the aspen foliage. Now I pick up the acrylic with a coping saw blade and drag it down straight over the right, left, and center of the middle ground. For individual tree trunks, I use a single-edge mat knife blade. While the acrylic is still damp, I use the tip of this blade and draw in the branches. I use my fingertips to add greater variety in the foliage area. I let this study dry overnight.

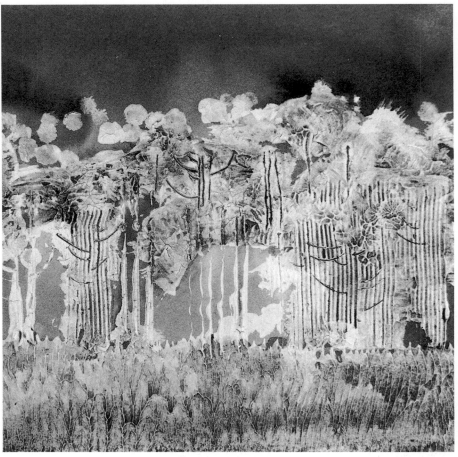

(above) Step 2. I saturate the board with clear water using a ¾" (1.9 cm) single stroke sable and lightly wash a mixture of sap green and a little ultramarine blue watercolor over the entire surface. The acrylic resists this wash somewhat, but it still settles into the depressions and enhances the forms. With the same brush and a deeper mixture of the same colors, I wash in the area above the trees. This is allowed to dry.

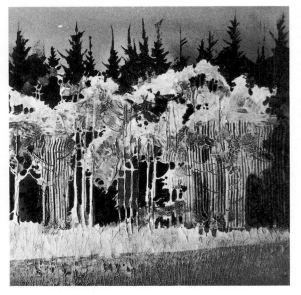

(left) Step 3. Mixing the sap green and ultramarine blue watercolor to a somewhat deeper value and using a ¼" (.64 cm) single stroke sable, I develop the aspen trees and their foliage. With an even darker value I paint the negative areas around the trunks, and, working upward, paint into the negative areas around the branches and foliage. I then paint the background spruce trees in a positive way. To add foreground interest, I load a ¾" (1.9 cm) single stroke sable with ultramarine blue and a little sap green and lay in the shaded area. With a clean, damp ¼" (.64 cm) single stroke sable, I create the highlights on the foliage by lifting off the watercolor wash.

EXERCISE 6. COLLAGE: ACRYLIC AND CASEIN

Crescent # 100 cold-pressed, heavyweight illustration board

When Picasso and Braque first began to paste various materials onto their canvasses and incorporate them into their compositions, it was a revolutionary idea. Since that time, collage has become an accepted process for compositions in both water media and oil. Almost any material can be used, as long as the material is not so heavy that it will stress the support. Textured fabrics, printed paper, vegetable matter, sand, and pebbles can all be used. Acrylic matte medium provides an ideal adhesive and protective covering for these various materials. I am also using acrylic paint for the first step of this wave study because of its brilliance and because it will not lift off after it dries. Casein is used in the final paint layer because of its opacity and insolubility when dry.

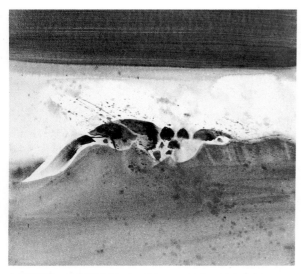

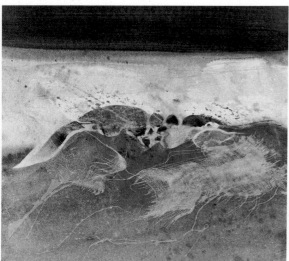

Step 1. I splash water at random over the board, allowing the clear water to suggest fluid patterns. The upper and lower part of the board are wet down in a more usual manner. Using a 1½'' (3.8 cm) single stroke synthetic brush, I flood the foreground with permanent green light acrylic mixed with a little cobalt blue acrylic. The suggestion of the horizon line is painted in with very light permanent green. While the board is still very wet, the sky area is covered with pure Acra violet acrylic just to the horizon line where the two colors interact. When the board is just a bit more dry, I mix the Acra violet with cobalt blue acrylic for a deeper violet tone and paint the sky with this color, leaving a strip of the underlying pure Acra violet showing just above the horizon line.

Using the same 1½'' synthetic brush, I mix Hooker's green and cobalt blue acrylic and paint in the foreground area, suggesting wave forms by variations of the color. Permanent green and cobalt blue acrylic are used to enhance these darks and to develop some negative spaces in the wave form. For a directional spatter, I tap the loaded brush across my forefinger as I move from left to right. More spatter is done with the Acra violet-cobalt blue mixture.

Step 2. First, I make about a half cup of adhesive, using three parts acrylic matte medium to one part of water. Beginning at a point just below the horizon line, I paint this adhesive mixture over the board using an old 1½'' (3.8 cm) single stroke brush. I apply a torn piece of rice paper near the horizon line, position it, and paint over it with the matte medium solution, pressing out air bubbles as I go. Then, I place tissue paper over the foreground in a way that will enhance the composition and paint over it with the adhesive. The various cracks and ridges that develop as I paint over the tissue creates an interesting texture. Second, I tear up some scraps of tarlatan (a sheer cotton netting used by printmakers) and place a narrow piece of it on top of the rice paper near the horizon line, pressing it down as I paint the adhesive solution over it. Third, I arrange smaller scraps of the tarlatan in a way that will enhance the movement of the water, brush them with matte medium, and then allow the entire board to dry thoroughly.

Step 3. Using a 1½'' (3.8 cm) single stroke synthetic brush, I apply a controlled wash of phthalo green and cobalt blue casein in very dark tones directly over the foreground area. This enhances the ridges and crinkles in the tissue paper. I leave the central area untouched for contrast. When this is dry, using a ½'' (1.27 cm) single stroke synthetic, I scumble over the tarlatan near the horizon line with cobalt blue mixed with titanium white casein. Next, I scumble over the tarlatan in the wave form using cadmium red pale casein. This color, used pure and very dry, makes a sharp contrast with the underlying dark green acrylic. Finally, I apply some directional spatter, first using the pale blue and then the bright red casein paint. Then I hit the board again with a few brilliant touches of these same colors for additional excitement.

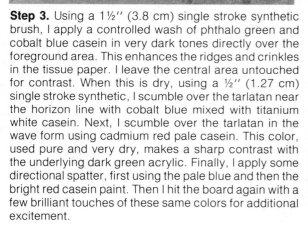

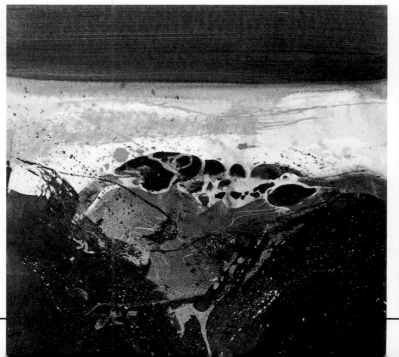

EXERCISE 7. OPAQUE AND TRANSPARENT ACRYLIC AND TRANSLUCENT GOUACHE

Arches cold-pressed watercolor board

This sketch might be called "wave remembered" because it's the result of a lot of sketching and a lot more looking during my many visits to the Oregon coast. It's a memory of the movement of water and the wind on the foam: of a wave cresting and the wind blowing the froth, making beautiful patterns from the spindrift. This subject is ideally suited for acrylic used in both an opaque and transparent manner for the first stages because of its color intensity and because it's insoluable when dry. I chose gouache for the second stage because it flows easily on the brush and is easy to manipulate. Also, after a medium wash of permanent white gouache dries, it becomes translucent and gives the look of foam on water.

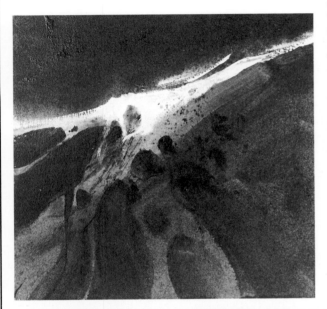

(left) Step 1. First, I wet down the board with a 1″ (2.5 cm) single stroke synthetic brush. Just to get the composition moving, I start working loosely with shades of blue and green. Along the upper-right diagonal, I load up with more Hooker's green and phthalo blue acrylic and work in a more opaque manner, intensifying the rich color. Along the lower right, I use more cobalt blue acrylic in the mixture and paint some negative spaces in the foreground of the wave. Some diagonal spatter is added for interest by gently tapping the loaded brush across my forefinger. The diagonal spatter is used to intensify the general movement of the composition. Originally I had left a line of white paper along the upper diagonal, but as this had gradually become obliterated by paint, I picked it out again using titanium white acrylic. The softened edge is the result of the paper being somewhat damp.

(below left) Step 2. Now I use permanent green light and cadmium red medium acrylic in a totally opaque manner. First of all, I put down some controlled spatter with a ½″ (1.27 cm) single stroke synthetic brush. Then I take the tube of permanent green light and apply the paint with the open end of the tube, to form the circle shapes in the middleground. The controlled dots in the same area are made with the head of an ordinary nail dipped into cadmium red acrylic. In some places I have tipped the nail head on its side and made irregular lines with it, such as the line running next to the white diagonal at the top of the study.

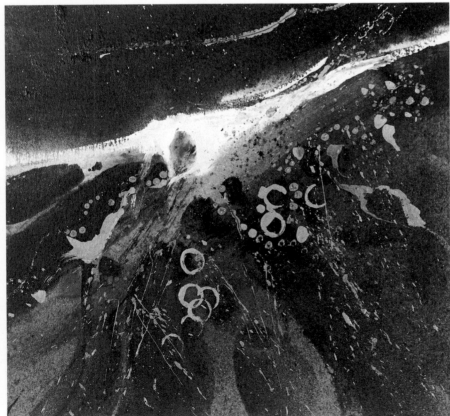

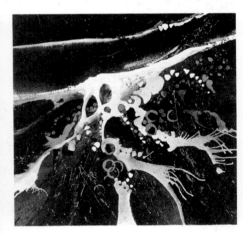

Step 3. I now mix the permanent white gouache to a medium-thick consistency. It looks opaque when it's wet, but when dry it will be translucent. I pick up the white gouache with a clean damp ¼″ (.64 cm) single stroke sable brush and create rhythmic patterns and circular pockets. The way I make those areas of spindrift is to mix the gouache with more water, brush it on the painting, put my face down close to it, and blow very hard, until the paint starts to resemble a frothy sea spray.

PART 3 MULTIMEDIA DEMONSTRATIONS

This section contains twelve demonstrations that show my working procedures. They are not the only way to paint these subjects, but they work for me. When I develop a painting, it generally goes through a series of steps. First, the idea and the sketch; then, in the studio, a value study and a series of color studies, and finally the painting begins. My feeling about the subject, rather than the subject itself, is the important part of my paintings. My paintings have recognizable images, but they are not literal records of visual fact.

During my years of teaching water media workshops, I have found that beginning students tend to make the same mistakes over and over again. So I began to compile a list of the ten most common mistakes that beginning students make. The list became a very effective teaching tool. Remember, there is no substitute for time spent in thinking out the order of working procedures for a painting. So look over the following list and keep in mind these common pitfalls when you are planning your own multimedia painting.

1. *Using watercolor or gouache as a base undertone that will be overpainted.* This makes it difficult to paint over without lifting the water-soluble underlayer. Acrylic is the ideal base layer for water-media techniques; it has great adhesive qualities, and because it is insoluble when dry, will not lift when overpainted.

2. *Using opaque white to correct areas in a transparent watercolor.* This will give a "pasted on" effect that is unrelated to the rest of the painting. Any change in media or visual surface (transparent, translucent, or opaque) should be intentional and add to the total effect.

3. *Choosing acrylic as an overpainting in order to give strong opaque coverage.* Acrylic doesn't have good opaque covering power, especially when used light over dark. Choose gouache or casein instead.

4. *Trying to work too large before becoming thoroughly familiar with the medium.* Begin by working small and develop control and knowledge of each medium.

5. *Using too small a brush for a given area.* Using brushes that are too small for the job will easily give a scrubbed, overworked result. A good general rule to follow is to use as large a brush as possible while still having control. Then each area of the painting will look fresher.

6. *Not enough preplanning.* Thought should be given to color, value, and composition, as well as to media selection. Don't combine the water media as some kind of a crutch, but as the best possible way of making your statement.

7. *Spattering processes and tools for scraping and texturing are used merely as gimmicks.* Any tools and techniques should add to the expression of the painting. No painting should be so technique oriented that it loses all feeling.

8. *Repeating only the techniques that I've demonstrated; afraid to experiment on your own.* All I can say is "Go for it!" The worst that can happen is that it won't work. And who knows? It may be great.

9. *Being timid with paint and tight with materials.* Don't be afraid to use plenty of paint and don't be afraid of that white paper. Visualize how to apply the paint, then squeeze out a lot on the palette, and apply it to the paper with confidence.

10. *Creating a painting with equal amounts of transparent paint and opaque paint.* This is hard to do successfully. It's easier to do a successful painting that is either mostly opaque with some transparent areas, or mostly transparent with some opaque areas.

DEMONSTRATION 1. ASPEN #1

Transparent and opaque acrylic and transparent watercolor

I always carry a sketchbook with me, because my best ideas seem to come unexpectedly, frequently while I'm driving and my mind is alert yet at ease.

I happened to see this aspen tree one day in late May, when I was on my way up to a favorite beaver pond for a bit of fishing. Snaking the Scout up over the switchbacks, this particular tree blazed up in front of me, and I just had to stop, back up, and make a few sketches of it. Still leafless, it just shone in the brilliant sunlight with the dark forest behind it. In a country full of aspen, you'd think there would be dozens more like it, but I've yet to find another tree as exciting as this one was, though I've done a lot of looking.

Anyway, I was so inspired by this one tree that this painting was completed in only two days from the time of the first sketch.

MEDIA AND TECHNIQUE

To achieve a sharp outline for the tree trunk, the first painted application will be masking fluid, which will protect the white paper from succeeding washes of paint. Acrylic paint, both transparent and opaque, is used for the background because of its rich intense color, and because when dry it won't smudge when the mask is rubbed off. Rubbing off masking fluid can

be rough on a paint surface, and durable acrylics hold up well. Cerulean blue watercolor is used for modeling the tree trunk for several reasons: the soft quality of transparent watercolor contrasts in a pleasing way with the greater brilliance of the acrylic; the color itself is right for the job; and finally, because it's not a staining color, it can be lifted off with a damp brush.

PAINTING SURFACE

I select a Strathmore 240-lb. cold-pressed illustration board for this painting because it is made of 100% cotton fiber and has an unusual whiteness. The brilliant white of the untouched board is used for the white of the tree trunk. The medium-smooth surface means that the masking fluid flows on easily, making a close bond. This means a crisp edge will result when it is lifted. The heavily granulated pigment of cerulean blue watercolor shows to good advantage on this smooth surface and can be lifted off easily to create additional texture. I cut the board to 29″ x 21½″, staple it to a plywood board, and prop it up about 4″ along the upper margin on my work table. My preliminary sketches are tacked up before me.

BRUSHES

2″ squirrel hair
1″, 1½″ single stroke synthetics
¼″, ⅝″ single stroke red sables
#4 round sable
old single stroke or round brushes
 for applying masking fluid

PALETTE

Acrylic: permanent green, cadmium yellow light, phthalo blue, Hooker's green, cerulean blue
Watercolor: cerulean blue, alizarin crimson

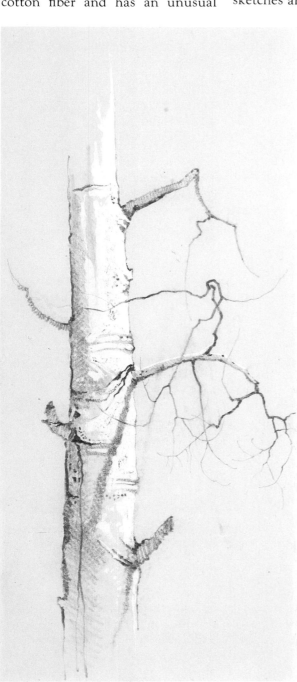

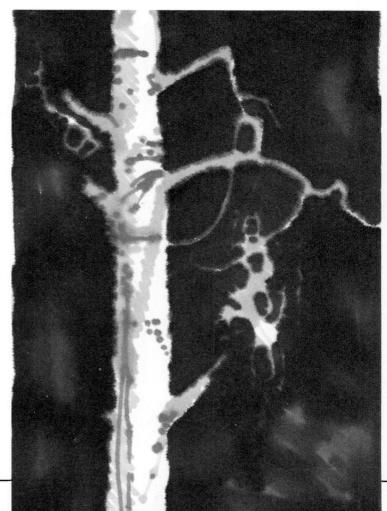

(left) Figure 1. 7″ x 15½″ (17 x 39 cm). Back home in the studio, using my rough sketch for reference, I made this very detailed study of the tree using a 4B pencil on Stonehenge paper. This is a lightly toned paper, and I used white casein for the pattern of highlights on the trunk. I really worked hard on this drawing because I wanted the lights and darks to define the form as well as to make an interesting pattern.

(below) Figure 2. 6½″ x 4½″ (16 x 11 cm). Because I want the background to be very dark in contrast with the white tree trunk, the placement of the tree is very important. I made several of these value studies, shifting the position of the trunk several times before I was satisfied that the design worked well. I used Eberhard Faber design markers in various shades of gray. The inks of these markers bleed somewhat, and because details are impossible, it's easier to concentrate on values and primary shapes.

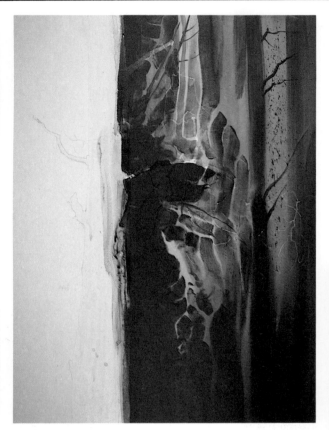

(left) Step 1. I lightly sketch in the aspen tree. Soaking a big, old brush first in water, then in masking fluid, I paint the trunk. The finer branches are painted the same way with a #5 old round synthetic. When this dries, I wet down the entire board on the right side of the trunk using clear water and a 2'' (5 cm) squirrel hair brush. With a 1½'' (4.8 cm) single stroke synthetic, I wash in a transparent mixture of permanent green and cadmium yellow light acrylic as a background color. While this is very damp, I use the same brush and wash in middle values using phthalo blue, Hooker's green, and cerulean blue acrylic, leaving plenty of the first lighter wash showing through to suggest light penetrating the forest. With a 1'' (2.5 cm) single stroke synthetic, I mix phthalo blue and Hooker's green acrylic to a rich dark and use it opaquely for the darkest areas and the suggestion of branches. The paper is now barely damp, and using this dark opaque color, I concentrate on the central section and work in more negative pocket shapes. Using Hooker's green and phthalo blue, I apply some directional spatter on some of the vertical passages by hitting the loaded brush gently across my opposite forefinger.

(right) Step 2. I wet down the left side of the trunk to the edge of the board using a 2'' (5 cm) squirrel hair brush. As the board gradually dries, using the same colors and the same brushes I used in step 1, I model the forest forms to the left of the trunk. Although simpler than the complicated shapes on the right, both relate to each other. I work from light to dark and from large areas to more detailed passages, using a 1½'' (4.8 cm) single stroke synthetic for the large areas and a 1'' (2.5 cm) single stroke synthetic for finishing touches. When the entire painting is totally dry, I rub off the masking fluid using a kneaded eraser. The resulting crisp white edge is very apparent.

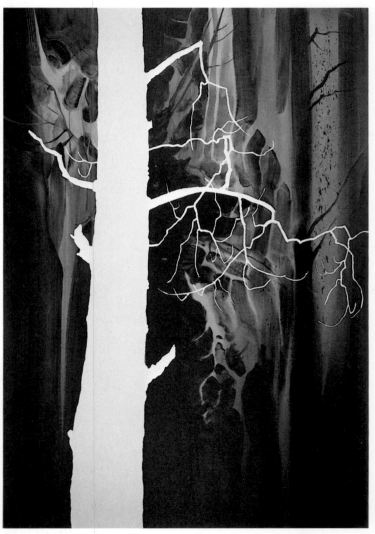

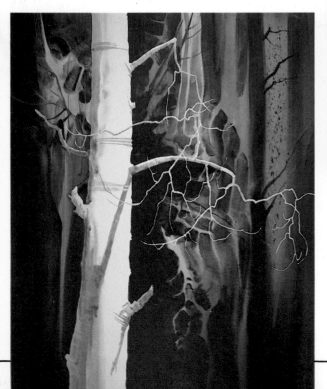

(left) Step 3. I begin modeling the trunk using only cerulean blue watercolor. Constantly consulting the detailed drawing pinned up in front of me, I start with the lightest of washes, gradually darkening them, using a ⅝'' (1.6 cm) single stroke sable. The angle of the shadows cast by the branches and the modeling of the ridges in the bark are all very critical. I do this step with the greatest care and deliberation, using a ¼'' (.64 cm) single stroke sable for details.

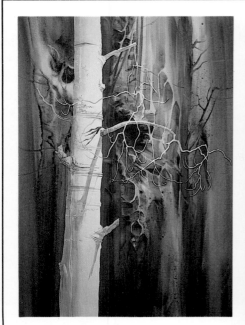

Aspen #1. Acrylic and watercolor, 29'' x 21½'' (74 x 55 cm). Collection of Charles and Nancy Wallick.

With a #4 round sable brush, I work in the deepest pockets of color and I paint the bumpy ridges of the trunk. For the textured areas in the shadows, I lift off areas of color using a #4 round sable dampened with clear water. I'm working dark on light and light on dark to create the texture so characteristic of an aspen tree. Using a damp ⅝'' (1.59 cm) single stroke sable, I lift the color off the vertical ridges below the central stub. The color used for the darkest areas just above the main branch and on the central nub is made with a mixture of cerulean blue and alizarin crimson water color, painted on with a #4 round sable. This concentrates the area of greatest contrast and activity in the upper central section of the painting.

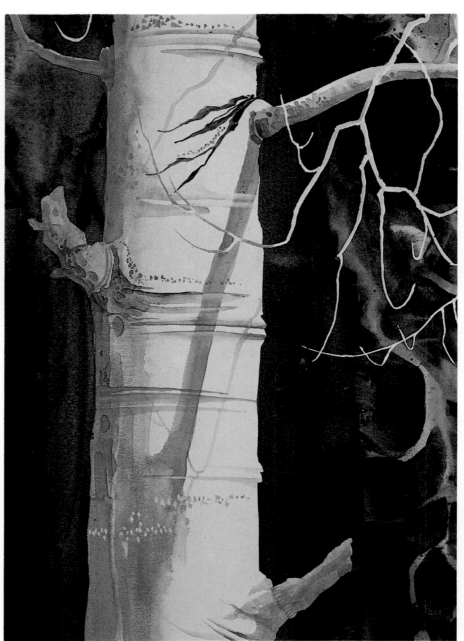

Detail. It's easy to see the contrast between the brilliance of the dark acrylic used for the background and the soft tones of transparent watercolor. Transparent watercolor is used for the shaded side of the trunk, and here the texture is created by lifting off some of the paint with a clean damp brush. On the sunlit side of the trunk, I paint the texture directly, and leave the edge of the trunk crisp, just as it is when the masking fluid is removed. On the shaded side, I soften and blurr the edge. The delicate branch is a good example of how fine lines can be created by painting in first with masking fluid, followed when dry with a wash of color.

Transparent and opaque arcylic and transparent watercolor

I've done a lot of these aerial views of mountain landscapes. One of my neighbors is a pilot who takes me with him on flights in a light plane, and the mountains have an entirely different look when seen from above. Another inspiration is provided by the view from the deck of my house, which looks down over the valley, where flights of birds frequently pass below.

My first aerial perspective paintings included a lot of representational detail, such as buildings, fences, and shadows. Over the years, the landscapes have become more abstract, even though they still include some representational elements. I always begin one of these paintings in a totally abstract manner; thinking only about colors and shapes and rhythms, and that's how I began this one. The most important features of this painting are the interaction of the colors and the rhythm made by the hills and valleys. The sweeping curve made by the flight of birds provides a second rhythm that counterbalances the

first. Realistic details are kept to a minimum.

MEDIA AND TECHNIQUE

The first layer of this painting is done using transparent acrylic colors that have the intense glow characteristic of the medium. This color will radiate through succeeding layers of transparent watercolor, and because the acrylic won't lift when it's dry, it will survive all the scraping it will have to endure when the watercolor is lifted off. Transparent watercolor handles in a very fluid way and lifts off easily, both wet and dry. When transparent watercolor dries, the colors have a pleasant softness that tones down the somewhat garish acrylic colors. Cerulean blue watercolor is just right for shadows on snow, pleasing in combination with the other colors of the painting, and has an interesting granular texture.

PAINTING SURFACE

I'm using a full sheet (22″ x 30″) of Arches cold-pressed watercolor pa-

per. This paper responds better than any other I've tried when doing wet-in-wet washes. Because it's so heavy, it stands up well under scraping and scarring. I tape it to a plywood board using 2″ masking tape, and before I begin work I lightly sketch in the composition. My board is propped up slightly on my work surface.

BRUSHES

2″ squirrel hair
#3, #5 round red sables
¼″, ¾″ single stroke red sables
¼″, ¾″ single stroke synthetics
#3 round synthetic
toothbrush

PALETTE

Acrylic: titanium white, Acra violet, cerulean blue, cadmium orange, yellow oxide, cadmium red light, burnt sienna
Watercolor: burnt sienna, burnt umber, alizarin crimson, Prussian blue, brown madder alizarin, raw sienna, cadmium red light, cerulean blue

Figure 1. 6″ x 8″ (15 x 20 cm). This is one of a series of sketches preliminary to this painting that I made using a Pentel brush pen. It's almost totally abstract and identifies the darkest, lightest, and middle values in the composition.

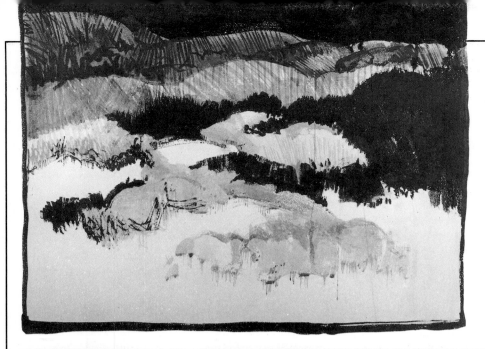

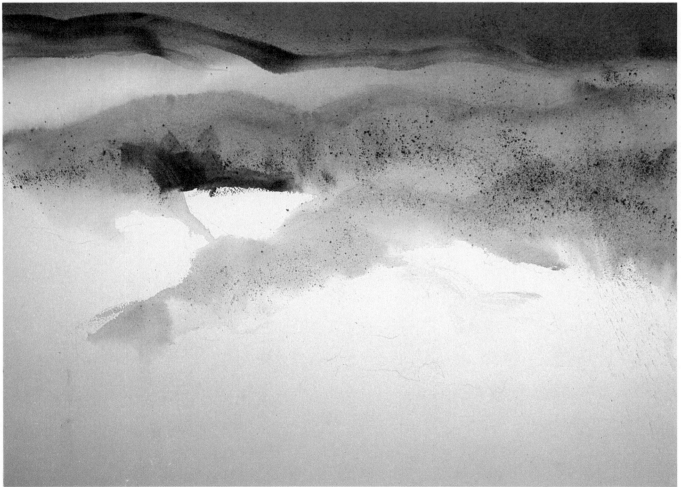

(left) Figure 2. 22″ x 30″ (56 x 76 cm). I made this ink-and-wash study on a rough watercolor board, using a very large Sumi watercolor brush. Working very loosely, I define the dark and light patterns. Finally, using the pointed tip of the brush, I add the lines suggesting tree trunks. This is the study I propped up in front of me as I began this painting.

Step 1. With a 2″ (5 cm) squirrel hair brush I wet down the upper part of the paper, leaving the central area dry. Using the same brush, I float transparent Acra violet acrylic over most of the wet area. For the upper section I mix a transparent mixture of cerulean blue and Acra violet acrylic, while the distant mountain ridge is done with nearly pure violet. Rinsing out my brush, I flow in a transparent mixture of cadmium orange and yellow oxide acrylic over the mountain ridges in the foreground. This blends with the underlying violet. The dark area above the central white pocket is done transparently with Acra violet acrylic using a 1″ (2.5 cm) single stroke synthetic. While the paper is still damp, I add some spatter with a toothbrush, first using cadmium red light, then burnt sienna acrylic. Now I let it dry.

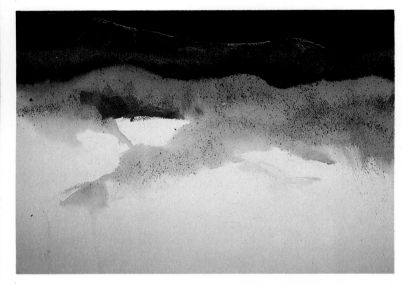

(left) Step 2. I rewet the upper third of the board with clear water, using a squirrel-hair brush and flowing in burnt sienna watercolor from the top down to the middle range of mountains. Mixing burnt umber and alizarin crimson watercolor, I paint over the upper section, defining the distant mountain range. To define the middle mountain range, I spatter the paint from a toothbrush charged with burnt sienna and alizarin crimson, along the upper part of a paper stencil, which has been torn in the desired mountain shape from heavyweight drawing paper. The stencil is then about ¼'' (.64 cm) above the painting surface with my opposite hand. When the paper is nearly dry, I use a mat knife as a squeegee to create the irregular edge of the distant range. With a clean damp ¾'' (1.9 cm) single stroke sable, I lift off the color between the far and middle ranges, suggesting varying contours by exposing the violet acrylic underneath.

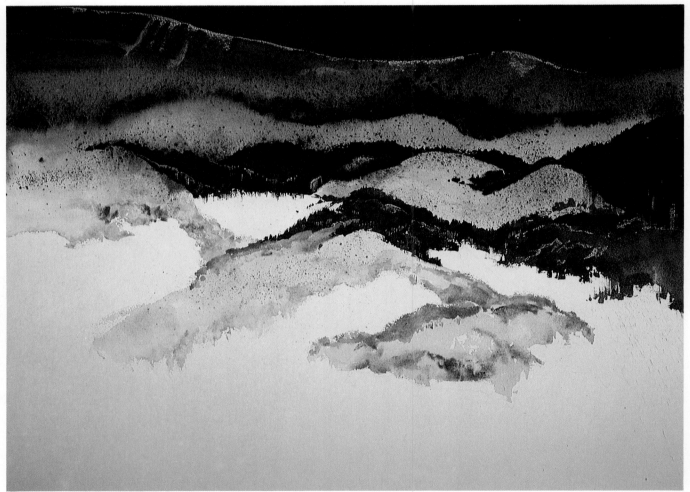

Step 3. I wet down a section behind the central white area, cover the rest of the painting with paper towels and apply a light spatter of burnt sienna. With a mixture of burnt umber, alizarin crimson, and brown madder alizarin watercolor, I paint in the dark forest area, using a ¾'' (1.9 cm) single stroke sable. Using the bottom edge of the brush, I alternately apply pressure and release it to suggest tree forms. When the paper is semidry, I use a mat knife to squeegee off the dark paint to suggest contours in the slopes and the patterns of tree trunks. Other tree trunks are done with a #3 round sable. The other spruce forests are done the same way. The aspen forests in the foreground are made with transparent washes of raw sienna and cadmium red light watercolor, with burnt sienna for deeper values. I blot out some areas for variation.

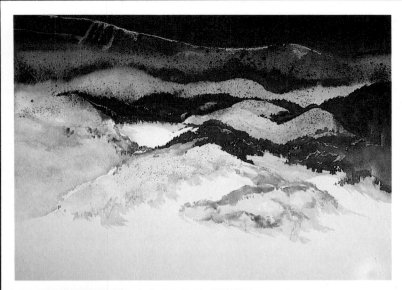

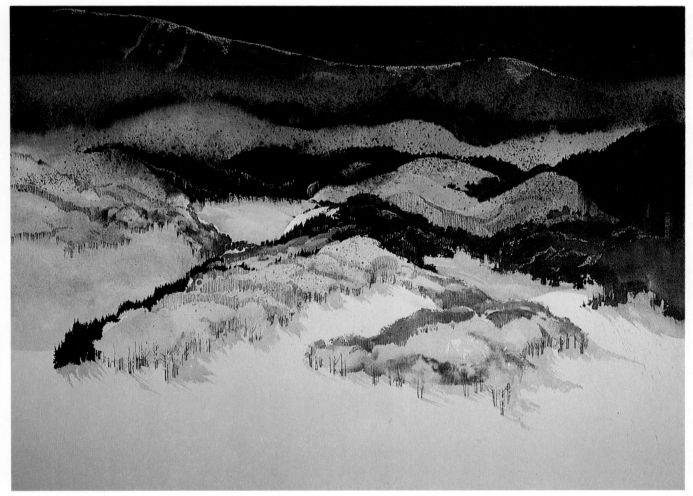

(left) Step 4. The cerulean blue areas are painted in a controlled wash using a ¾'' (1.9 cm) single stroke sable. Just in front of the aspen, I use the heel of the brush to make the paint skip on the paper. The elongated tree shadows are all made using a # 5 round sable, and I make sure they're all going in the same direction. I darken the area in front of the central white pocket with a mixture of cerulean blue and brown madder alizarin watercolor.

Step 5. The spruce trees just behind the ridge of aspen on the left are painted with burnt umber and alizarin crimson watercolor, using a ¾'' (1.9 cm) single stroke sable and very little water. The spruces that are scattered through the aspen grove toward the center are painted using a ¼'' (.64 cm) single stroke sable. With a # 5 round sable and a mixture of burnt sienna and raw sienna watercolor, I start developing a pattern of vertical linear strokes suggesting aspen trunks. I tone down the central white area with a wash of cerulean blue watercolor, and at the far left, I scrape off some of the cerulean blue using a razor blade. This visually changes the direction of the strong diagonal with some strong curving lines.

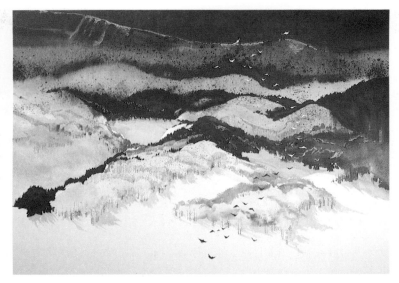

Flight. Acrylic and watercolor,
21″ x 29″ (51 x 74 cm). Collection of Barbara
Whipple.

With the painting on the easel, I begin at the top of the composition painting the birds in one by one, using titanium white acrylic and a #3 round synthetic. As I move down over the lighter values of the middle right-hand section, I change to watercolor, using a #3 round sable and a mixture of burnt umber and brown madder alizarin. This passage takes me a very long time, as I stop to consider the placement of each bird. The movement made by the flying birds provides a counterbalance for the strong horizontal rhythm of the mountain ranges.

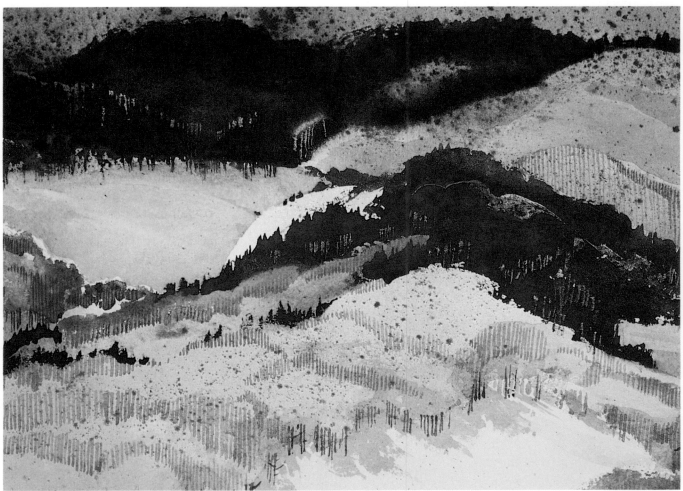

Detail. This is a good example of the visual quality of a brilliant transparent acrylic background softened by a wash of transparent watercolor. Here I use cerulean blue watercolor as a glaze. This is such a heavily pigmented color, it gives a cloudy, almost translucent effect. Mountain ridges and tree trunks are created by using a mat knife as a squeegee while the dark color is wet. The general shape of the aspen clumps is washed in with raw sienna using a ¾″ (1.9 cm) single stroke sable, and when this dries, I paint the aspen trunks, using a small round brush.

Textured acrylic and transparent watercolor

One August I was visiting friends on the Oregon coast, and there just wasn't enough time to do any painting or sketching. After I'd been back home in Colorado for some time, I found myself daydreaming about coastal scenery and running surf, and I began to thumb through my sketchbooks until I found a group of drawings I wanted to work from.

You might wonder why I didn't use photographs while I was trying to crystallize my experiences. I occasionally do take slides, and sometimes I make sketches from them. But I find a photograph can be merely an easy way of getting an image. If I have time to make even a quick sketch, that image becomes a part of me. It's more than an image, it's a whole collection of ideas and memories that pertain to that image. I can recall the mood of the scene, what the light was like, who the person was, how I felt. When I begin a painting, all of this is remembered and becomes incorporated one way or another into the final result. It's part of what makes a

painting come to life. When this happens, I just stand back and let the painting take over.

MEDIA AND TECHNIQUE

Titanium white acrylic is used as the first textured underpainting. It is resilient and has good bonding powers. When applied heavily, an infinite number of textures can be created with a variety of tools. I use this texture to give rhythm and vitality to the rock forms and to emphasize the distant surf.

I use sap green and cerulean blue watercolor because together they create just the atmospheric quality I'm after. Brown madder alizarin and sap green are both staining colors and are most effective when used over a textured underpainting. As these two colors are complementary, I can easily control their intensity. This limited palette of only three colors emphasizes the abstract qualities of the landscape and enhances the impact of the underlying texture. Too complicated a color scheme would have been a distraction.

PAINTING SURFACE

I selected a rough 300-lb. Arches watercolor paper because it is a very expressive paper that is good for the bold handling of paints: it's heavy enough so it provides a good support for the thick layer of acrylic; it won't buckle; and it will stand up well under scraping and scarring. The roughness of the surface can be exploited when using drybrush. I cut it to size, tape it with 2″ masking tape to a plywood board, prop it up at the upper edge, and I'm ready to begin.

BRUSHES

1½″ single stroke synthetic
#6 round red sable
⅛″, ¼″, ⅝″, 1″, 1½″ single stroke red sables
2″ squirrel hair

PALETTE

Acrylic: titanium white
Watercolor: sap green, alizarin crimson, cerulean blue

(left) Figure 1. 4½″ x 6″ (11 x 15 cm). This study is a composite of several ideas I found in my sketchbook. It's done on toned paper using a Pentel brush pen, and the highlights are brushed in with white gouache. I was trying to capture the memory I had of this moody, powerful scene: of running surf, distant shore, and the upthrust of enormous rock forms close by.

(below) Figure 2. 4⅞″ x 7″ (12 x 18 cm). By raising the right-hand bank, the surf comes into sharper focus. The weed at its crest balances the spruces on the left. The rockey gulley in the foreground is emphasized and becomes an insistent diagonal thrust to the composition. The proportion has been altered. The idea is coming to life.

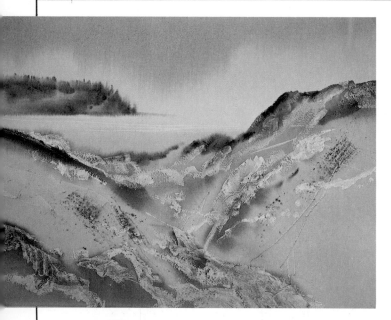

(left) Step 1. I apply a thick layer of white acrylic to the lower portion of the dry paper using a 1½'' (4.8 cm) single stroke synthetic, then I manipulate it to suggest the rhythm of the rock forms by using a coping saw blade, a mat knife, and my fingers. I paint some horizontal lines with the heavy acrylic to suggest the distant ocean. This dries overnight. I then saturate the whole paper with water using the 2'' (5 cm) squirrel hair brush and follow this clear wash with a transparent wash of cerulean blue and sap green watercolor. More cerulean blue is used in the mixture for the sky. I raise the paper to let the color fuse downward and lower it when the drizzly cloud looks right. The distant island is painted with a 1'' (2.5 cm) single stroke sable using sap green watercolor toned with brown madder alizarin. The foreground is painted with a 1½'' (4.8 cm) single stroke sable, using more brown madder alizarin and less sap green. The watercolor paint repeats the movement already established by the underlying acrylic. While the paper is drying, I scar and scrape the paper in the left-middle foreground with the corner of a single-edge mat knife. In the right foreground area, I use the blade as a squeegee to push the paint into broken and speckled lines. When the paper is nearly dry, I apply a controlled spatter with the two colors using a 1'' (2.5 cm) single stroke sable tapped across my forefinger.

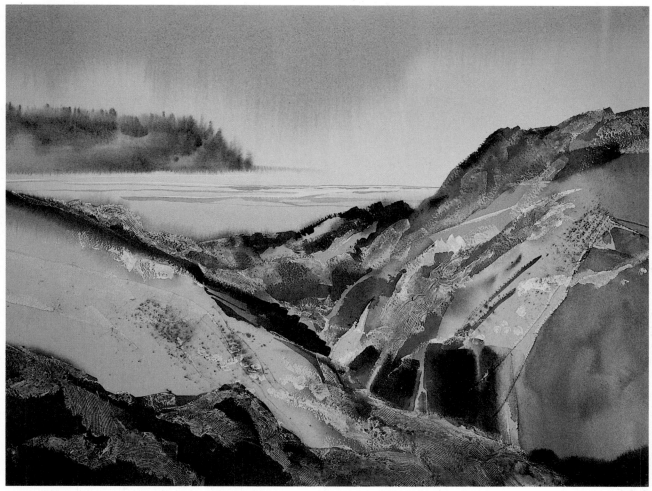

Step 2. After the paper is dry, I begin establishing rock forms in a way that will emphasize power, movement, and drama. Using sap green and brown madder alizarin watercolor, I work as freely as possible with a 1'' (2.5 cm) single stroke sable. I paint in the darker values, defining the forms and the shadowed areas. In the center foreground I create some of the forms by painting in the negative spaces. Passages that already satisfy me are left untouched. Gradually I intensify certain details with repeated darker washes, such as in the right foreground. For the distant ocean I lay in a controlled wash of sap green with a little cerulean blue. With a ¼'' (.64 cm) single stroke sable, I work the color to suggest long combers breaking on the beach.

Oregon Squall. Acrylic and watercolor,
21'' x 29'' (53 x 74 cm). Collection of Kay Wyley.

Now I allow the paper to dry completely. With a ⅝'' (1.6 cm) single stroke sable, I paint in the two pine trees of the upper-left middle ground, using mostly sap green. These trees are painted right over the misty island and the stretch of distant ocean as a way of enhancing the illusion of depth. The weed at the crest of the right-hand rock is done with a #6 round brush, using mostly brown madder alizarin. The grasses in this area are painted using the same #6 round but with more sap green in the mixture. The trees and the delicate weeds function as a compositonal device that draws attention to the foreground area of jagged rocks, which has the greatest visual variety in texture and contrasting values.

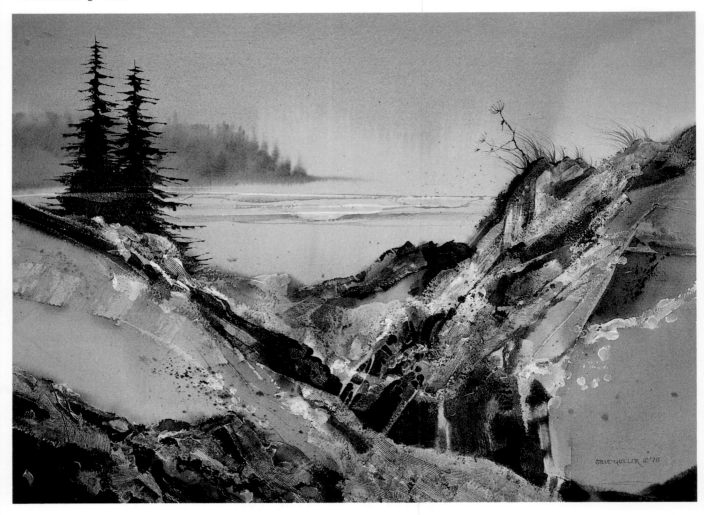

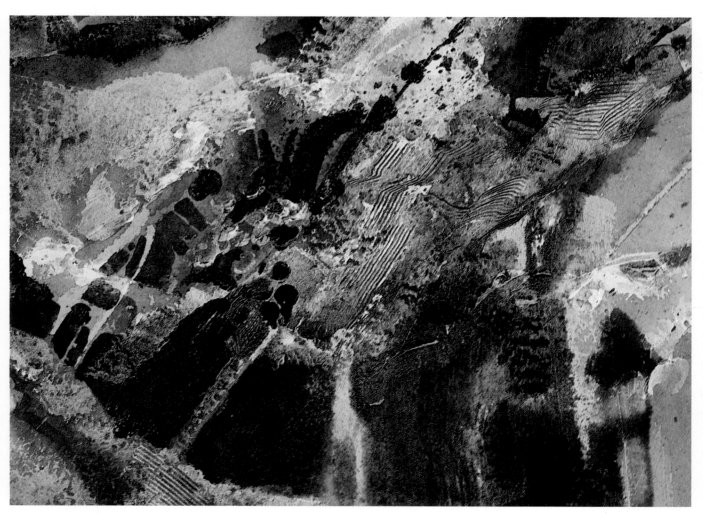

Detail. When the paper is dry, I use a ⅛'' (.32 cm) single stroke sable to float sap green over the rocks in the upper right and central areas. Then I squeeze some of the sap green watercolor out of the tube and directly onto the paper. The globs of paint blur slightly on the dampened paper, and I pull the paint along by rolling the edge of the tube opening against the surface. I tip the paper every so often to regulate the direction of the bleeding. Another wash of sap green is applied to the lower rock area, and this time I use the brown madder alizarin directly from the tube to paint with. This somewhat unusual method of paint application enhances the abstract quality of the rugged texture of the rocks, which has already been suggested by the underlying layer of textured acrylic paint.

The paintings of the French impressionists were nonnaturalistic, concentrating on design, flat patterns, and the interaction of color. Paul Gauguin pioneered a way of painting using heavy outlines that surround areas of flat brilliant color. His colleagues named this technique "Cloisonnisme" and were so intrigued by the idea that many of the artists of that period adapted it for their own use.

Once, after seeing an exhibition of impressionist and postimpressionist work, I too was inspired by Cloisonnisme and felt certain I could adapt the idea to water media. This painting is an example of a process I've devised, a process that achieves effects unobtainable in any other way.

The impressionists used complementary nonnaturalistic colors. Because color is so important in this painting, I consulted my homemade color wheel based on the Dudeen color triangle. The Dudeen color triangle is described in *The Gist of Art* by the American painter John

Sloan. It's the only color wheel I know that can be set up using actual artist's pigments and that also allows space for the earth colors. I recommend it highly.

MEDIA AND TECHNIQUE

I decided to paint the weeds a golden tan, complemented by a pale violet background. The cloisonné outline, formed by the initial transparent wash, would be a brilliant red-violet. My selection for this initial wash is acrylic, because of its intensity, its transparency, and because it's insoluble when dry. Gouache is selected for the rest of the painting because it's excellent for flat opaque areas, and its matte surface provides contrast with the brilliant acrylic. Gouache flows easily on the brush and is excellent for opaque detail.

PAINTING SURFACE

I'm using a Crescent #100 cold-pressed, heavyweight illustration board, cut to size, stapled to plywood, and propped up about 4"

along the upper margin. This smooth surface is chosen because small details can be more easily painted, and all the texture can be formed by the brush. The heavyweight board requires no preliminary soaking or stretching.

BRUSHES

2" squirrel hair
#2, #5 round red sables
¾" single stroke red sable

PALETTE

Acrylic: Acra violet, cadmium red light, cadmium orange
Gouache: burnt sienna, cadmium red pale, cadmium orange, alizarin crimson, burnt umber, raw sienna, zinc white, permanent white, cobalt blue, spectrum violet

(right) Figure 1. 10½" x 6" (27 x 15 cm). I collect weeds wherever I go. They're propped up all over the studio and decorate my house, too. One evening I caught myself admiring a group in a jug on the floor beside the stove, so I made this drawing with a Pentel pen. The next day in the studio, I selected five weeds with especially interesting forms: a milkweed pod, small sunflowers, a round-headed Canadian thistle, some seed heads of blue flax, and an iris pod. They worked well together and had much of the same appeal as the arrangement I had sketched the previous evening. I spent nearly an hour moving them around in a vase, until I got them in just the right positions for this painting.

(left) Step 1. Referring to the arrangement in front of me, I make a careful drawing on the illustration board using a 2B pencil. I then saturate the board with repeated washes of clear water using a 2″ (5 cm) squirrel hair brush. I float cadmium red light acrylic across the wet surface, followed by Acra violet acrylic, and then cadmium orange acrylic, allowing the three colors to fuse almost at random. This brilliant, varied, transparent wash is allowed to dry.

(right) Step 2. Using a # 5 round sable, I mix burnt sienna and cadmium red pale gouache for a dark opaque value, and block in the sunflower at the top of the composition. I add more cadmium red pale to the mixture and paint in more petals. I lighten the mixture with raw sienna, painting in the lighter areas to model the rounded form. The stem is painted in the same way, and final opaque highlights are added using a mixture of zinc white, cadmium orange, and raw sienna gouache, touched onto the darkest area to suggest pinpoints of light on the bristled surface.

The large circular shape of the Canadian thistle is done with the same brush. I mix a translucent wash of zinc white and burnt sienna gouache and brush it on lightly, allowing some of the underlying red-orange acrylic to show through. With somewhat less water in the mixture, I scumble over this area with the heel of the brush, creating the rough texture so characteristic of this particular seed head.

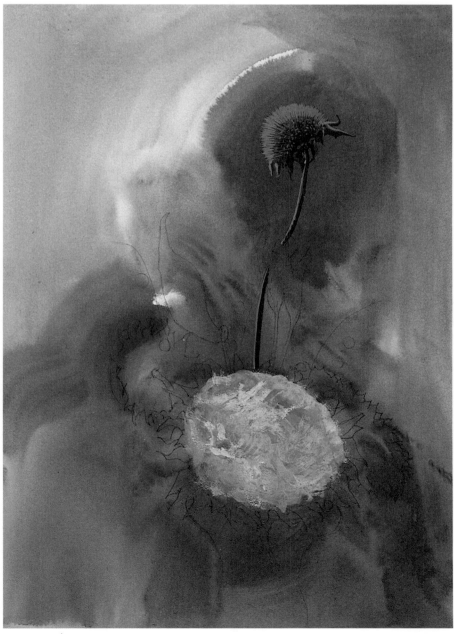

(right) Step 3. Using a #5 round sable, I carefully paint the lighter colored petals around the Canadian thistle, using a mixture of zinc white, raw sienna, and cadmium orange gouache in a translucent way. The darkest petals along the lower edge are painted using burnt sienna and cadmium red pale. I don't let these darker petals actually come in contact with the lighter petals. I let the underlying paint show between the two edges, thus creating a line of red-violet. This is the cloisonné effect. The entire milkweed pod is painted with a translucent middle value of cadmium red pale and raw sienna gouache. Zinc white is added for the lighter areas, and more raw sienna is used in the mixture for the darker, shaded side.

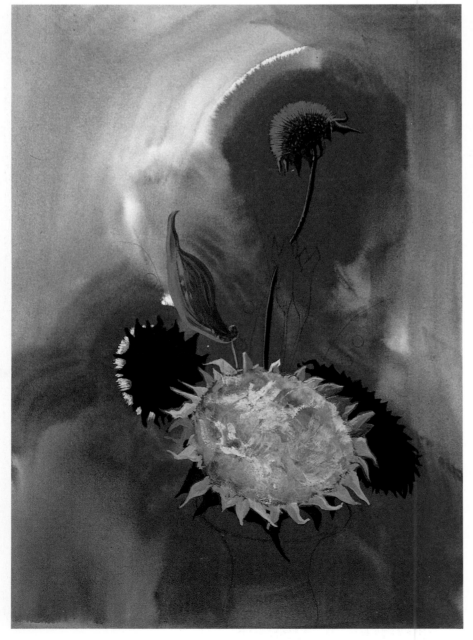

(left) Step 4. The thistle on the right is painted with burnt umber and alizarin crimson gouache, mixed to a dark shade. Using a #5 round sable, I paint in the entire semicircular shape, leaving ¼'' (.64 cm) unpainted between it and the petals of the Canadian thistle, thereby creating another cloisonné line. With a somewhat lighter mixture of the same colors, I paint the petals underneath the large thistle, letting the first dark coat of paint form the spaces in between. For the sunflower to the left, I use the same dark tone and block in the whole shape, again leaving a cloisonné line around the petals on the left side of the thistle. Adding raw sienna to the mixture, I paint in some of the petals, while others at the back of the sunflower are made by painting into the negative areas. The hidden flower face is painted with various mixtures of zinc white and raw sienna gouache using the #5 round sable.

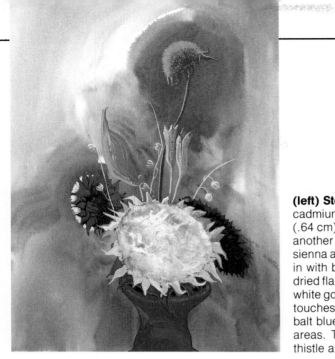

(left) Step 5. With a #5 round sable and a middle value of raw sienna and cadmium red pale gouache, I paint in the iris pods. I leave untouched the ¼″ (.64 cm) space between the pod and stem of the tall sunflower, thus making another cloisonné line. The lighter tones on the iris pod are a mixture of raw sienna and zinc white, painted very dry and opaque. Dark details are touched in with burnt sienna mixed with burnt umber. The dainty seed heads of the dried flax are painted with a mixture of raw sienna, cadmium orange, and zinc white gouache, working from a middle value up to the lightest, with a few dark touches to create roundness. I paint the vase with an opaque mixture of cobalt blue and spectrum violet gouache with zinc white added for the lighter areas. The red cloisonné line shows between the petals of the Canadian thistle and the vase.

(right) Step 6. Zinc white and smaller amounts of spectrum violet and cobalt blue gouache are mixed vigorously in a small jar for about five minutes. Using a #5 round sable, I carefully paint around the foreground shapes, leaving the red cloisonné line untouched between the golden yellow weeds and the pale violet background. I spread open the round sable brush when I paint around the tall sunflower, to give a fuzzy outline. Then I use a ¾″ (1.9 cm) single stroke sable to carry the violet paint out to the top and sides.

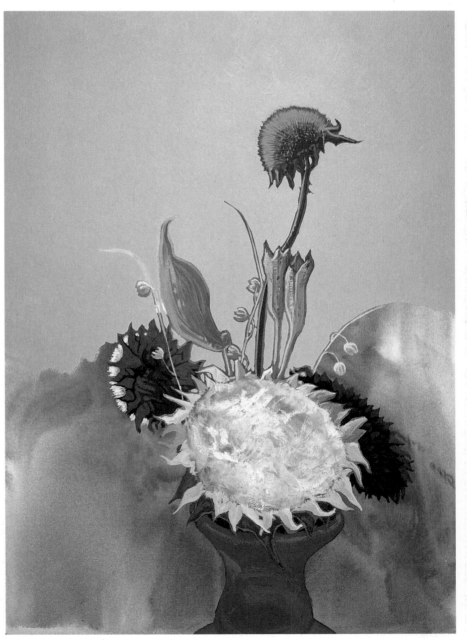

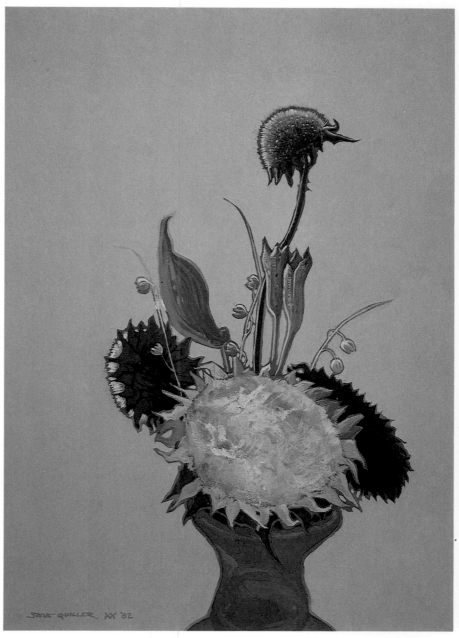

(left) Detail 1. It's easy to see how I build up the various weed forms with different shades of golden brown. The brilliant, transparent cloisonné line is clearly visible, providing an exciting contrast with the flat, opaque gouache.

(right) Still Life. Acrylic and gouache, 15'' x 11'' (38 x 28 cm). Collection of the artist.

I complete the background using a ¾'' (1.9 cm) single stroke sable. The final highlights are carefully added to the weeds with a #2 round sable, using various combinations of cadmium yellow medium, cadmium orange, raw sienna, and permanent white gouache, used totally opaque.

Detail 2. Here it's easy to see the brilliant cloisonné line around the forms and how it contrasts with the translucent and opaque gouache. Note the rough texture in the head of the Canadian thistle, which I make by loosely brushing the gouache in a translucent and opaque way over the transparent red-violet acrylic background. This texture makes a pleasing contrast with the smoothness of the other passages.

When I look south from the studio, I can see a mountain range, a pond, a hay meadow, and a group of log and frame buildings. These buildings make up the Lafont ranch, and it's been the Lafont family home for many years.

One evening in July, I was driving home just after sunset. I was about a mile from the house when the whole sky lit up with a beautiful afterglow. The thinnest crescent of a new moon hung in the pale sky over the dark silhouettes of the mountains. The entire scene moved me so that when I pulled up to my house, I jumped out of the car, ran up on the deck, and sat down to watch the light fade, all the time taking notes and making sketches. Then I worked late into the night sketching many small studies of the scene.

The next day I did another group of sketches, in which I rearranged the elements in the composition, moving them around to heighten the effect of the afterglow. I wanted to emphasize the ladder on the house, the smoke from the chimney, and the wisps of clouds. I wanted to show the pale sky over the dark mountains and the glitter of reflected light in the pond. I felt that a simple color scheme would be one way to enhance the mood I wanted to convey.

MEDIA AND TECHNIQUE

Because this painting deals almost exclusively with the luminosity of an evening sky and reflected light, I'm using transparent watercolor because it gives the greatest luminosity of any of the water media. It will lift off, whether wet or dry, and I plan to lift certain areas in the buildings and mountains to emphasize the forms.

The soft translucence of gouache always combines beautifully with transparent watercolor, and this painting uses permanent white gouache as an underpainting followed by transparent watercolor. The white gouache, bleeding up through the watercolor, creates an unusual translucent effect, ideally suited for a painting whose subject is the afterglow of a sunset.

PAINTING SURFACE

I'm using 300-lb Arches cold-pressed watercolor paper because it's an excellent surface for wet-in-wet applications. It's heavy enough so that it will take the scraping and lifting off of paint that I intend to do. Its weight means it won't buckle. I cut it to size, tape it to a plywood board with 1½" masking tape, and put it on my worktable, propped up about 5" at the upper margin.

BRUSHES

2" squirrel hair
#1, #4 old, round synthetics
¼", ⅝", 1½" single stroke red sable
#4 round red sable

PALETTE

Gouache: permanent white
Watercolor: alizarin crimson, vermilion, ultramarine blue, burnt sienna

(right) Figure 1. 2" x 8" (5 x 20 cm). While I was working up the composition of this painting, I referred constantly to many small sketches of the ranch houses at Lafont's that I'd done previously. This particular line study was done in the wintertime, and it's easy to see the ladder that's used for roof repairs going up the side of the building.

(left) Figure 2. 4½" x 9¾" (11 x 25 cm). This is one example from the series of sketches I made while I was in the process of working up the pattern of the clouds in the luminous sky, and the values and shapes of the mountain ranges. Essentially this is a value study, and comes fairly close to what I use in the painting. I tacked this up in front of me while I was working, together with some sketches of the ranch buildings.

(left) Step 1. I mask out the crescent moon with masking fluid, using an old # 1 round brush. After this dries, I saturate the entire paper with clear water using a 2″ (5 cm) squirrel hair brush, followed with a translucent application of permanent white gouache. I turn the paper upside down and prop it up on the upper margin (which actually is the bottom edge of the painting). Using the squirrel hair brush, I mix alizarin crimson and vermilion watercolor to a middle value and wash it over the damp white gouache to about the middle of the paper, lightening the color as I go. I blot excess water along the tape edges and return the paper to its normal position. I wash a middle value of ultramarine blue along the top and let it bleed downward to blend with the rosy color of the first wash. While this is still damp, I change to a ⅝″ (1.6 cm) single stroke sable and paint in the wisps of clouds, using a mixture of alizarin crimson and burnt sienna. Ultramarine blue is added to these colors for the darker clouds.

(right) Step 2. I sketch in the outlines of the buildings and mountains with a 2H pencil. Using an old # 4 round brush dipped in masking fluid, I carefully mask in the building shapes. While this dries, I mix up a large amount of a middle value of ultramarine blue watercolor. Using a 1½″ (4.8 cm) single stroke sable, I outline the mountain tops and wash this color down over the building shapes protected by the mask. I paint around the pond area and carry the wash down to the bottom of the paper. The underlying rosy tone gives the blue watercolor a violet translucence. This step is completed as carefully and as rapidly as possible. Any reworking would lead to blotchiness. The paper dries.

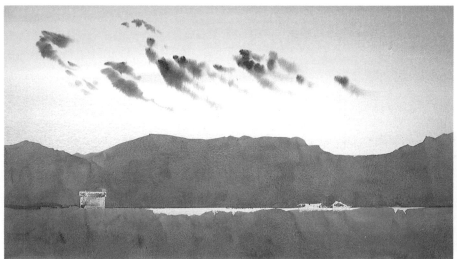

(right) Step 3. I mix more ultramarine blue watercolor to a deeper value. Using a 1½″ (4.8 cm) single stroke sable, I paint another range of mountains in the background, coming over the masked-out areas and down to the edge of the pond. As before, this wash is enhanced and enriched by the underlying colors. When this paint has dried, I suggest crags and gullies in the mountains with variations of this dark blue. When the painting is totally dry, I gently rub off the mask with my finger, exposing the buildings and the crescent moon as crisp white shapes.

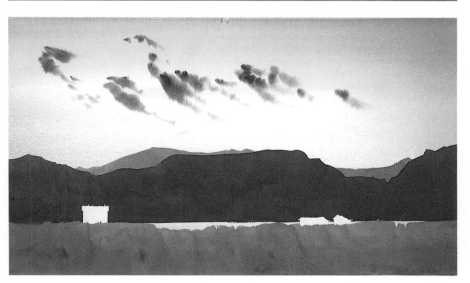

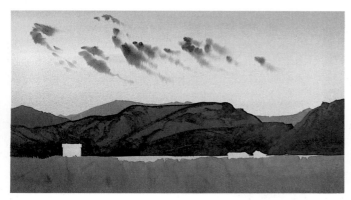

(left) Step 4. With ultramarine blue mixed with alizarin crimson watercolor, I paint in the darkest, closest range of mountains with a ⅝'' (1.6 cm) single stroke. I bring this dark color down to the edge of the pond and around the edges of the buildings. This gets rid of that unpleasant ''cut-out'' look that masking fluid can give. When these dark areas are nearly dry, I paint in even darker tones, using the watercolor in a nearly opaque way. While the paint is still damp, I refer to my sketches, and using a pocket knife, scrape off certain areas to suggest crags and ridges in the mountains. On the left side of the two-story building, I use a nearly dry brush to paint in negative areas suggesting clumps of grass.

(right) Step 5. With a mixture of alizarin crimson and vermilion watercolor, I paint the texture of corrugated tin on the roofs using a # 4 round. For the stucco of the building on the left, I first apply a soft wash of ultramarine blue watercolor over the entire building, excepting the roof. When this is dry, I add succeeding light washes of burnt sienna. I make the stippled texture by using the tip of the brush to touch in burnt sienna, which bleeds into the underlying wash. The shadows at the roof edge and between the rungs of the ladder are made with dark ultramarine blue and burnt sienna watercolor, using a ¼'' (.64 cm) single stroke sable. For the remaining wooden buildings, I make a darker mixture of ultramarine blue and burnt sienna, using drybrush technique with vertical strokes and scraping off highlights with a pocket knife while the paint is still wet. The weeds in the foreground are done using a ⅝'' (1.6 cm) single stroke and a mixture of alizarin crimson, burnt sienna, and ultramarine blue. I apply these colors quite dry and vary their tone from cool to warm.

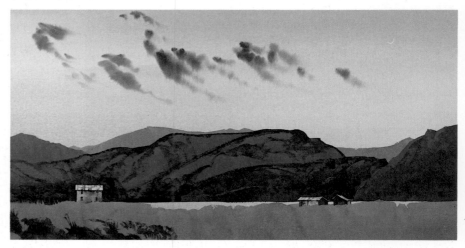

(below) Twilight, Lafont's. Gouache and watercolor, 16½'' x 29'' (42 x 74 cm). Collection of Dick and Linda Musci.

To create the effect of smoke in front of the dark mountain range, I lift the color off with a clean, damp # 4 round sable and some tissue. I do this carefully in order to vary the density of the smoke and also to give the curling plume just the right shape. The smoke trailing up into the sky is painted directly using a tint made of ultramarine blue and burnt sienna watercolor. At the upper portion, the pigment is thinned with clear water so it appears to drift off into the sky. The foreground weeds are developed by painting positive and negative shapes with a ¼'' (.64 cm) and ⅝'' (1.6 cm) single stroke sable brushes. Being careful to avoid having too many distracting details, I balance open areas with texture. I suggest rock forms on the far right, using burnt sienna and ultramarine blue; and when the paint is dry, I create the texture of the rock surface by lifting off the pigment with a clean damp brush.

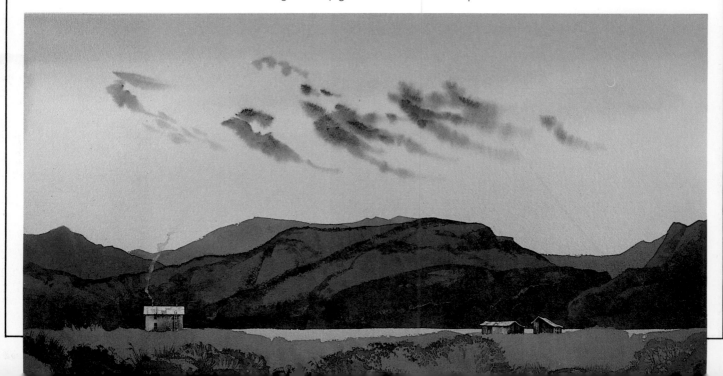

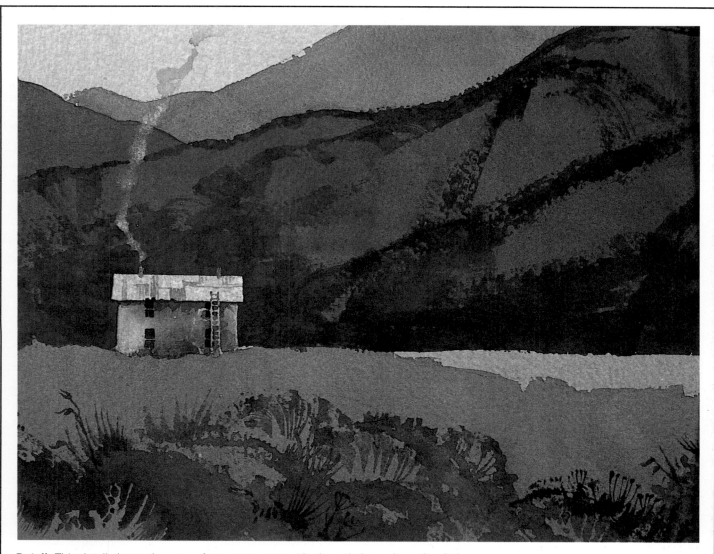

Detail. This detail shows the area of greatest contrast in the painting: where the dark mountains forms a background for the bright, crisp details of the building, with the smoke curling upward. I've designed it this way, to pull the eye to this part of the painting. I have far less contrast in the foreground, where I use soft washes of transparent watercolor to create the simple weed forms. This is done so that the foreground will not compete with the area of greatest interest, and, at the same time, heighten the effect of an after-sunset mood.

This painting is a composite of many sketches I've made on the Oregon coast. You can't imagine a more spectacular place. Enormous rock forms are everywhere. They loom up on the beaches or disappear in the distance behind fog banks. Although at times the weather is spectacularly clear, most of the time there's a golden haze that is very beautiful. Wind and water are constantly at work changing the shape of the beaches.

Although this is a remote place, there always seem to be a few people wandering about, surf casting or horseback riding. Sometimes you'll see a youngster building a sand castle or exploring the tide pools. There are walkers and joggers and birdwatchers, and because they're all so involved in what they're doing, they make wonderful models. I always have my sketchbook with me when I'm there, and it's great discipline to work quickly from the unposed figures and the ever-changing land and sea.

MEDIA AND TECHNIQUE

This painting has to do primarily with a misty, shimmering quality of light. Watercolor used wet-in-wet is ideal for creating such atmospheric effects as rainy clouds with their diffuse radiance. The distant, more transparent rock forms are done using watercolor, and this provides contrast with the opaque rocks in the foreground that are painted with gouache. This combination of transparency and opacity enhances the effect of depth I'm after. Also, because I'm working on a toned paper that gives me middle values, I use opaque gouache to create the glitter of sunlight on the distant sea and for the reflections in the tide pool in the middle distance. The ease with which gouache flows from the brush makes it ideal for painting the figure and the driftwood.

PAINTING SURFACE

I'm using a toned English paper, DeWint, in a soft beige tone. The tone of the paper will be used as a middle value in the painting. I cut the paper to 16″ x 29″ and soak it in water for about five minutes to remove the sizing. I hold it up and let it drip before putting it on a board to rest another five minutes. This allows the paper to expand. I staple-gun it to a plywood board, stretching it as I go, putting the staples in about an inch apart. Then I let it dry.

BRUSHES

2″ squirrel hair
¼″, ⅝″, 1″ single-stroke red sables
#5 round red sable

PALETTE

Watercolor: cadmium yellow medium, cadmium orange, alizarin crimson, cerulean blue, raw sienna, ultramarine blue
Gouache: burnt sienna, raw sienna, alizarin crimson, orange lake light, ultramarine blue, zinc white, permanent white

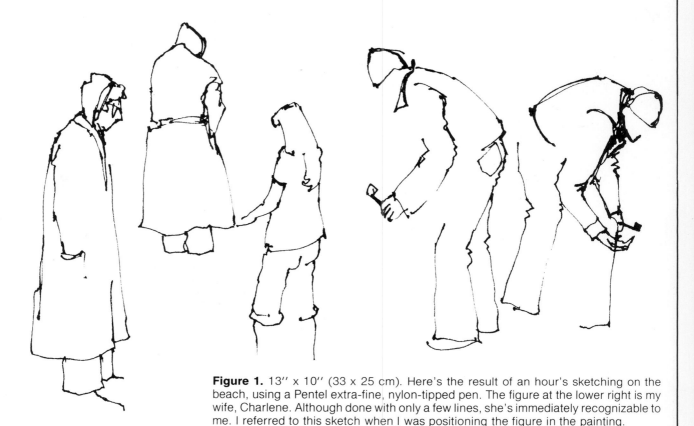

Figure 1. 13″ x 10″ (33 x 25 cm). Here's the result of an hour's sketching on the beach, using a Pentel extra-fine, nylon-tipped pen. The figure at the lower right is my wife, Charlene. Although done with only a few lines, she's immediately recognizable to me. I referred to this sketch when I was positioning the figure in the painting.

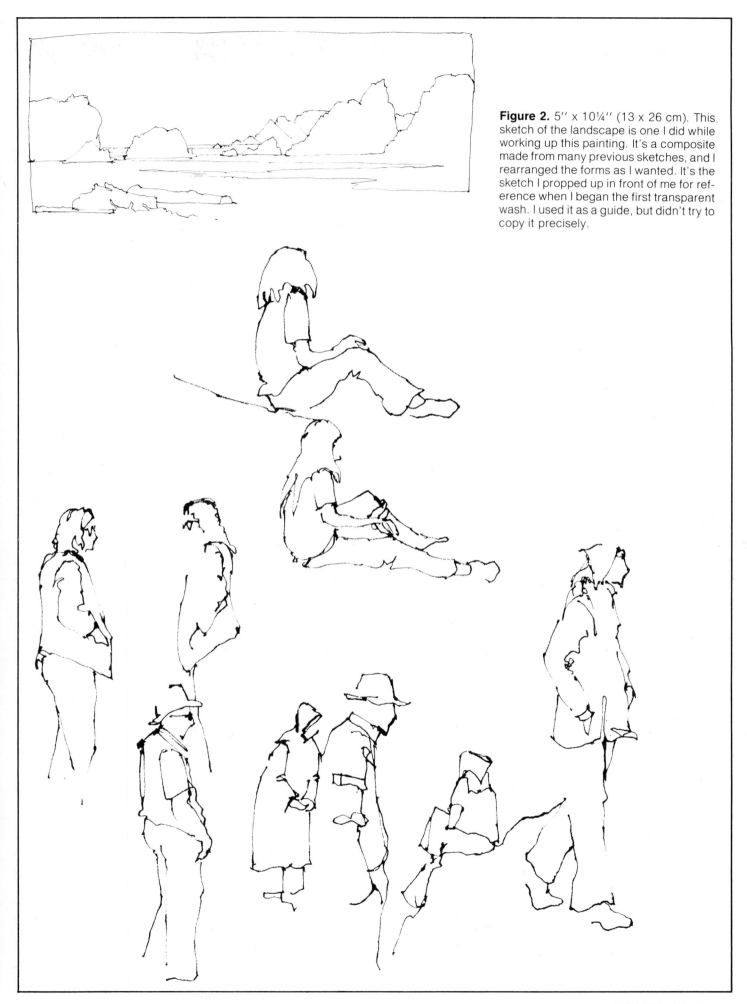

Figure 2. 5″ x 10¼″ (13 x 26 cm). This sketch of the landscape is one I did while working up this painting. It's a composite made from many previous sketches, and I rearranged the forms as I wanted. It's the sketch I propped up in front of me for reference when I began the first transparent wash. I used it as a guide, but didn't try to copy it precisely.

(below) Step 1. With a 2″ (5 cm) squirrel hair brush and clear water, I work the paper over three or four times to saturate it again. Then I mix cadmium yellow medium with cadmium orange watercolor and wash this transparent golden tone over the entire sheet. While this is still wet, I add some cerulean blue and a touch of alizarin crimson to this warm tone and wash in the cloud area at the top, working transparently. Because the board is propped up about 5″ (13 cm) on the upper side, this cloud form diffuses downward, interacting with the golden tones to create the effect of a rainy cloud. I'm working as spontaneously as possible. Although my sketch is in front of me, I want the wash to be done freely enough to allow for happy accidents.

(left) Step 2. Once the paper has thoroughly dried, I sketch in the rock forms using a 2H pencil. These forms aren't a slavish copy of the preliminary study. I'm letting the tones of the first wash give me some ideas. Mixing up a fluid transparent wash of alizarin crimson and cerulean blue watercolor, and using a ⅝″ (1.6 cm) single stroke sable, I paint in the distant rocks. When this is dry, I use a ¼″ (.64 cm) single stroke sable and mix these two colors in a somewhat darker, but still transparent mixture to model and define these distant rock shapes.

(below) Step 3. Gouache is used for the rocks in the middle distance so they will appear closer than the distant ones painted with transparent watercolor. Burnt sienna, raw sienna, alizarin crimson, ultramarine blue, and zinc white gouache are used in various combinations. For large areas that need less definition, I use a 1″ (2.5 cm) sable brush. Where I need greater precision, I use a ⅝″ (1.6 cm) single stroke sable. Some of the rocks have more ultramarine, others have more alizarin crimson gouache in the paint mixture. I use burnt sienna for the large fissuers, and raw sienna contributes a warm golden brown in keeping with the colors of the rest of the composition. Although the gouache is opaque, it's not impasto. If I were to hide the texture of the paper with the gouache passages, they would not relate to the rest of the painting.

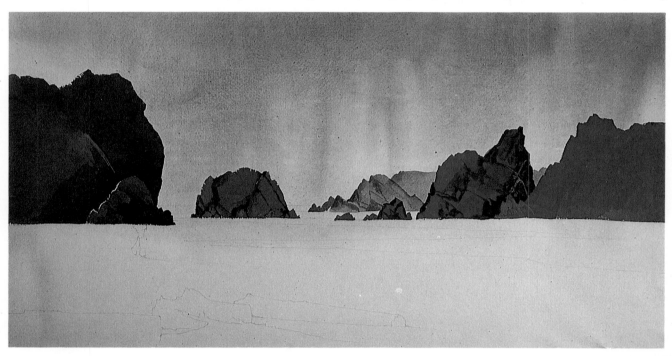

(right) Step 4. This step involved both transparent watercolor and gouache. For the tide pool in the middle distance, I wet this particular area with clear water. Then, using the same ⅝″ (1.6 cm) single stroke sable, I tone the wet area with some raw sienna and a bit of ultramarine blue watercolor. For those vertical reflections, I puddle in ultramarine blue and alizarin crimson watercolor, keeping it transparent. After allowing the passage to dry, I paint the sunlight on the sea in the far distance using a ¼″ (.64 cm) single stroke sable and permanent white gouache in an opaque manner. I use the same brush and paint the crisp white areas that suggest a faint ripple on the surface of the pool and the foam lying at the edge.

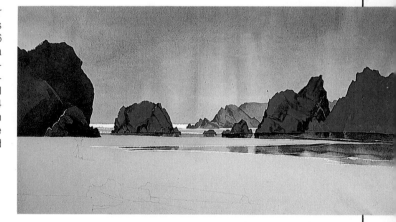

(below) Step 5. Using a 1″ (2.5 cm) single stroke sable, I apply a wash of clear water to the lower third of the painting. I mix orange lake light, raw sienna, burnt sienna, and zinc white gouache to an even blend and brush it over the dampened paper to give the beach in the foreground a warm translucent tone. When this passage is dry, I cover the upper two-thirds of the painting with paper towels. Using the same foreground colors in different combinations, I make a controlled opaque spatter by hitting a loaded brush across my forefinger. I then use a ⅝″ (1.6 cm) single stroke sable with the pigment well mixed with water for the larger spatter and a dryer brush for the smaller spatter. To increase the illusion of depth, I put the larger spatter in the foreground and the smaller toward the background. Ultramarine blue and alizarin crimson are added to the original colors for a violet tone. To give more variety to the pattern, I use a # 5 round sable from time to time. Gradually this controlled spatter creates an illusion of pebbles.

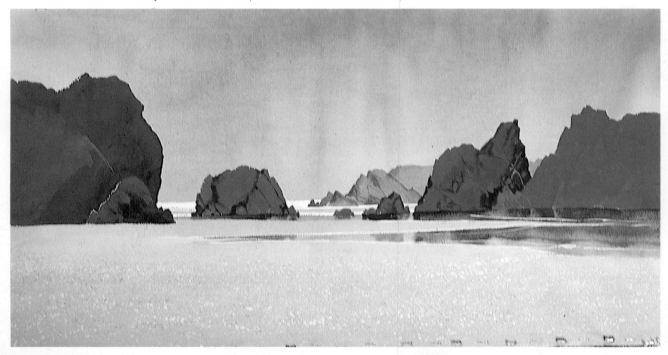

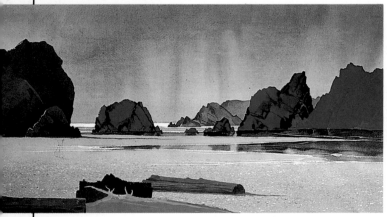

(left) Step 6. After picking out a few more highlights in the sand with light, opaque touches of gouache, I'm ready to put the driftwood in the foreground. Working in an opaque manner, I block in the forms using a ⅝″ (1.6 cm) single stroke sable and using various combinations of raw sienna, burnt sienna, alizarin crimson, ultramarine blue, and permanent white gouache. You can see there's more burnt sienna and white used for the right-hand and left-hand logs and more purple tones in the middle one. The foreground shadow is painted primarily with alizarin crimson and ultramarine blue and a lot of permanent white gouache. The shadows that model the forms of the logs are made with the same combination of colors but with less white.

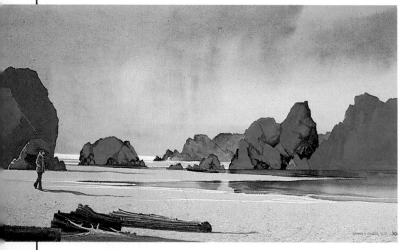

(left) Beach Light. Watercolor and gouache, 15¼″ x 29″ (39 x 74 cm). Collection of the artist.

Referring to my sketches and using the same gouache colors I've been using all along, I lightly brush in the figure using a ¼″ (.64 cm) single stroke sable brush. Very deliberately, with long periods of looking, interspersed with brief moments of painting, I gradually define the form, using the darker tones of burnt sienna and ultramarine blue gouache for the shadows. Finally, I touch the scarf with a brilliant spot of orange lake light and the figure is complete.

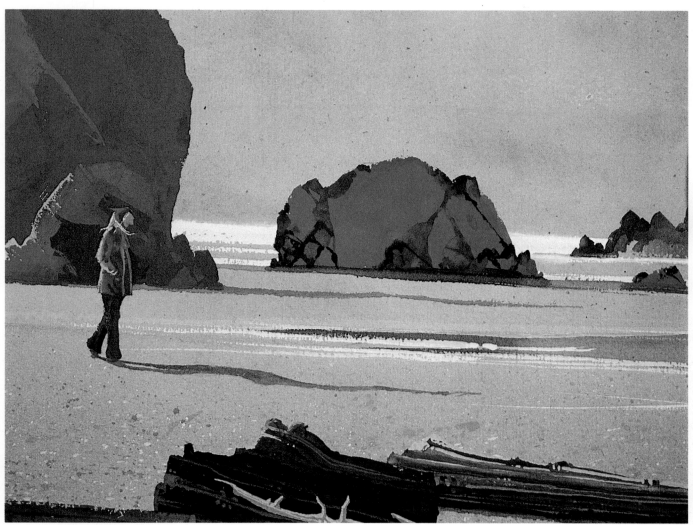

(above) Detail. So many times in the course of my workshops I've seen a painting nearly brought to a successful conclusion, only to be ruined by the addition of a figure that just doesn't fit. So much depends on this one figure that the artist is rigid with fear that something will go wrong, so of course it does. You can help yourself over such a crisis by doing separate figure studies until you're satisfied. The figure should intensify the feeling of the painting; it should be done in the same style and should use the same colors. Once you have a sketch that pleases you, you can trace it onto your painting. Or you can paint it onto a piece of glass or plastic film and try positioning it in various places in the painting until you're satisfied.

Transparent watercolor and opaque gouache

Every year, about the 10th of July, ranchers truck sheep to a corral about two-hundred yards down the road from my house. After they are unloaded, the sheep are moved up to the high country for the summer. Then, about the middle of September, they're driven back down to the corrals and trucked out. Because sheep have been a favorite subject of mine for many years, I always try to be on hand at these times.

Although everything in this painting is drawn from nature, it's almost surrealistic. This is partly because of the loss of detail, which is characteristic of a nighttime scene. Sheep are somewhat unreal looking animals, and this unreality is enhanced by backlighting. The triangular shapes of the trees, arranged in repeated curves, recede into the distance. The crescent moon shows a subtle circular shape, the result of "earthshine" from the Pacific Ocean. The milkweed pod and the shape formed by the group of foreground weeds repeat the crescent shape. The composition itself forms yet another triangle, with the moon at the apex and the sheep at the base. This carefully planned repetition of triangular and semicircular elements creates a dreamlike quality and an hypnotic sense of stillness.

MEDIA AND TECHNIQUE

A transparent graded wash, of the type which forms the first step of this painting, can only be done with watercolor. Watercolor is the most transparent and luminous of any of the water media. Prussian blue is absolutely right for painting a night scene in the mountains. Acrylic and casein Prussian blue, however, streak and are somewhat different shades. So I selected gouache as my opaque medium. Also the creamy quality of gouache makes it ideal for detailed passages, such as the foreground weeds.

PAINTING SURFACE

This painting is done on 300-lb Arches watercolor paper. I like the way this paper responds when doing wet-in-wet washes, and the brush handles well on the surface. It's heavy enough so there is little buckling, so I cut it to size, tape it to plywood with 1½" masking tape, prop it up about 5" at the upper margin, and am ready to begin.

BRUSHES

2" squirrel hair
¼", ⅝" single stroke red sables
1½" single stroke synthetic
#4, #5, #6 round red sables

PALETTE

Watercolor: Prussian blue
Gouache: Prussian blue, burnt sienna, raw sienna, zinc white, permanent white

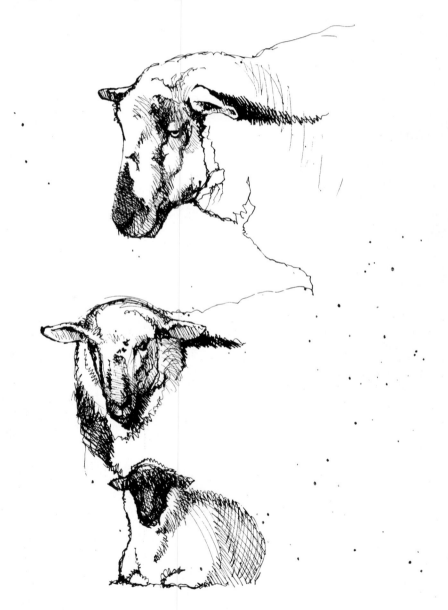

Figure 1. 10½" x 6" (26.7 x 15 cm). There's so much happening when the ranchers bring the sheep to the corrals, I frequently take photographs to save time. Later, I project the slides in the studio, pick out the ones that interest me, and sketch from them. These sketches were done this way, using a Pentel fine-line pen.

Step 1. With a 2″ (5 cm) squirrel hair, I saturate the surface of the paper by going over it three or four times with clear water. The paper is tilted up about 5″ (12.7 cm), and I apply a graded wash of Prussian blue watercolor. Very dense at the upper part of the paper, it gradually becomes lighter as I move down. I blot the edges of the tape with a paper towel to prevent the wash from running back on the paper. When this is totally dry, I mix a middle value of zinc white and Prussian blue gouache, stirring it thoroughly to make sure it is well blended and test it in advance on a scrap of mat board. The color is lighter than the upper part of the wash and darker than the lower area. Using a ⅝″ (1.6 cm) single stroke sable, I paint around the tree forms across the top of the painting. I paint the negative areas rapidly and accurately, moving from right to left in contiguous areas, in order to paint the entire passage at once.

(right) Step 2. Using Prussian blue gouache completely pure and opaque, I paint in the darkest trees in the foreground. I use a ⅝″ single stroke sable for the upper, delicate parts of the spruces and change to a 1½″ (4.8 cm) single stroke synthetic for the large area at the bottom of the painting. The tips of these trees form another semicircular shape.

(right) Step 3. For the middle row of trees, I mix Prussian blue and zinc white gouache in a small jar until the right shade is thoroughly blended. Using a ⅝" (1.6 cm) single stroke sable, I carefully paint around the dark trees in the foreground and paint the shapes of the spruces beyond. These trees and their placement repeat those in the first passage.

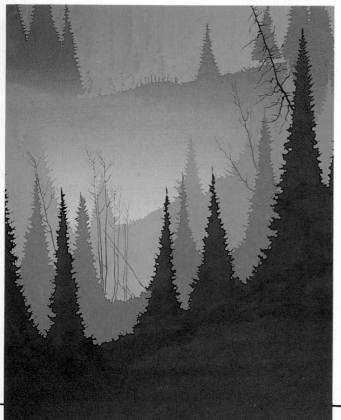

(left) Step 4. I mix another tone of Prussian blue and zinc white in a jar, which is lighter than either of the other two foreground passages, and much closer in value to the sky area. Using a ⅝" (1.6 cm) single stroke sable, I paint around the shapes of the first two rows of trees, and paint a third row in the middle distance. When this dries, I paint in the dead aspen using a #5 round sable brush with the same mixture of blue and white gouache used in the previous step.

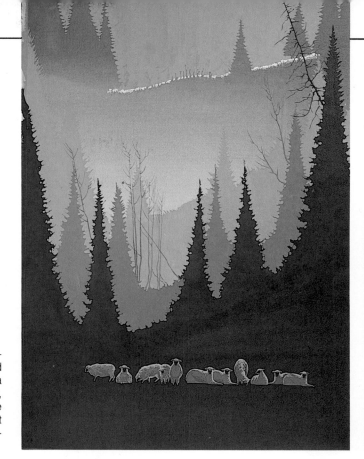

(right) Step 5. Referring to my preliminary sketches, I lightly outline the sheep with a 2H pencil. I mix a tone of zinc white and Prussian blue gouache for the darkest value of the sheep. With a # 6 round sable, I fill in the outlined forms. When the paint is dry, I paint the wool catching the moonlight using a lighter tone of the same colors and a # 4 round sable. Highlights are picked out with the lightest combination of blue and white. I leave the darkest value of these two colors to form the faces of the sheep.

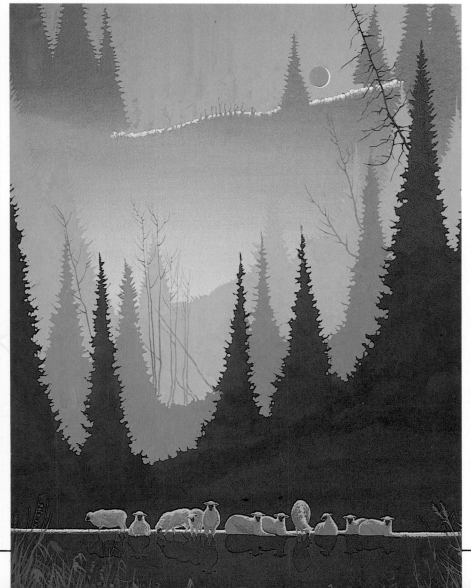

(left) Step 6. For the moonlight touching the background slope, I mix permanent white, burnt sienna, and raw sienna gouache and paint around the tree shapes. When this is dry, I come in with pure permanent white gouache and a touch of raw sienna for highlights that add a third dimension to this area. I outline the shadows of the sheep with a 2H pencil. Combining burnt sienna and Prussian blue gouache and using a ¼'' (.64 cm) single stroke sable, I paint around the outside of the shadows. I finish the rest of this passage using a 1¼'' (3 cm) single stroke synthetic and allow it to dry. The brilliant horizontal line of the meadow is first painted with pure burnt sienna gouache using a ¼'' single stroke sable. When this is dry, I paint over it with a mixture of burnt sienna, raw sienna, and permanent white gouache, leaving the original layer of burnt sienna visible along the lower edge. Final highlights are added to this strip using almost pure permanent white with a touch of raw sienna. The moon is done using a mixture of Prussian blue and zinc white gouache in a shade somewhat darker than the sky, using a ¼'' single stroke sable. When this area is dry, I paint the delicate crescent with a # 4 round sable using zinc white gouache tinted with raw sienna.

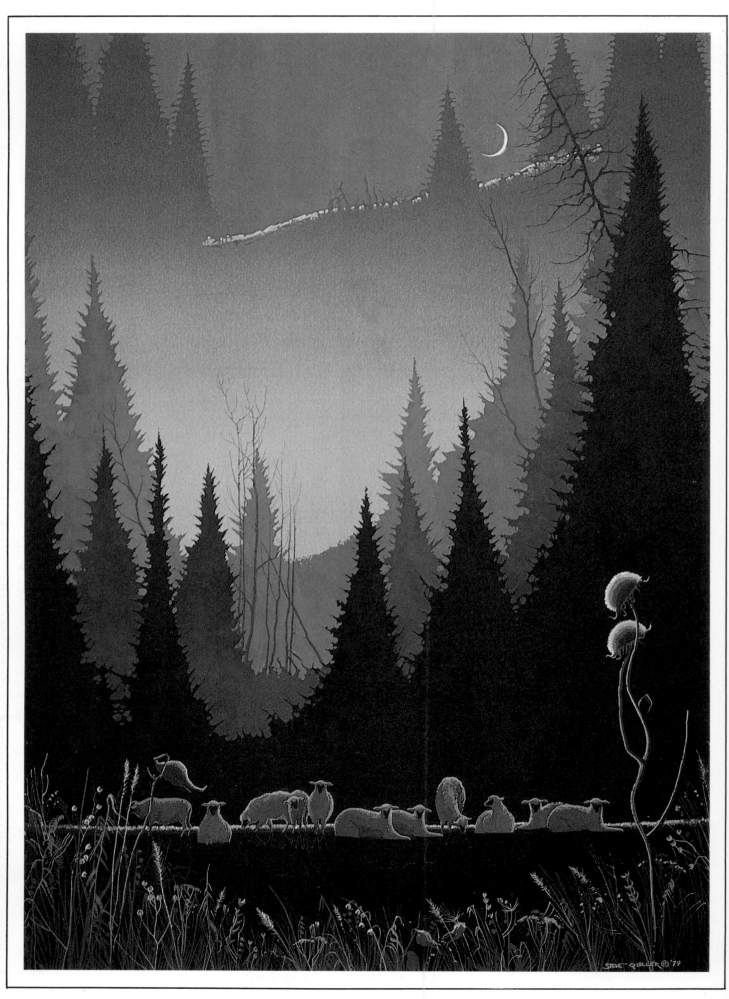

Detail. Although this painting is done using transparent watercolor and opaque gouache, this detail illustrates only the gouache, and is a good example of how it can be used for its flat, smooth covering power. The weeds and the sheep are painted from dark to light, which is the reverse of the usual transparent watercolor method of creating a form. Using a variety of small round brushes, I develop the forms by gradually lightening them, finishing off with the final, brightest highlights.

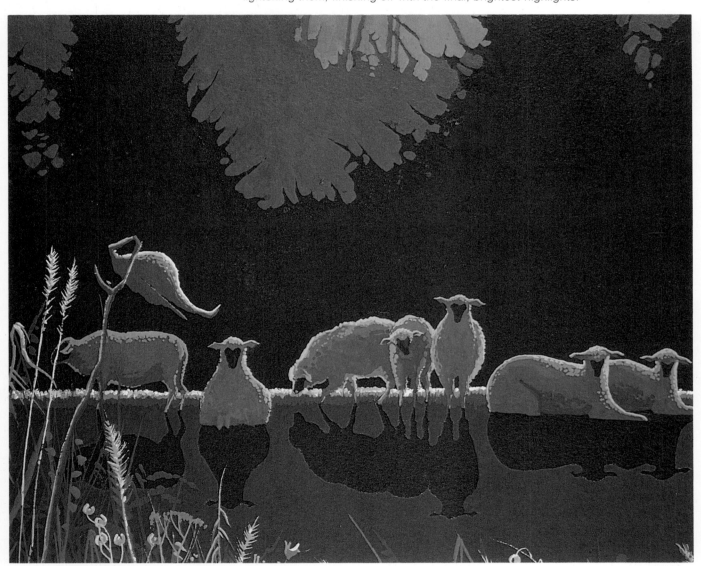

(left) New Moon. Watercolor and gouache, 29'' x 21'' (74 x 53 cm).
Collection of the artist.

For the interwoven weeds in the foreground, I use a ¼'' (.64 cm) single-stroke sable in a very loose, free manner. Using burnt sienna gouache, I turn the brush on its edge and turn it from side to side to make irregular thick and thin strokes. When this dries, I mix burnt sienna with some raw sienna gouache and use the brush in the same way to paint another layer of weeds in a lighter color which seems to be in front of the first layer. An even lighter color is used for the nearest weeds. Final details and highlights are picked out with a #4 round sable, using mostly zinc white and a touch of raw sienna gouache. These glittering highlights lead the eye through the painting.

Transparent acrylic with translucent and opaque casein

Occasionally in Colorado we have winters of sparse snowfall, and this means that areas usually blocked by snowdrifts are open for hiking and picnicking. One February, during such an open winter, I went on a hike with my family and some neighbors up Shallow Creek, a pretty little stream not far from my house. I knew that with all the pleasant socializing there would be little time for sketching, so I took along my camera.

In between socializing, hiking, and picnicking, I kept an eye out for anything I thought interesting. There were many small cascades and rocks that made interesting patterns in the water. Along the banks there were marvelous patterns made by snow, brushy patches, and areas of bare ground. Some places had four or five inches of snow; in other places ice had formed and melted and formed again. Snow had mounded over and drifted into shadowed areas protected from the sun. So by the end of the day I'd shot up a roll of film.

When the slides came back, I pulled out the ones that interested me, projected them on a screen, and made a series of sketches that became the basis for this painting.

MEDIA AND TECHNIQUE

I've done a lot of these ice flow paintings and find that acrylic phthalo blue and Hooker's green combined make a color that's just right. To create the effect of water flowing at various depths I use the transparent, brilliant acrylic paint, painting over each wash after it dries with masking fluid. The mask protects the wash from being darkened by additional layers of color. When masking fluid is removed, the acrylic will not lift. This is what I call the "batik process."

Casein is used for the snow and ice because it flows easily; and when more water is added, it has a nice translucent quality. When used with less water, it's good for smooth opaque coverage. Cerulean blue casein mixed with titanium white casein produces a variety of shades of light blue ideally suited to snow passages. The combination of the matte opaque casein and transparent acrylic creates exciting visual effects.

PAINTING SURFACE

A Crescent #100 cold-pressed illustration board is cut to 29″ x 21″ and taped to a plywood board. Its untextured surface is ideal for flowing paint on smoothly, and masking fluid lifts easily from it. I put it on my work table so that the upper part is raised about 4″.

BRUSHES

2″ squirrel hair
old single stroke synthetic for masking fluid
½″, ⅝″, ¾″, 1½″ single stroke synthetics

PALETTE

Acrylic: Hooker's green, phthalo blue
Casein: cerulean blue, titanium white

(far right) Figure 1. 4½″ x 3½″ (11 x 8.9 cm). This sketch is typical of many I made while looking at the slides. Using a Pentel superfine pen, I block out lights and darks and select the elements that interest me the most: the soft round shape of drifted snow, contrasting with crisply defined icicles melting into a running stream.

(right) Figure 2. 5″ x 3½″ (12.7 x 8.9 cm). This value study is the one I pinned up in front of me while I was working on this painting. White snow and icicles contrast with a circular shaded area in the center and in the foreground. Although the two sketches and the finished painting are not the same, they all have similar elements.

(right) Step 1. With the 2″ (5 cm) squirrel hair brush, I saturate the entire surface with water, except for the white area in the lower central section. Using a 12″ x 18″ (30 x 46 cm) scrap of white mat board as a disposable palette, I squeeze out Hooker's green and phthalo blue acrylic. With the squirrel hair brush, used very wet, I pick up some of each color until I have enough of the proper shade mixed right on the mat board. Then I flow this transparent color onto the wet illustration board. While this wash is still wet, I paint the dark pockets in the upper-left section with Hooker's green and phthalo blue using a ¾″ (1.9 cm) single stroke synthetic brush. The board is now allowed to dry. With an old brush dipped into masking fluid I paint the rock forms in the foreground. I also do a controlled directional spatter with the masking fluid by hitting the loaded brush gently across the forefinger of my opposite hand. Now the entire board is allowed to dry.

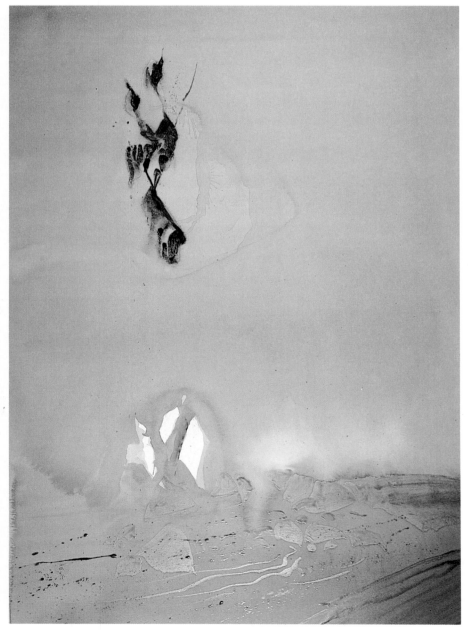

(left) Step 2. Using the squirrel hair brush again, I lay another transparent wash over the board using more of the phthalo blue and less of the Hooker's green acrylic. I don't touch the white area or the dark passage at the upper left. I come in close to this dark passage on its left side and swing wide around it on the right, creating the effect of a pocket in the snowbank. At the upper edge of the area that is left dry, I lean over and blow the wash into it, which creates the spontaneous movement of wet water on a dry surface. Now I carry the wash down into the foreground, around the white shapes and over the first layer of masking fluid. After this dries, I work the masking fluid on an old brush to paint in more rock shapes as well as lines suggesting current in the water. I also add some directional spatter in this area with the masking fluid.

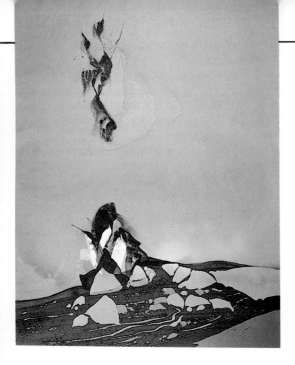

(left) Step 3. To achieve the soft edges around the white shape in the foreground, I first wet the area using a ⅝'' (1.6 cm) single stroke synthetic, then paint in the dark areas with transparent Hooker's green acrylic. The crisp outline where the water meets the bank is created on dry paper. The foreground water area is wet down, using a 1½'' (4.8 cm) single stroke synthetic; then I flow in a middle tone of Hooker's green mixed with phthalo blue acrylic. Darker streaks of this combination of colors give the effect of current. When all of this area is totally dry, I gently rub off the mask, exposing the lighter areas, which create rock forms, bubbles, and the lines of the current in the water.

(right) Step 4. Now I tone down the foreground rocks with a transparent glaze made of Hooker's green and phthalo blue acrylic washed on with a ¾'' (1.9 cm) single stroke synthetic. I add a bit more blue to the mixture and paint over and around the rocks so they seem to be partly out of the water. I paint in the ripples and wash more of the transparent blue acrylic into the central and lower part of the water area to give more dimension. Now I let this acrylic paint dry.

With clear water and a squirrel hair brush, I wet the board from its top edge to the upper line of the water, but go around the pocket. Mixing cerulean blue and titanium white casein, I flow it across the top with a big sweep, using a 1½'' (4.8 cm) single stroke synthetic. Because the upper part of the pocket is dry, I have a crisp edge there. Where the paper is wet, the paint fuses. It is opaque at the upper part of the snowbanks and translucent as I bring it downward. This is the way I make the snowbanks on the right and left; and, adding more water to the light blue casein, I wash in the translucent snowbank just to the right above the water. Finally, using the same colors, but less water so that the casein is opaque, I paint in the icicles hanging from the top of the pocket using a ½'' (1.27 cm) single stroke synthetic.

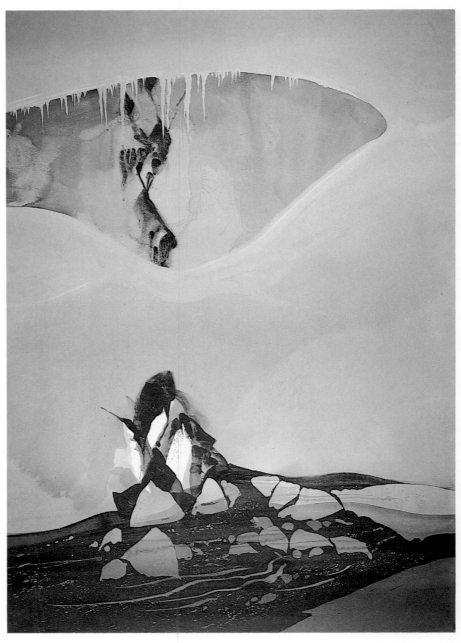

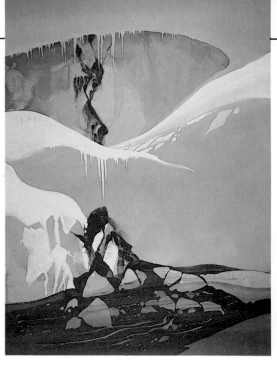

(right) Step 5. Now I rewet the area at the lower right of the pocket, and using a 1½″ (4.8 cm) single stroke synthetic, I paint in the area of brilliant sunlight with opaque titanium white casein. The negative areas of the snow shadows at the lower part of this passage are done using a ½″ (1.27 cm) single stroke synthetic on dry paper. The casein looks opaque when applied but will dry translucent. Now I lay in the area to the left of the pocket. Using the 1½″ single stroke synthetic, I carry the opaque white casein past the central area and allow it to diffuse and disappear into the shaded area. When this passage is dry, I paint the icicles hanging in the sunlight using the ½″ single stroke synthetic brush. I paint the sunlit bank on the lower left in much the same way, using titanium white casein with very little water.

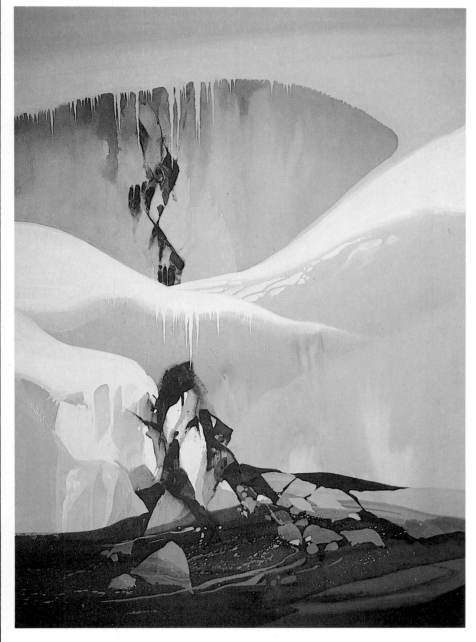

(left) Ice Flow. Acrylic and casein, 29″ x 21″ (74 x 53 cm). Collection of Grant Heilman.

As the sunlit bank in the left foreground is too brilliant, I soften it with a translucent wash of the same light blue, made with cerulean blue and titanium white casein. A few more directional spatters and some carefully placed strokes of opaque cerulean blue in the water; a few highlights of pure titanium white casein applied with a ½″ (1.27 cm) single stroke synthetic brush, and the painting is complete.

Opaque acrylic and opaque casein

This painting is not of an actual beaver pond. Instead, it's a cove on Upper Klamath Lake in the Cascade range of Oregon. I have an artist friend who lives there, and I frequently visit him when I'm there in the spring.

One morning at the end of such a visit, I was packing up to leave when I decided to walk down to this cove for a last look. It was a very still morning, and the warm spring sunlight was drawing moisture from the snow and the icy waters of the lake. This created a misty atmosphere that had such a beautiful soft radiance. I was so dazzled by this beauty that I made a sketch and took some photographs of the scene, making sure to take some closeups of the patterns I saw in the water. Then, unfortunately, I had to leave.

Back home in Colorado, I went through my slides and picked out several that related to my original sketch. I made several preliminary compositions referring to my

photos and actually completed a couple of watercolor paintings. The two watercolors merely enabled me to store up more information about what I wanted to say, and a year or so later, I painted this painting.

MEDIA AND TECHNIQUE

To create the impressionistic, shimmering radiance of this scene, I decided to use a textured underpainting of acrylic followed by opaque casein. Acrylic adheres to any surface without chipping or flaking, and it provides a good bond with any paint that follows. It can be manipulated with various tools, such as a brayer or a comb, to give texture, and a textured surface means that underlying colors will show. Casein can be handled almost like oil paint on a "bright" brush, and because it's juicy and opaque, casein can be scumbled across the textured surface. Its soft matte surface is ideal for atmospheric effects, and it can be overpainted when dry with very little

lifting of the underlayers.

PAINTING SURFACE

I'm using a Crescent #100 cold-pressed, heavyweight illustration board. It's heavy enough to provide a rigid support for many layers of paint. The smooth surface allows the paint to provide the texture, and it's tough enough so I can work it with a variety of tools. I cut it to size, staple it to a piece of plywood, and put it up on my easel.

BRUSHES

#4, #8, #20 "bright" synthetics
#5 round synthetic

PALETTE

Acrylic: chromium oxide green, cerulean blue, titanium white
Casein: terra verte, cerulean blue, cadmium orange, Shiva rose, Shiva violet, Shiva green, permanent green light, burnt sienna, cadmium red light, cadmium red extra pale, titanium white

(right) Figure 1. 7″ x 5″ (17.7 x 12.7 cm). This is one of several preliminary watercolor studies. Touches of white gouache provide highlights. Most of the compositional elements are here, although they are reversed in the final painting. I was attempting to catch the diffuse radiance of the atmosphere. Once I got this down, I was ready to develop the final painting.

(far right) Figure 2. 7¾″ x 5″ (20 x 12.7 cm). This pen-and-ink study is based on the watercolor study. I emphasize the foreground and shift the bank of the pond to the right side. The darkness and detail of the foreground contrasts with the brightness and lack of definition in the distance.

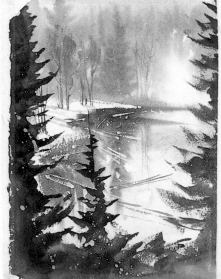

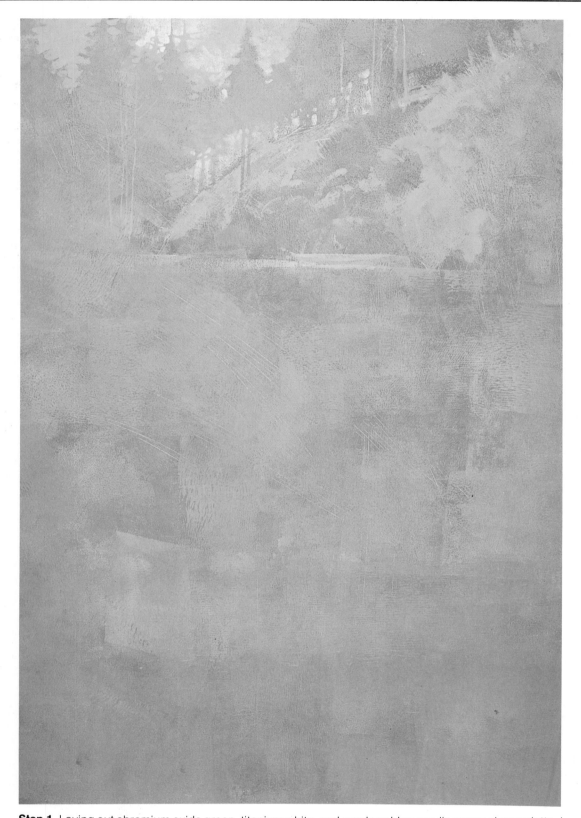

Step 1. Laying out chromium oxide green, titanium white, and cerulean blue acrylic on my glass palette, I roll the brayer back and forth over the colors, mixing them, then apply the paint in different directions all over the board. As it becomes tacky, I scrape into it in various places with a coping saw blade, and in the central area, I scrape with a single-edge mat knife and expose the board surface, now tinted green. This process produces a textured base of misty color. I let it dry thoroughly.

Using a #20 synthetic "bright," I mix terra verte, titanium white, and cerulean blue casein and paint opaquely the horizontal line where bank and water meet. I develop the forms in the bank area, letting the underlying color show through. Painting into the negative spaces around the distant trees with a lighter value of blue and white, I warm it with a bit of cadmium orange mixed with white in the left central area. For the background ridge and the warm light coming through the tree trunks, I paint in a mixture of Shiva rose, Shiva violet, and permanent white casein using a #8 synthetic bright and almost no water.

(left) **Step 2.** With cerulean blue, terra verte, and titanium white casein, I paint the trees on the right-hand bank with a #20 synthetic "bright." The brush is fairly dry, and I use the edge, the heel, and the tip of the brush to define the forms. Using the same color, I paint in their reflections, suggesting a bit of movement in the water. Along the edge of the bank, I paint a crisp edge with the tip of the brush, using a somewhat deeper shade of the same color.

Step 3. I paint the right-hand bank with a mixture of cerulean blue and titanium white casein, used fairly dry, on a #20 synthetic "bright." With the tip of the brush, I paint in the negative area around the tree trunks and give a crisp edge to the waterline. Titanium white and a touch of cadmium orange casein accents the left point of the bank and other warm areas of color along the bank. For the reflection of the most distant ridge, I mix permanent green light, terra verte, and titanium white casein and carry this color in a diagonal from left to right in the water and around the reflection of the trees.

Using a #20 synthetic "bright" and an opaque mixture of cerulean blue and titanium white casein, I drag the paint down vertically to create the reflection. I take care not to cover up the underpainting completely as I paint around the shapes in the water. Warm touches are added with a mixture of titanium white, Shiva rose, and Shiva violet. Notice how this lighter tone makes the reflected images seem darker.

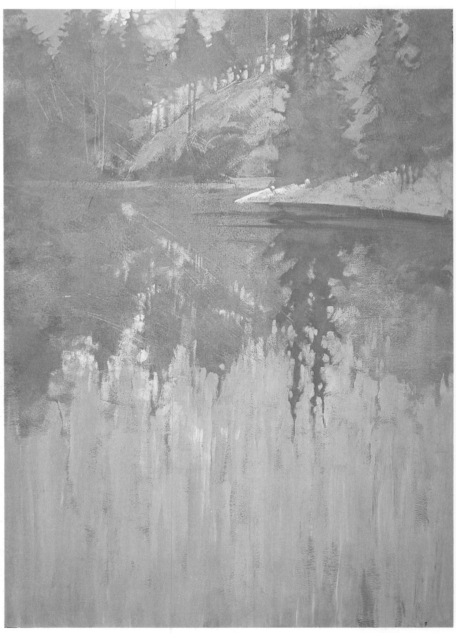

(right) Step 4. A mixture of cerulean blue and titanium white casein, which is lighter than the color of the water, is used to develop the forms of the bank. With a #20 synthetic "bright," I use the edge of the brush and scumble over the darker undertone. As I come forward, I deepen the color by adding more blue. The foreground bank is modeled with lighter and darker shades of blue, and the warm accents are a very pale mixture of cadmium orange and white casein.

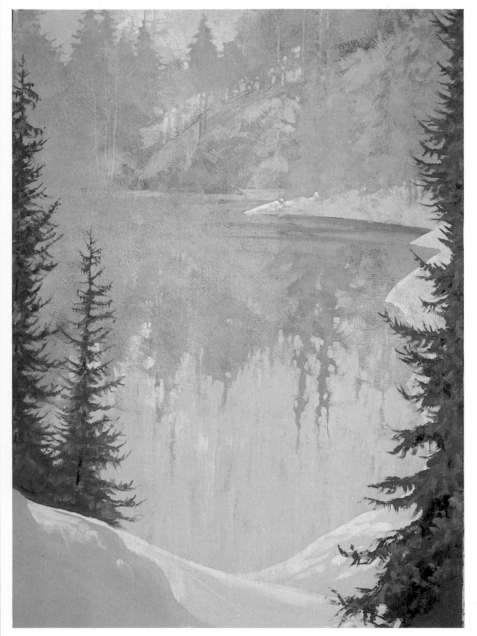

(left) Step 5. To help me position the spruce trees, I put a piece of glass in front of the painting and paint the trees on the glass. When I am satisfied with the composition, I brush in the trunks from bottom to top, using a #20 synthetic "bright" on its edge and a dark mixture of terra verte, Shiva green, and cerulean blue casein. I paint the foliage with a dark tone first, followed with lighter details, using a #8 synthetic "bright" allowing the darker undertone to show. The right-hand spruce is painted dark to light in the same way, and cerulean blue and burnt sienna are added for variation to the basic color mixture. The pinecones clustered at the top of the left-hand spruce are done using a #4 synthetic "bright" and a mixture of a burnt sienna casein, cadmium red light casein, and almost no water.

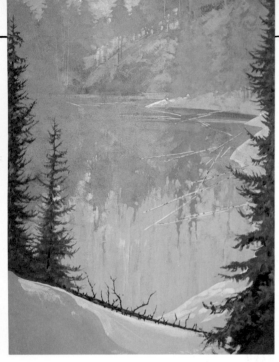

(left) Step 6. The dead tree lying across the lower bank acts as a visual link for the spruces on either side. The form is painted from dark to light, using a #5 round synthetic, with various mixtures of cerulean blue, burnt sienna, cadmium red extra pale, and titanium white casein. The delicate branches are painted the same way. Constantly referring to my sketches, I carefully paint the floating logs using titanium white and a touch of cadmium orange casein. Those in the shaded areas have some cerulean blue in the warm mixture. Details are added with darker tones mixed with burnt sienna, cadmium red extra pale, and titanium white casein. To show that the logs are floating, I paint a thin line of cerulean blue casein to indicate the trunks on the surface of the water.

(right) Beaver Pond. Acrylic and casein, 29″ x 21″ (73 x 53 cm). Collection of Bill and Sue Spencer.

With great care, and constant reference to my preliminary sketches, I paint the remaining aspen logs floating in the water nearby. The foreground rocks are done in various combinations of burnt sienna, Shiva violet, cadmium red extra pale, and titanium white casein, using a #20 synthetic "bright." This solidity helps emphasize the foreground and provides a contrast with the gradual loss of definition perceived when the eye moves back into the painting.

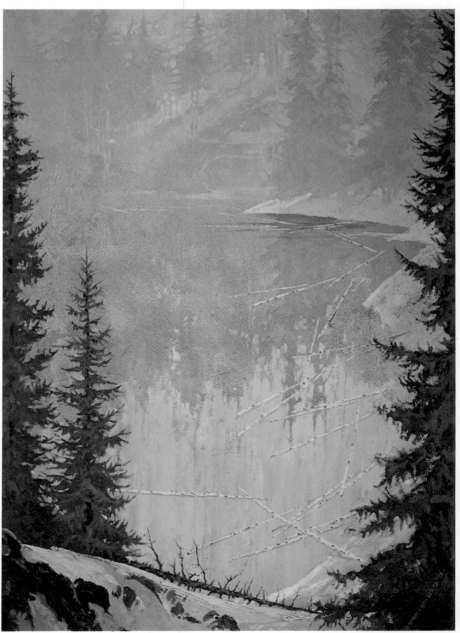

Transparent watercolor, opaque acrylic, opaque and translucent casein

Winter light is a favorite subject of mine. In Colorado, the bright winter sun makes the snow very brilliant, which contrasts with the darkness of the spruces. It highlights the delicate aspen and casts shadows of an intense cerulean blue.

Many times I'll go out cross-country skiing by myself, my daypack filled with sketching materials, lunch, and a space blanket. The space blanket has an aluminum side that reflects the sunlight and gives me a warm dry spot on which to sit. This particular morning I came around a bend and, looking up, saw an aspen tree in brilliant sunlight, along with other aspen nearby in the shadows. So I spread out my space blanket on the snow and sat down to sketch. I always carry some oil pastels with me because they don't freeze, so I made a color on-the-spot sketch of the delicate aspen. I also made some studies with a nylon-tipped, fine-line pen to work out the pattern of lights and darks. Then I skied back to the studio, invigorated by my morning out-of-doors and inspired by an idea for this painting that I could develop from my sketches.

MEDIA AND TECHNIQUE

The background of this painting is done in watercolor, chosen because it dries lighter than the other water media and its soft tones increase the effect of depth I'm after. I use it very spontaneously, so that the washes of color skip over the rough paper. I use acrylic in a flat opaque way for the spruces, because of its color intensity and because it can be painted over when dry without disturbing it. Casein is selected for the snow passages and for the shadows because of its excellent coverage for large opaque areas; and its easy flowing quality on the brush makes it excellent for painting details, such as the delicate aspen branches. Although it dries matte, casein has an almost waxy surface that is unique and pleasant. I know these three media interact well together, particularly when I repeat the same colors as I change from one medium to the next.

PAINTING SURFACE

I select Arches rough 300-lb. water-color paper, 22″ x 30″. Because of its weight, it needs no soaking or stretching. Its rough texture adds sparkle to the spontaneous handling of the transparent watercolor brushstrokes. I tape it to a piece of plywood with 2″ masking tape and prop it up on my work table raised about 4″ along the upper margin.

BRUSHES

2″ squirrel hair
¼″, ½″, ¾″, 1″ single stroke synthetics
#3, #8 round synthetics
#8 round red sable
¾″ single stroke red sable
toothbrush

PALETTE

Watercolor: sap green, ultramarine blue, brown madder alizarin, burnt sienna
Acrylic: Acra violet, phthalo blue, Hooker's green, burnt umber, cadmium red light
Casein: titanium white, cerulean blue, alizarin crimson, burnt sienna, cadmium red extra pale, raw sienna, golden ochre

(right) Figure 1. 6¼″ x 4¾″ (15.8 x 12 cm). This is one of many quick sketches I made of this subject that helped me work up the composition. It's done with a Pentel brush pen on newsprint. Although it was done very rapidly, in a most impressionistic style, it gives the feeling of the forest and the intersecting sloping banks of this area.

(far right) Figure 2. 10″ x 7″ (25 x 17 cm). This is the last of a series of many preliminary sketches I made before beginning this painting. Done with transparent watercolor and opaque gouache, it's the one I tacked up in front of me for reference. You can see that I shifted the sunlit aspen from its center location here over to the right in the final painting. I feel this adds greater interest and improves the composition.

(left) Step 1. I splash water across the upper part of the paper using a 2″ (5 cm) squirrel hair brush. Mixing sap green and ultramarine blue watercolor, I flow in the basic shapes of the background trees. Deeper tones are made by adding burnt sienna and brown madder alizarin. To suggest trunks of these distant trees, I scar the wet paper with a single-edge mat knife, creating lines that the color sinks into. At the upper right, I use a #8 round sable to paint in more trees. Where the paper is wet, the paint blurs, and where it's dry, the branches have crisp definition. With a #8 round sable and clear water, I paint in more trees in this area. The water pulls the pigment to the sides, exposing the paper stained with sap green. When the paper is dry, I paint the central background spruces using a ¾″ (1.9 cm) single stroke sable.

(right) Step 2. I apply clear water with a squirrel hair brush to the diagonal bank just below the background forest. Mixing sap green, cerulean blue, and burnt sienna watercolor, I drag it across on a diagonal from left to right. Covering the upper area with a paper towel, I use a toothbrush and a mixture of sap green, burnt sienna, and brown madder alizarin watercolor to apply a soft spatter. With a single-edge mat knife, I squeegee the damp surface, creating patterns on the bank. Then, using a ¾″ (1.9 cm) single stroke sable, I define these areas with deeper tones of sap green and burnt sienna watercolor. I add some dark spatter with the same brush and colors. Shifting to acrylic, I mix phthalo blue, Hooker's green, and Acra violet to a rich opaque consistency and paint the dark middle-ground spruces right over the dry watercolor, using a ¾″ single stroke synthetic, developing the forms from the bottom up.

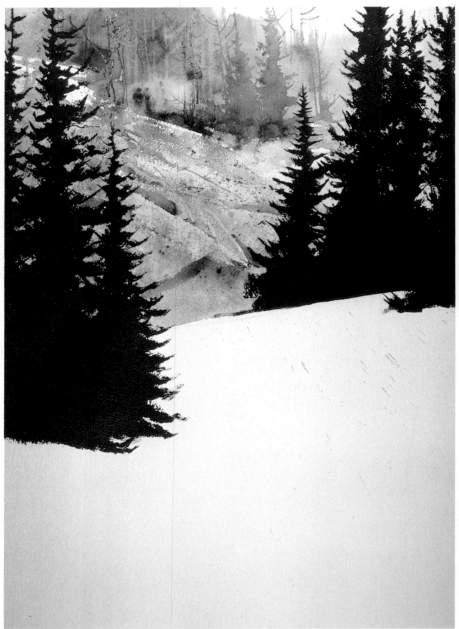

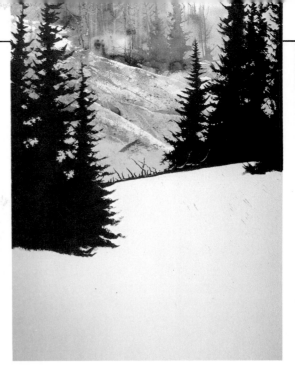

(right) Step 3. With the painting on my easel, I paint the fallen tree limb in the middle distance using a #8 round synthetic and a mixture of burnt umber and Acra violet opaque acrylic. Touches of cadmium red light and Acra violet are added when it's dry for vitality. I drybrush opaque, light blue casein in some areas of the distant bank. As I come forward, I use it in a creamy, opaque manner and paint around the branches of the fallen tree as well as between branches of the spruces with a ¼″ (.64 cm) single stroke synthetic. I touch the smaller branches of the fallen limb with a translucent mixture of this blue to suggest a light layer of snow, then add highlights with opaque titanium white casein.

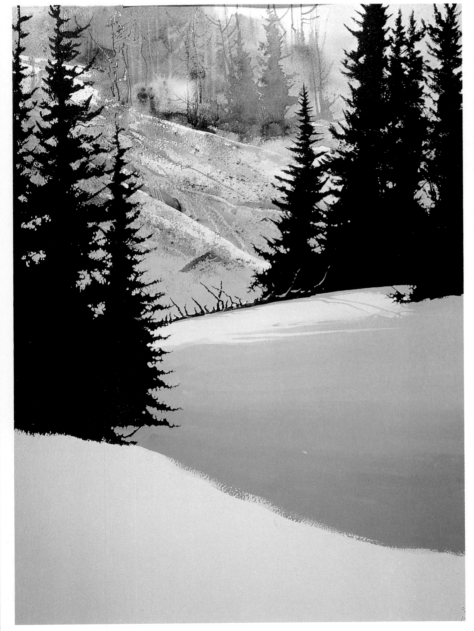

(left) Step 4. With a ½″ (1.27 cm) single stroke synthetic, I paint titanium white casein from the underside of the limb over to the lower edges of the spruces on the right. While the paint is wet, I add cerulean blue casein and paint in the shadow under the log and also the shadows cast by aspen trees, which will be painted in later. Adding more blue paint to the mixture, I paint around the branches of the spruces. Near the bottom of this passage, I use a 1″ (2.5 cm) single stroke synthetic with very little white in the mixture, finishing off with a nearly dry brush. I then let it dry.

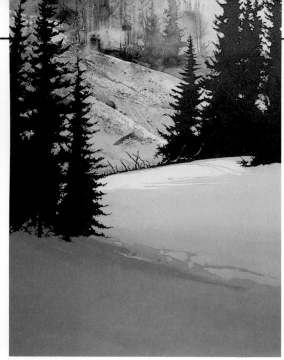

(left) Step 5. To make an even transition, I rewet the bottom edge of the previous cerulean blue passage with a 1½'' (4.8 cm) single stroke synthetic and carry a darker mixture of blue and white casein to the bottom of the paper. To add interest at the transition, I paint some negative shapes with the lighter value, which bleed into the darker. With the same brush, I paint nearly pure cerulean blue casein at the bottom of the left-hand spruces. When this dries, I paint around their trunks using a ¼'' (.64 cm) single stroke synthetic. When dry, I add a deeper cerulean blue casein above the edge of the distant fallen limb. Returning to watercolor, I darken the forested area behind the distant ridge with a mixture of burnt sienna and sap green using a ¾'' (1.9 cm) single stroke sable.

(right) Step 6. Referring to my preliminary sketch, I paint the fallen log in the foreground with casein, using a # 8 round synthetic and a mixture of burnt umber and alizarin crimson, adding warmer tones of burnt sienna, cadmium red extra pale, and raw sienna for accent. When dry, I paint snow along the branches and trunk with cerulean blue and titanium white casein. For the streak of sunlight in the snow, I rewet the area and paint in titanium white casein with a ½'' (1.27 cm) single stroke synthetic. The aspen in the middle distance is painted using a # 3 round synthetic with burnt sienna, raw sienna, and cadmium red extra pale casein. More burnt sienna is added for the shadowed areas, and golden ochre and titanium white casein are used for the sunlit branches. Additional accents of light blue casein are touched in to relate this passage to the rest of the painting.

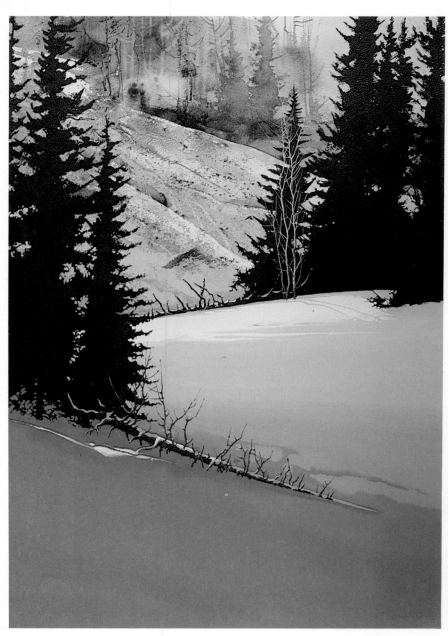

(right) Winter Light. Watercolor, acrylic, and casein, 29" x 21" (74 x 53 cm). Collection of the artist.

The foreground aspens are painted with a mixture of burnt sienna, raw sienna, and cadmium red extra pale casein, using a #3 round synthetic. I paint them from the ground up varying the tones. The sunlit tree has details and texture of burnt umber and alizarin crimson casein. The sunlit side is painted with a mixture of raw sienna and cadmium red extra pale. The effect of strong backlighting is created by painting a "halo" of golden ochre and titanium white casein on the left side of the aspen trunk and branches. Small dots of light blue and warm orange add texture to the trunks. All the smaller saplings are painted in the same way. With titanium white casein, I extend the bright streak of sunlight in the foreground, and with a dark green mixture of opaque acrylic and a ¼" (.64 cm) single stroke synthetic, I add a small bush in the distance.

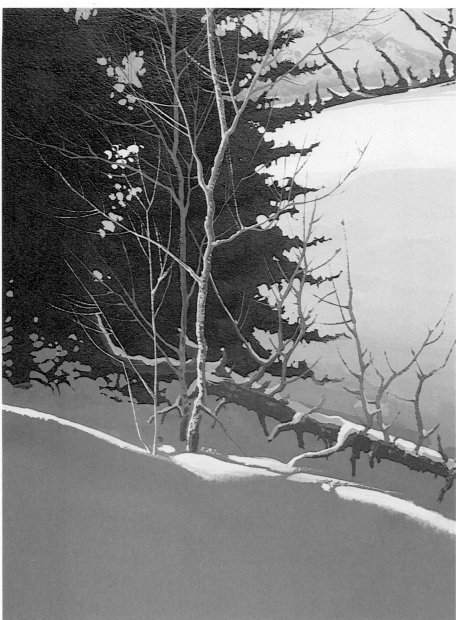

Detail. This is a good example of how visual excitement can be produced by the different ways of handling the paint. These spruce trees are painted first with dark acrylic, and the snow behind the trees and the light pockets seen through them are formed by painting opaque white and light blue casein right over the dry, dark acrylic. I paint the aspen trees directly using various shades of opaque casein. That bright streak of sunlight is painted directly, and the soft edges are the result of wetting down the area first with water.

Transparent and opaque acrylic, translucent and opaque gouache, and translucent and opaque casein

A few years ago the Creede area had a winter of tremendous snowfall, and the wild animals were having a very bad time. The Colorado Fish and Game Commission provided feed for people who wanted to help. My wife and I put hay in the meadow just below our house, and it wasn't long before we were feeding about ninety head of elk.

This gave me a great opportunity for sketching and close observation. I learned a lot about elk and how they behave. I learned that the cows are always the leaders and the bulls hang back in the rear of the herd and are more gray-blue in color than the brownish cows.

The inspiration for this particular composition came while I was driving home from South Fork one winter afternoon. The canyon of the Rio Grande is deep and narrow here, and the low sunlight creates some startling effects. The walls of the canyon are in very deep shade, and the winter sun hits the branches of trees or patches of snow with intense contrast.

MEDIA AND TECHNIQUE

I select this combination of media because of the intense contrasts in this composition. Deep transparent acrylic gives interesting effects when used wet-in-wet, and it also can be used opaque and textured. The flat, opaque covering quality of casein is excellent for the foreground, and it can be used for painting in highlights. Gouache has a pleasing translucence and can be lifted off with a damp brush to reveal the underlying acrylic.

PAINTING SURFACE

I'm using a Crescent #100 cold-pressed, heavyweight illustration board. This smooth surface allows the initial transparent acrylic wash to float easily over the surface. It provides a receptive base for the spatter and texture I apply and will take a lot of scraping. It's a sturdy support and takes a lot of punishment. However, for this painting, the paint, rather than the surface, provides the texture. I staple the four corners to plywood and prop it up about 4″ on my worktable.

BRUSHES

2″ squirrel hair
¾″, 1″, 1½″ single stroke synthetics
1″ Aquarelle synthetic
#8 round sableine
¼″, ½″ single stroke sables
#5 round synthetic
toothbrush

PALETTE

Acrylic: Hooker's green, phthalo blue
Gouache: cerulean blue, zinc white, permanent white
Casein: titanium white, cerulean blue, raw sienna, burnt sienna, cadmium orange, alizarin crimson, cadmium red pale

Figure 1. 2½″ x 9½″ (6 x 24 cm). This drawing done with a 2B pencil is based on other sketches made while the elk were feeding in the meadow just below the house. There's more refinement in this drawing, and some thought has been given to the arrangement of the animals in the long horizontal.

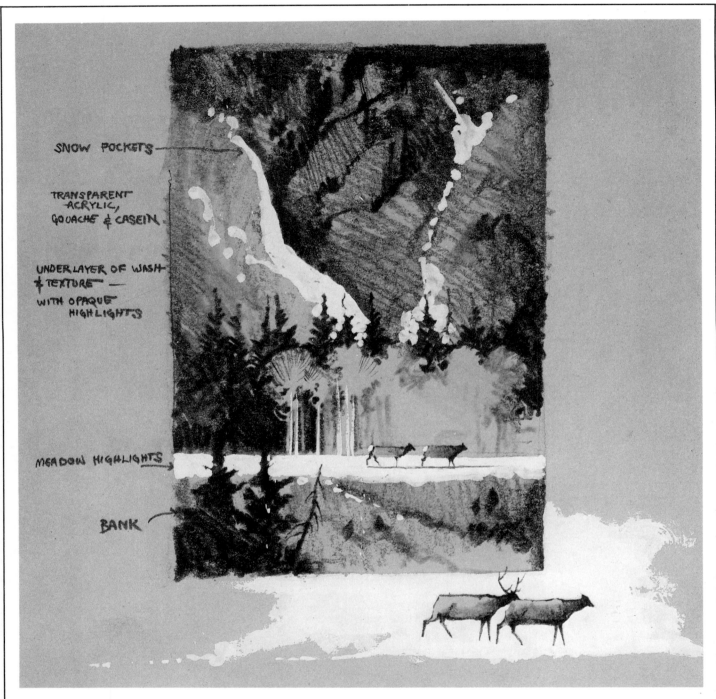

SNOW POCKETS

TRANSPARENT
ACRYLIC,
GOUACHE & CASEIN

UNDERLAYER OF WASH
& TEXTURE
WITH OPAQUE
HIGHLIGHTS

MEADOW HIGHLIGHTS

BANK

Figure 2. 6½″ x 7″ (16.5 x 17.7 cm). This value study is on Stonehenge paper, which has a warm beige tone and provides the middle value for my composition. Darks are built up using 3B and 4B pencils, and white gouache is painted in for highlights. This study is the final in a series that I made while working up this painting. It's the one I tacked up in front of me for reference.

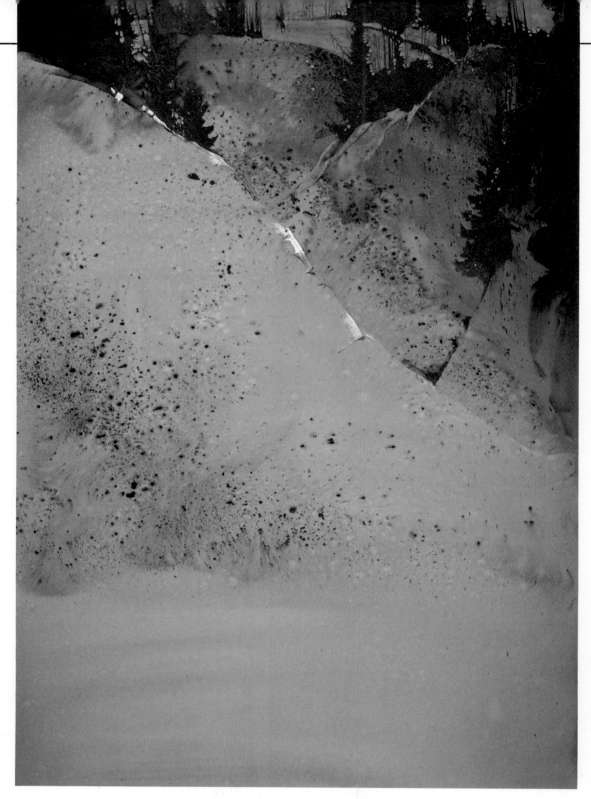

Step 1. I saturate the board with water using the 2'' (5 cm) squirrel hair brush and stroke on phthalo blue acrylic, letting it run down the surface of the board to establish a background suggesting mountain shapes. Using a ¾'' (1.9 cm) single-stroke synthetic and Hooker's green, I apply a spatter to suggest shapes under the snow. I follow with a spatter of clear water, using a toothbrush, to give an effect I call ''balloons of light.'' Using a mat-knife blade held like a squeegee, I refer to my sketch, and scrape out some diagonals to suggest mountain ridges. Now the paper is beginning to dry, so I quickly paint in tree forms very loosely, using a ¾'' single stroke synthetic and the blue and green mixture.

I rewet the upper-right side of the paper, and using a 1½'' (4.8 cm) single stroke synthetic, I add transparent phthalo blue acrylic until the area seems to recede. When the acrylic dries, I mix cerulean blue and zinc white gouache to a translucent milky mixture; and using a ½'' (1.27 cm) single stroke sable, I paint in and around the distant tree forms and add variations to the snow shadows. With a clean, moist ¼'' (.64 cm) single stroke sable, I lift the paint for further definition of the tree forms. Loading the same brush with a mixture of light blue gouache, I add directional spatter under the trees.

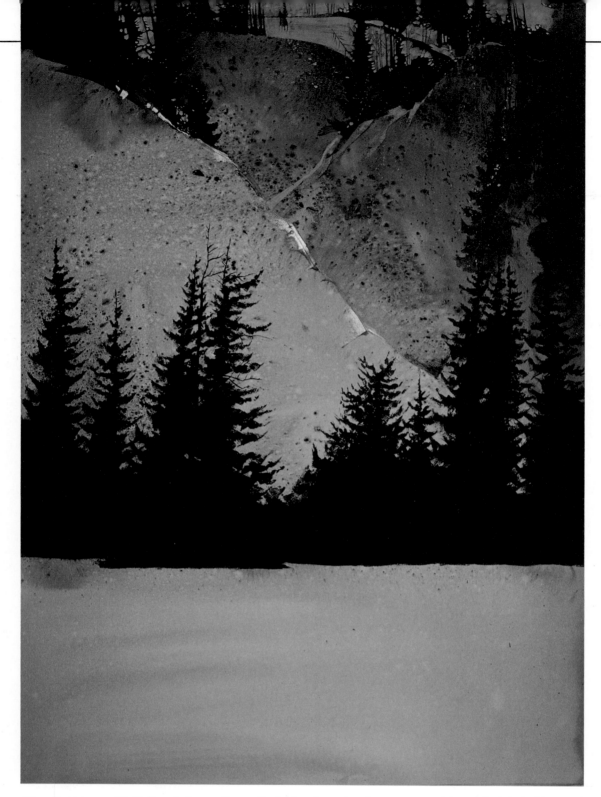

Step 2. Using a 1″ (2.5 cm) Aquarelle synthetic brush and a dry, opaque mixture of phthalo blue and Hooker's green acrylic, I paint the evergreens in the middle ground. I paint the trunks first, from bottom to top, then develop the foliage using the corner of the brush. I vary the size and shape of the spruces intentionally and paint in the shorter evergreens to the right of center for added interest.

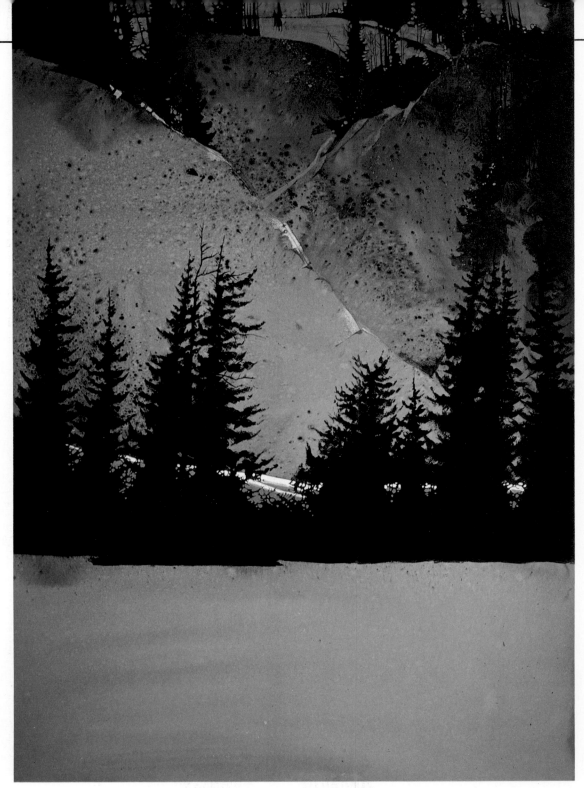

Step 3. Now the painting is dry enough to put on the easel. Standing back from it, I visualize pockets of snow beyond the tree forms and paint them in with a mixture of cerulean blue and zinc white gouache using a ¼″ (.64 cm) single stroke sable. When the gouache is dry, I paint the effect of sparkling sunshine on the surface of the snow with permanent white gouache. I let it dry.

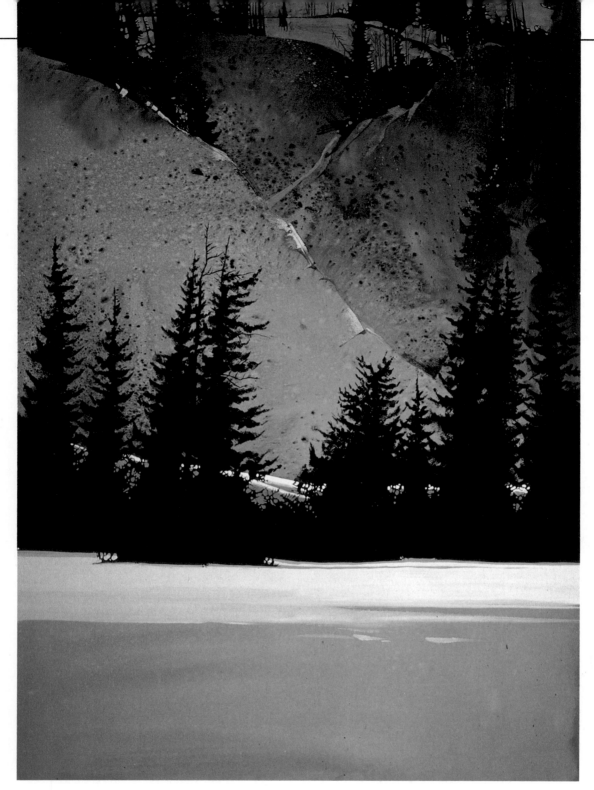

Step 4. I rewet the foreground thoroughly, using a 1'' (2.5 cm) single stroke synthetic and paint translucent titanium white casein over the entire meadow area. At the upper part of this damp area, I paint the casein in solid and opaque; and as I come forward, I use it translucently, adding some cerulean blue casein to make an easier transition over the acrylic. I then indicate small snow pockets at the edge of the meadow that contrast with the blue translucent wash of the foreground.

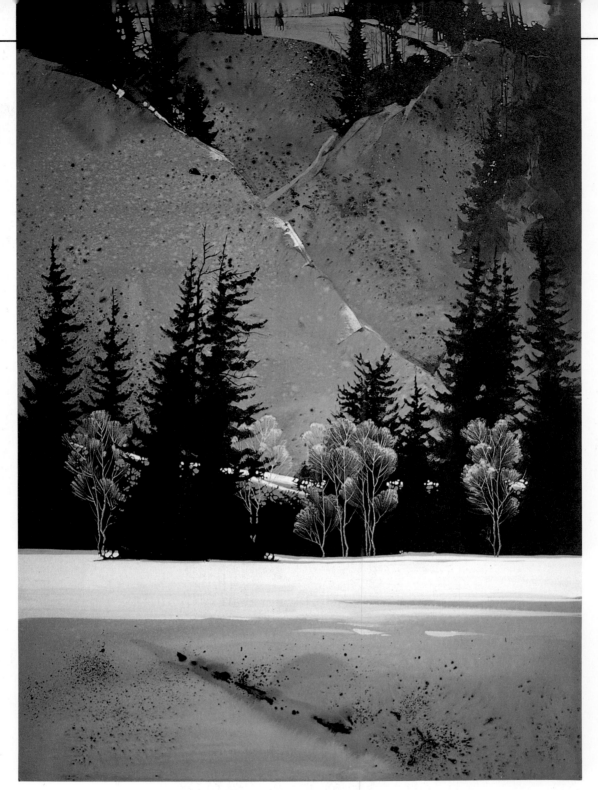

Step 5. The sunlit aspen are painted entirely with a #8 round sabeline. I use a mixture of raw sienna and titanium white casein for the trunk shapes and some of the branches. When dry, I model the trunks with cerulean blue casein. For larger branch areas, I splay the brush. Using the brush nearly dry, with various mixtures of raw sienna, cadmium orange, burnt sienna, and titanium white casein, and working from middle value to light, I paint in the lacy texture of the upper branches.

To create the spatter texture of the foreground, I rewet the surface. Then, using Hooker's green and phthalo blue acrylic, I dotted the foreground area with a ¾″ single stroke synthetic.

Finally, stroke by stroke, I paint in the shadows, using light blue casein and a #5 round synthetic.

(right) Winter Elk. Acrylic, gouache, and casein, 29″ x 21″ (74 x 53 cm). Collection of Mike and Janette Ronco.

To help me while making important final decisions, I frame the painting with strips of mat board to eliminate distracting elements around it.

The foreground spruce trees are painted with a ¾″ (1.9 cm) single stroke synthetic using phthalo blue, Hooker's green, and some titanium white acrylic. The tips of the trees are somewhat lighter than the lower foliage, so that they come forward from the background.

(left) Detail. Referring back to my sketches, I paint the elk with a #8 round sabeline brush and a mixture of titanium white, raw sienna, cadmium orange, burnt sienna, alizarin crimson, and cerulean blue casein. Because the bull is somewhat grayer than the cows, I add a little cadmium red pale to the mixture for their heads, just for a bit of pizzazz.

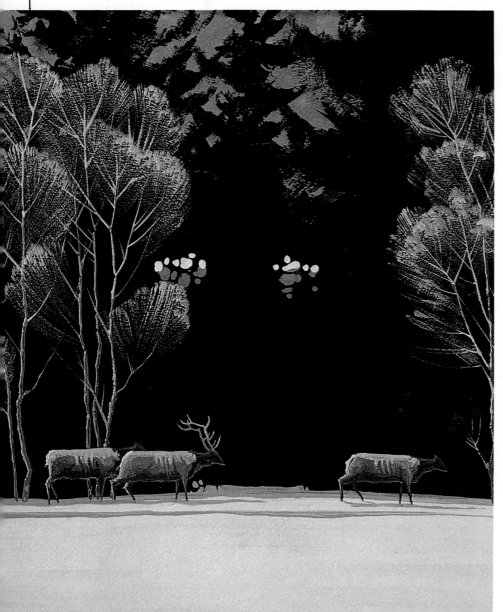

Collage: transparent, acrylic and acrylic matte medium, transparent watercolor, opaque gouache, masking fluid, rice paper, and cheesecloth

Although Taos, New Mexico, is only three hours from Creede, going there is like going to another country. The buildings are different, the country is different, and the culture is different.

This painting is based on a group of buildings I saw on a back street in Taos one February day. In the brilliant light so unique to New Mexico, the smooth adobe walls were in sharp contrast with the dark cottonwoods in the background. Winter cottonwoods reveal the dense brushy structure of their angular branches, so they contrast both in texture and in value with the smooth brilliance of adobe walls.

First, I made a few black-and-white sketches with a nylon-tipped, fine-line pen. Then, I did some color sketches using my little traveling watercolor box, a scrap of Arches watercolor paper, and water from a nearby mud puddle. After making these quick studies, I decided to use artistic license and weight the composition heavily toward the left and to add shadows cast by the vigas (the support beams), even though, because of the angle of the sun, none was visible while I was sketching.

MEDIA AND TECHNIQUE

Collage is a good way to create interesting textures, and because textures are of prime importance in this painting, I decided to use a lamination of rice paper and cheesecloth. The brilliance of the first acrylic wash will carry through underneath the layers of superimposed collage material. Acrylic matte medium dries transparent, so it won't hide this first wash. It also provides a strong flexible adhesive for collage materials. Acrylic doesn't lift when dry, so it is easily painted over. Watercolor responds well on laminated rice paper, settling into the crevices and folds to emphasize the texture. Gouache gives the necessary opacity; it flows easily on the brush, is excellent for fine detail, and for scrumbling light over dark texture.

PAINTING SURFACE

Crescent #100 cold-pressed, heavyweight illustration board provides a rigid support for the many layers of paint, rice paper, and cheesecloth that make up this painting. The first transparent acrylic wash flows evenly onto its smooth surface. It gives a good bonding surface for the transparent matte medium and the collage materials. I cut it to size and staple it to a piece of plywood. The fine Unryu rice paper has a feathery texture that lends a soft irregular surface to the adobe. Torn cheesecloth emphasizes the brushy quality of the cottonwood branches.

BRUSHES

2″ squirrel hair
¾″, 1″, 1½″ single stroke synthetics
1″ Skyscraper synthetic
old ⅛″ single stroke synthetic
¼″, ⅝″ single stroke red sables
#3, #5 round red sables

PALETTE

Acrylic: Acra violet, cadmium orange, yellow oxide, burnt sienna, burnt umber, cadmium red light, phthalo blue, cerulean blue
Gouache: raw sienna, cadmium red extra pale, burnt umber, Prussian blue, alizarin crimson, cerulean blue, permanent white
Watercolor: raw sienna, cadmium orange, alizarin crimson, ultramarine blue, cadmium red light

(right) Figure 1. 5″ x 9″ (13 x 23 cm). Here's one of the line studies I made on the spot. It's the area that holds the most interest for me; actually it's the space between the two buildings rather than the buildings themselves. The arching branch covered with snow serves as a connecting link across this space. Contrasting textures and hard shadows cast by brilliant sunlight are beginning to be emphasized.

(below) Figure 2. 6″ x 11¾″ (15 x 30 cm). This is the final watercolor study I made and the one I used for reference. This is the proportion I felt was right for the final painting. I've eliminated some unnecessary details, weighted the composition to the left, enhanced the shadows cast by the roof and the vigas, and developed some of the dense brushy feeling of the cottonwood branches that will contrast with the smooth adobe walls.

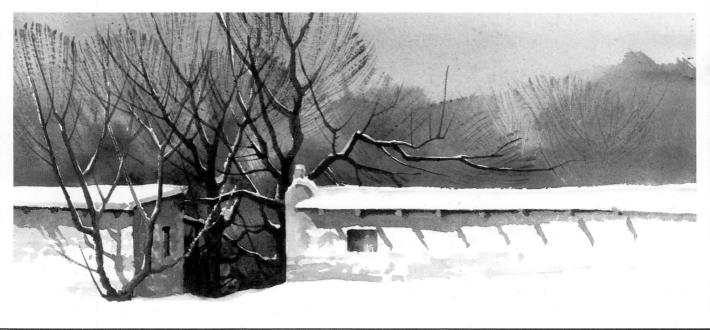

(left) Step 1. Referring to my watercolor study, I lightly sketch in the outline of the buildings with a 2H pencil. Using an old brush, I paint in masking fluid along the upper edge of the buildings delicately outlining the edges of the two buildings. When this dries, I saturate the area above the mask with clear water using a squirrel hair brush. With a 1½″ (4.8 cm) single stroke synthetic, I wash on an intense but transparent mixure of yellow oxide and cadmium orange acrylic. A mixture of Acra violet and phthalo blue is washed over areas of this warm tone, and an even richer mixture of these two colors is used for the background tree shapes. Touches of burnt sienna are added to give an interesting interplay of color. This is allowed to dry.

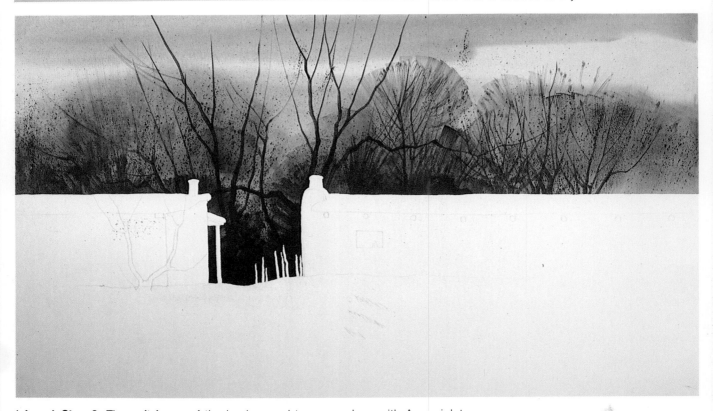

(above) Step 2. The soft forms of the background trees are done with Acra violet acrylic and a ¾″ (1.9 cm) single stroke synthetic. When this area is dry, I cover the lower part of the painting with newsprint and apply directional spatter with a mixture of burnt sienna and burnt umber acrylic, using the same brush. With a #5 round synthetic, I draw in the linear branch forms using burnt sienna and burnt umber acrylic. I enrich the dark area between the buildings and paint in more branches. When this is entirely dry, I gently rub off the masking fluid, leaving the crisp, clean edges of the two buildings and the fence.

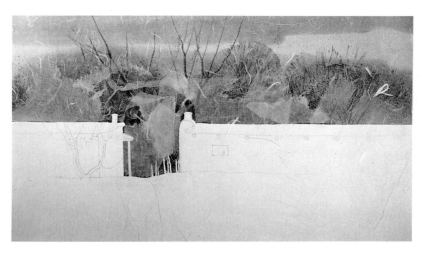

(right) Step 3. I wash water over the whole board using a 1½″ (4.8 cm) single stroke synthetic, then I cover the board with an equal quantity of acrylic matte medium, mixing the medium and the water on the board. I lay the rice paper over the entire board, beginning at the bottom. Air bubbles are pressed out with the brush loaded with medium. When this dries, I tear cheesecloth into irregular stringy pieces about 6″ (15 cm) square and place them along the upper edge of the buildings. Where I need straight edges, I trim the cloth with scissors. These pieces are then laminated to the board by pressing them down with the brush and more matte medium. I let the board dry thoroughly.

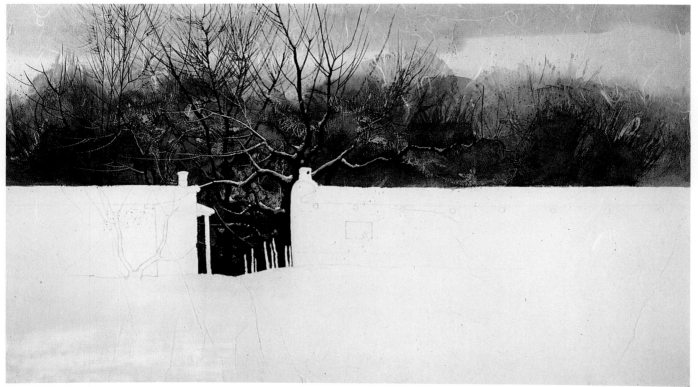

(above) Step 4. I rewet the area above and around the buildings, saturating it with Acra violet and burnt sienna acrylic but leaving some areas untouched. Adding ultramarine blue to the mixture, I build up a very dark area on the cheesecloth behind the buildings by very carefully painting around the buildings and the fences with the tip of a 1″ (2.5 cm) single stroke synthetic. When this dries, I change to gouache; and using a 1″ (2.5 cm) Skyscraper synthetic brush, I scumble opaque lighter tones of raw sienna mixed with cadmium red extra pale over the dark cheesecloth. Referring to my sketch, I paint in the cottonwoods using a #5 round sable and a mixture of burnt umber, Prussian blue, and alizarin crimson gouache. After rinsing the #5 brush, I paint the snow along some of the branches with cerulean blue gouache, gradually lightening it with permanent white gouache. To emphasize the collage texture and add sparkle, I mix raw sienna, cadmium orange, and some permanent white gouache, and using a ¼″ (.64 cm) single stroke sable, I drag it across a few areas in the background.

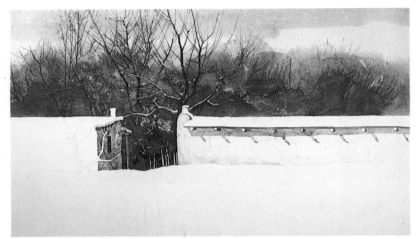

(left) **Step 5.** Before applying any more paint, I touch the ends of the vigas with masking fluid. With a ⅝'' (1.6 cm) single stroke sable and a mixture of raw sienna and cadmium orange watercolor, I lightly wash in the chimney top and corner of the roof of the right-hand building. With a 2'' (5 cm) squirrel hair brush, I wash the same pale tone over the rest of the building, leaving some white areas. After this dries, I paint the shadows under the eaves, on the chimney, and around the vigas with a violet mixture made with alizarin crimson and ultramarine blue watercolor. The shadowed side of the left-hand building is first washed with raw sienna watercolor using a ⅝'' single stroke sable. Then, while the wash is still wet, a mixture of burnt sienna and cadmium red light watercolor is dotted in and allowed to bleed. When dry, a violet tone is washed on, allowing some of the acrylic undercolors to show through. When nearly dry, a dark mixture of alizarin crimson and ultramarine blue is used for the window and eaves line. Snow on the porch roof is painted with cerulean blue watercolor.

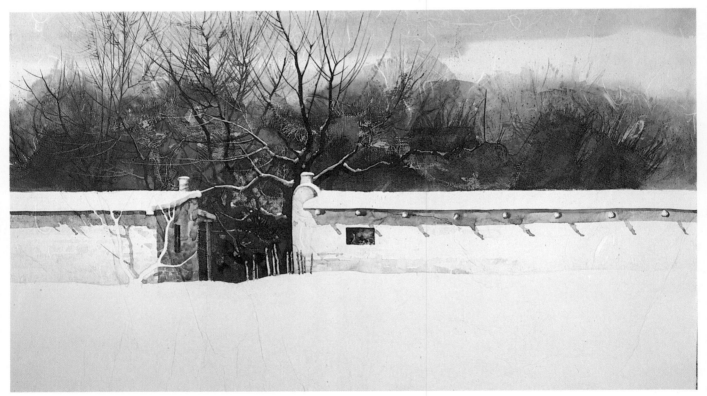

(above) **Step 6.** The window of the right-hand building is touched first with cadmium red light watercolor using a ¼'' (.64 cm) single stroke sable. When dry, a thin wash of ultramarine blue and alizarin crimson watercolor is first floated over and around the red shapes, then deeper violet tones are washed in. This treatment suggests reflections and avoids a rigid, one-value treatment of the window. A wash of raw sienna and cadmium orange is painted over the left wall and around the tree form, using a ⅝'' (1.6 cm) single stroke sable. The shadow under the eaves and behind the tree is done with a violet watercolor wash.

Taos Adobes. Collage: acrylic, watercolor, and gouache, 15½″ x 27½″ (39 x 69 cm). Collection of Jim and Ruth Brennend.

The tree to the left is painted dark over the light background areas, and light over the dark background areas. I start painting the branches with a mixture of raw sienna and burnt sienna watercolor using a #5 round sable. Some of the branches are untouched. I deepen the color in the shaded side of the building so that the branches appear light. Where the light-colored branches reach across the window and above the roofline and over the rough cheesecloth, I switch to gouache, using permanent white and raw sienna. The spindly fence is done with a mixture of raw sienna and burnt sienna watercolor and a #5 round sable. The fence wire is painted in an irregular way using a #3 round sable and ultramarine blue mixed with burnt sienna watercolor. As a final touch, I wash on a very light wash of cerulean blue watercolor with the 2″ (5 cm) squirrel hair brush to reduce the brilliance and bring out the texture of the rice paper in the foreground. The patterns of the bricks are touched in with a mixture of raw sienna and burnt sienna watercolor, using the #5 round sable.

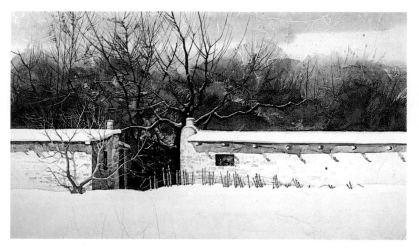

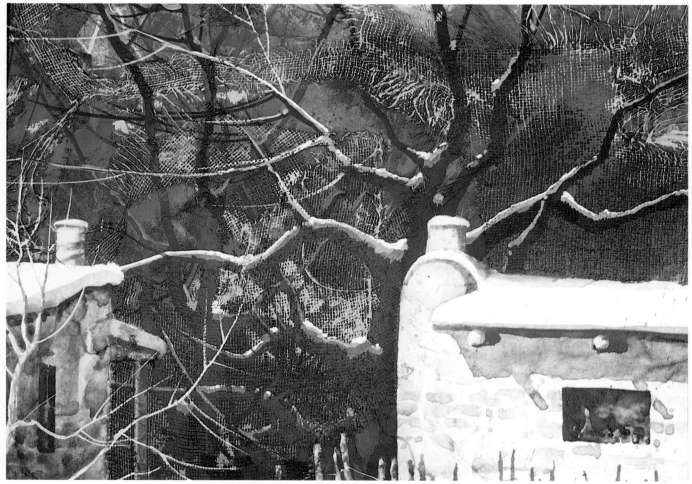

Detail. This detail brings into sharp focus the contrasts in texture and paint quality I wanted in this painting. Note how the brilliant red-violet acrylic glows softly through the rice paper overlayer, and see the texture possible by scumbling light, opaque gouache over the very dark cheesecloth. The dark, textured cottonwoods contrast with the soft smooth transparent watercolor I use for the adobe wall. The shaded side of the left-hand building is glazed with transparent tones of violet and sienna watercolor, providing additional contrast with the opaque gouache used for the small tree in the left foreground.

PART 4 WATER MEDIA WORKSHOP

The aim of the workshop section is to let you scrutinize fourteen of my finished paintings. Each painting has details taken from it, to help you see how the paint takes to the paper.

There is no development in the complexity of technique throughout this section. The selection of paintings covers quite a span of years in my own progression as a painter. It includes one or two of my earliest experiments at combining the water media, as well as some of my newest paintings, where I've discovered the fun of splashing color around, a direction that I'm very excited about.

There is nothing magic about the painting techniques used here; they are all quite simple. Start by going quickly through all the paintings and identifying the different media that make strong statements in each painting: you should be able to trace them back to the combined media exercises on pp. 32-39, at the beginning of the book. Aim at becoming a detective, so that you can discover instantly how these and other paintings have been worked. After a while, painting techniques will become easy to identify, and some of the "mysteries" of water media will seem quite ordinary. Try them and make them work for you—none of them is difficult.

Note: Because all students of water media have the same general concerns, I have included a list of the most frequently asked questions about the water media at the end of this section on page 140.

RIO GRANDE ASPEN, LATE LIGHT

Acrylic and casein on Crescent illustration board. 34″ x 26″ (86 x 66 cm). Collection of Sarah Purnell.

The idea for this painting came during a spring evening when I was driving up the Rio Grande canyon between South Fork and Creede. Some of the aspen were leafed out, others were not, and the late evening light hit the top of the mountain ridges, reflecting here and there on the water. The subtle color changes in the dark-shadowed canyon walls behind the brilliant aspen tree patterns were my challenge and inspiration. Throughout the entire painting, I tried to achieve this contrast and luminosity, not by using natural color, but rather by using color that would best express this feeling.

With the board in a vertical position, I began the painting by washing transparent cadmium orange acrylic onto the very wet surface, followed by a wash of transparent Acra violet acrylic, which fused into the orange. Although I had an idea for the composition, I let the interaction of the colors suggest the precise location of the mountain shapes, which I painted in using a dark violet opaque acrylic, followed by an opaque spatter for texture.

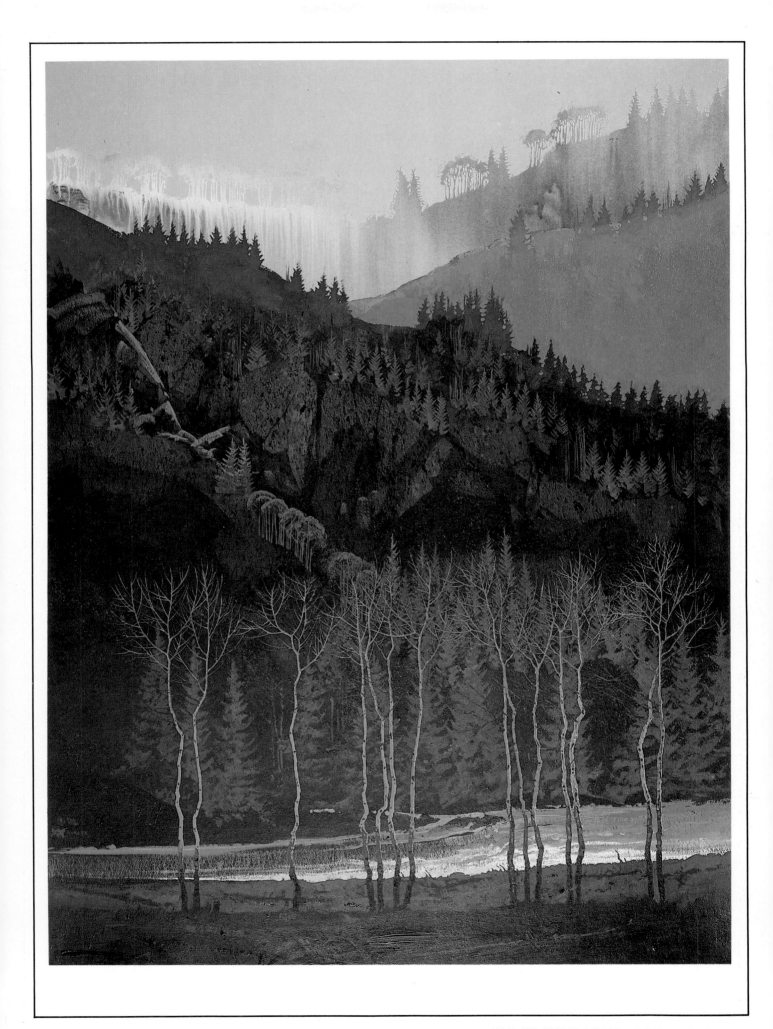

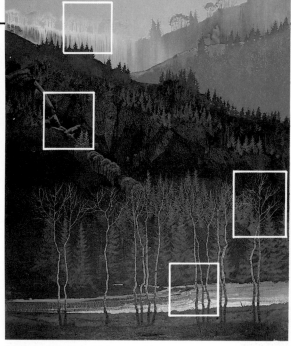

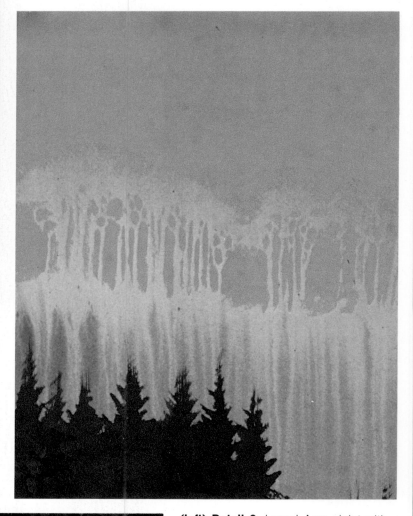

(right) Detail 1. Using a 1½'' (4.8 cm) single stroke synthetic, I applied a wash of transparent cadmium orange acrylic followed with Acra violet, with the board in a vertical position.

In a jar, I mixed Shiva violet, cobalt blue, and titanium white casein. When the first paint application was dry, I used this lavender mixture to paint the sky, creating the aspen trees by painting around them. I used #4 and #16 ''bright'' synthetics to apply the opaque casein.

Yellows and yellow-oranges and violets and blue-violets are complementary colors, and I selected them because I thought they would best convey the effect of evening light.

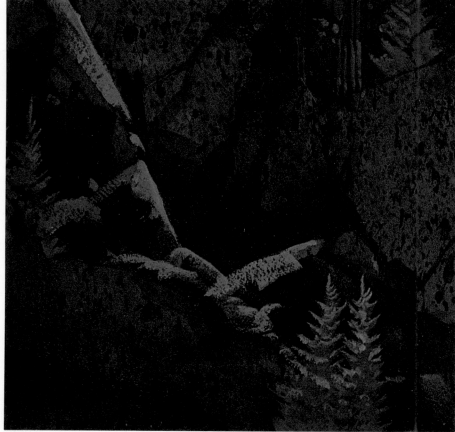

(left) Detail 2. I used Acra violet with some cobalt blue to make a transparent undertone. When this was dry, I spattered an opaque mixture of dioxazine violet and cobalt blue acrylic over the transparent wash. I used dark opaque violet and cobalt blue for the rock forms and opaque cobalt blue and permanent green to form the trees. The trees are painted light opaque over dark opaque. These colors seem to best express the shadowed rock area.

I used a variety of single stroke synthetic brushes for this passage, including the brush I used to make the controlled, opaque spatter needed to create the rock texture.

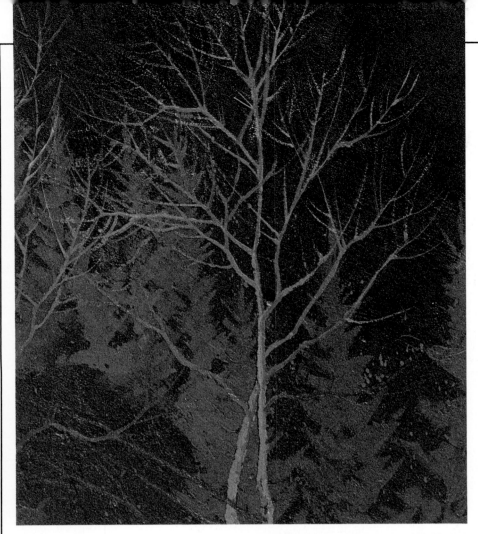

(left) Detail 3. For the shaded rocks, I began with a transparent light wash of Acra violet acrylic followed by dark opaque dioxazine purple. I used cobalt blue and permanent green light for the spruces, which I painted light over the dark passage. The aspen tree branches are painted with a mixture of titanium white and Acra violet or cadmium orange. I had to go over the branches three times with the light-colored opaque paint before I got adequate coverage. It would have been easier to do the branches using casein, but I wanted the brilliant acrylic color. It was worth the trouble, too.

(right) Detail 4. This passage was done entirely with opaque acrylic, working both dark to light and light to dark. The biggest challenge came in modeling the aspen trunks light against the dark background and dark against the light background. I selected the colors here to relate to the rest of the painting, rather than with an eye to naturalism. I used a larger single stroke synthetic to paint the mountain background and tree forms. Synthetic "bright" brushes were used to paint most of the water and the aspen trunks, and small round synthetics were used for the final details.

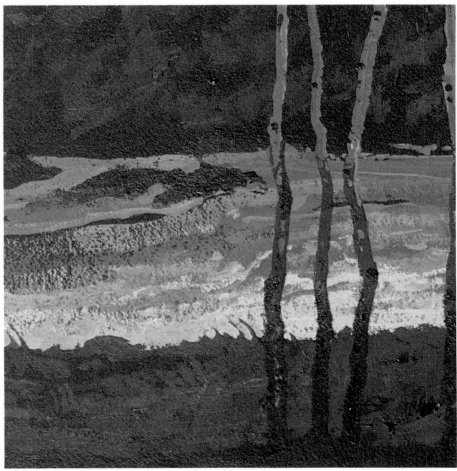

EARLY FROST

Acrylic and gouache on Fabriano watercolor board. 19″ x 25½″ (48 x 64.7 cm). Collection of Jerry and Joan Hix.

The title of this painting could be "Frozen Landscape" because the San Luis Valley looks like this when the thermometer goes below zero. You can be sure it wasn't painted on location; instead, it's done from memory after a bitter cold morning I spent pheasant hunting with a friend.

This painting is one of the first I ever did that used a wash of acrylic in a warm tone, followed immediately with a wet-in-wet wash of translucent and opaque gouache.

The combination of the brilliant transparent acrylic with the translucent and opaque gouache creates most exciting effects. I allowed the paint interaction to suggest the location of the butte and tree forms. Warmer and cooler tones of opaque gouache form the snow in the foreground. I especially like the area to the right that suggests trees, where I had mixed zinc white gouache with a little blue to a translucent mixture and dragged it across the underlying darker paint.

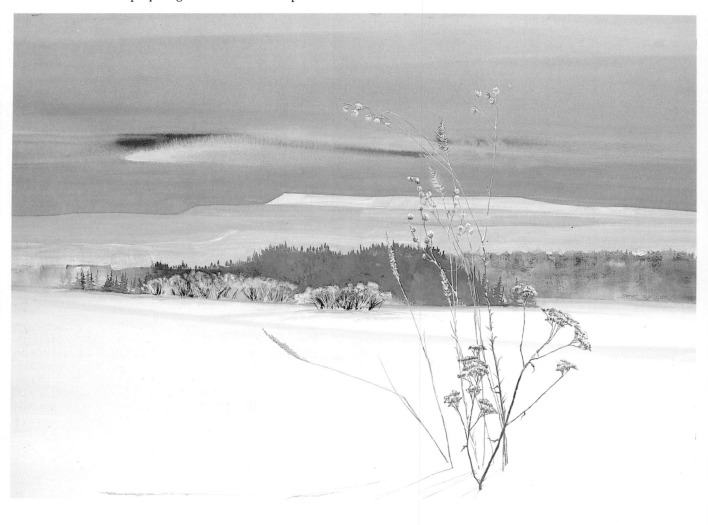

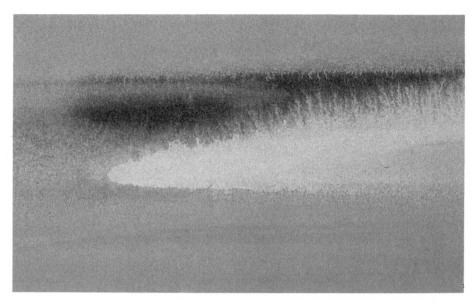

(right) Detail 1. I've selected this palette for its warm-cool relationship. Acrylic was used because of its brilliance and its insolubility when dry. This area was painted by applying a wet-in-wet transparent acrylic wash of cadmium orange and cadmium red medium, followed while still wet by a wash of translucent and opaque gouache in combinations of cerulean blue, alizarin crimson, burnt sienna, and zinc white. This area was painted light to dark, with the final wash made in gouache light over dark. The only brush used is a 1″ (2.5 cm) single stroke sable.

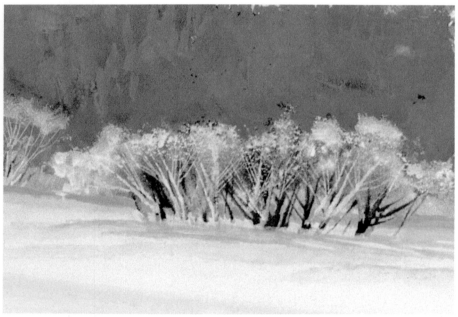

(left) Detail 2. This detail also has the light transparent undertone of cadmium orange mixed with cadmium red medium acrylic. Plateau forms suggesting spruces were painted opaque over the dry acrylic, using a dark value mixed of cerulean blue, alizarin crimson, and some zinc white gouache. I left untouched the area where the nearer scrub oak trees are to be. I applied cerulean blue and zinc white opaquely to form the snow and the shadow areas of the valley. With a round red sable brush and a razor blade, I formed the scrub oak trees, allowing some patches of transparent warm acrylic to show through. Finally, I splayed the bristles of a round sable and applied zinc white and a touch of cerulean blue for the frost on the branches.

(bottom, left) Detail 3. Here, the first warm transparent wash of acrylic was left to dry. I then made the background plateau form by lightly drybrushing a mixture of white and blue-violet gouache translucently over the acrylic. The valley snow and shadows were made using combinations of opaque white and blue gouache. An opaque mixture of blue-violet gouache was used for the darker tree forms. Finally, I used a small round sable brush to paint the weed in opaque gouache using warm sienna tones. Cerulean blue and white opaque touches were added for the frost.

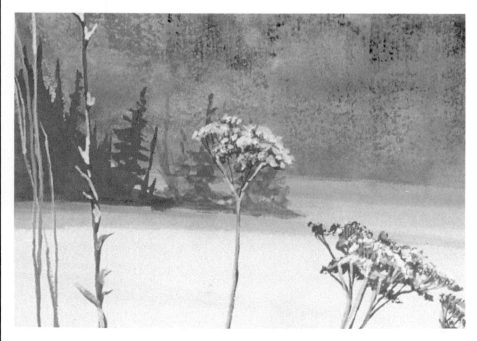

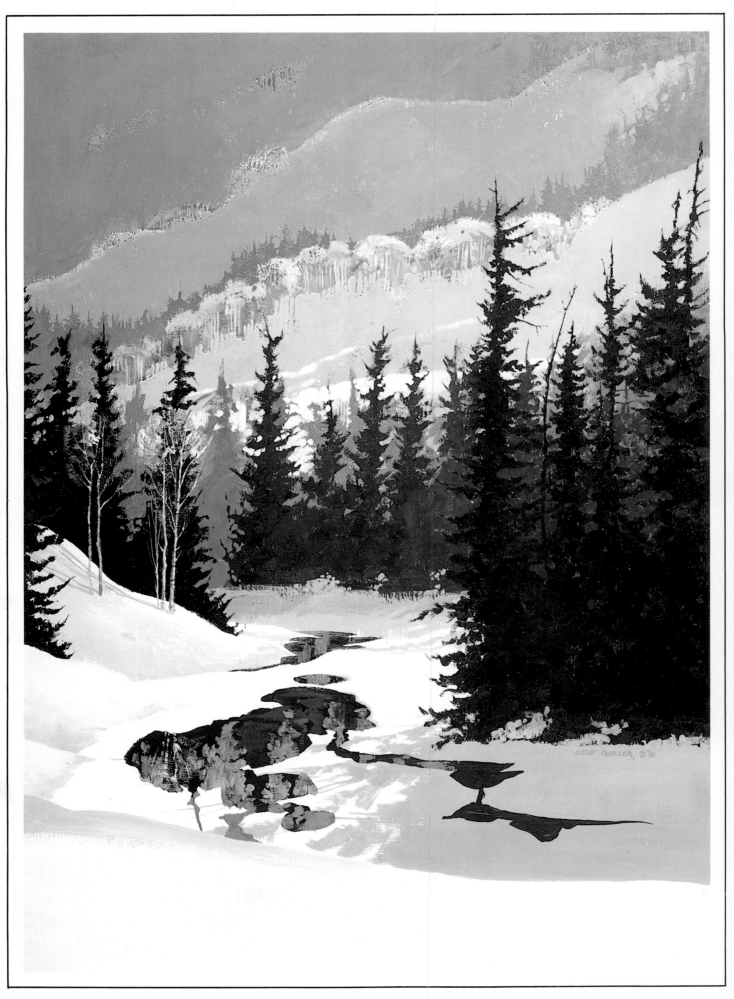

RIO GRANDE WINTER

Acrylic and casein on Crescent illustration board. 27″ x 21″ (68 x 53 cm). Collection of the artist.

The idea for this painting came when I was driving up the valley of the Rio Grande one evening in early spring. At that time of year, the ice is beginning to break up in the river, and I find myself intrigued by the abstract patterns created by ice, snow, and open water. This painting is the first of a series, and I'd like to do more, using abstract shapes and patterns, perhaps with only the faintest indication of nearby banks and trees.

I began by applying a warm tone of acrylic, a mixture of cadmium red light and titanium white, with a brayer to give a heavy opaque-textured underlayer. I used a coping saw blade to give different texture in selected areas. The rest of the painting is in opaque casein, and when I used a synthetic "bright" brush on its side, it gave a scumbled effect, which allowed the warm underlayer of acrylic to glow through in certain sections.

Detail. The underlayer of textured red-orange acrylic is in this detail, which influences the overpainting. Actually, this passage was the most exciting area of the painting to develop. First I painted the snow with white opaque casein, and when this dried I painted in the shadows with cerulean blue. The foreground bank was painted with a continuous contour. The water was painted with the same colors that are in the rest of the painting, more with an eye to pattern than to realism: I used Shiva green first, then added lighter tones of green, cerulean blue, and raw sienna. The touches of cadmium red extra pale were added as accents to draw the eye to this area. The paint here was applied in juicy strokes, and the reflections only make sense when the painting is seen as a whole.

WINTER STORM

Watercolor and gouache on Arches 300-lb. paper. 19″ x 24″ (48 x 61 cm). Collection of the artist.

This is one of the first paintings I did after returning from Oregon to live in the mountains. The theme of man and nature isn't new, but I had to express my feelings about isolation and winter storms in the mountains. This is also one of the first paintings I did that combines two of the water media.

The subtle colors of this painting result from mixing two intense complementary colors: alizarin crimson and phthalo green. It's interesting that these rather garish colors, when combined, can produce such soft tones. The entire painting was done with a variety of single stroke sable brushes.

I began by saturating the paper with clear water, then tilted it and applied wet-in-wet washes of alizarin crimson and phthalo green. While the paper was still wet, I loaded white gouache heavily onto a toothbrush and dragged my thumb over the bristles, spattering the opaque white. As I did this I held my breath and hoped for the best. The white gouache flowed as it willed, blurring into the areas of transparent color. While this surface was still wet, I mixed a deeper mixture of the two transparents and developed the left-hand ridge of trees. Another spatter of opaque white gouache was applied. Then I let the entire painting dry.

Later on, I mixed the two watercolors, and with controlled brush strokes, I formed the foreground thicket and the somewhat paler tree to the right. This tree might not seem important, but it's necessary to prevent the composition from "falling off" on that side. It also suggests that the soft diffuse background is really tree and mountain forms. White gouache was brushed on to give solidity to the snow in front of the thicket. The figure was painted with the two watercolors, using a bit more alizarin crimson in the mixture.

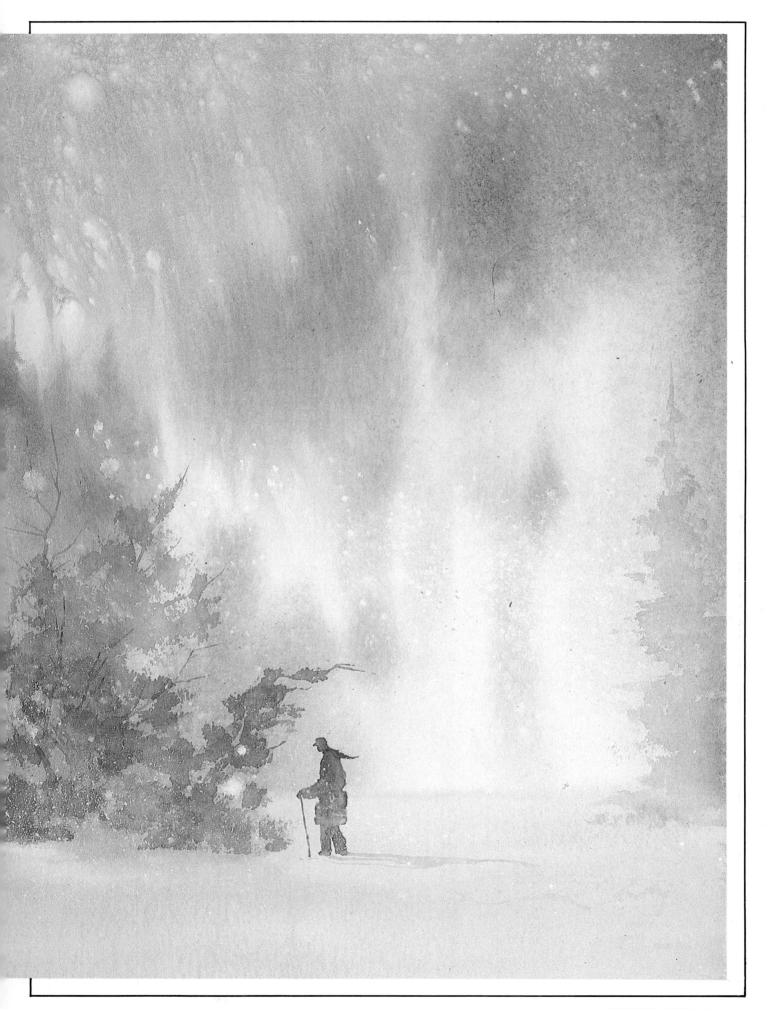

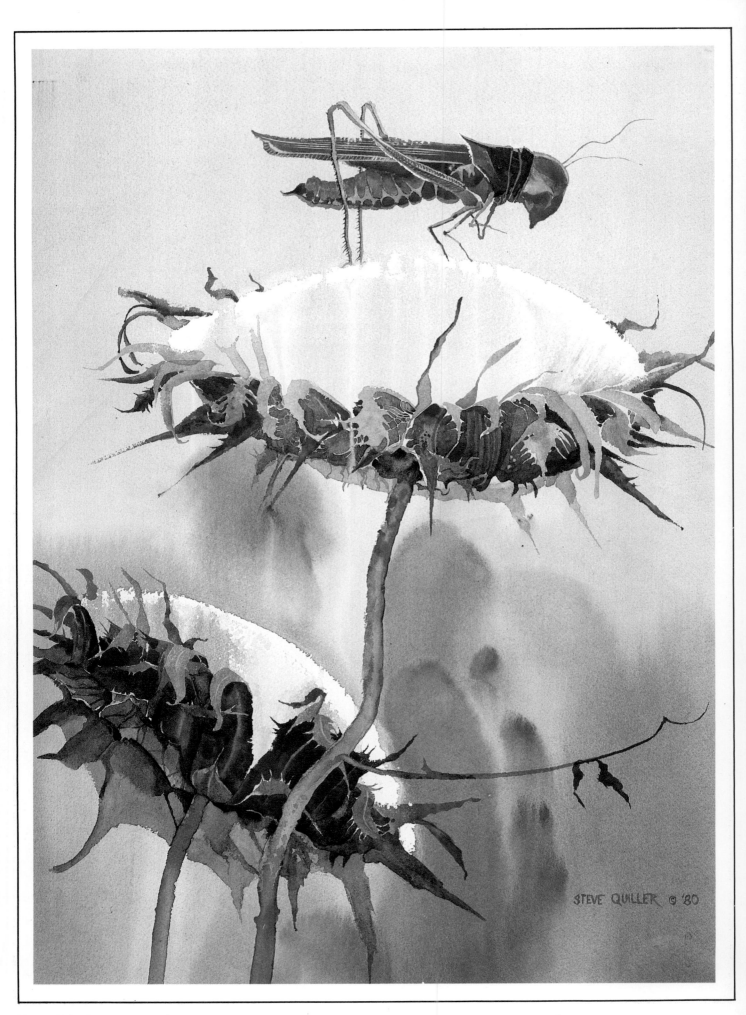

SEPTEMBER STILL LIFE

Watercolor and Acrylic on Arches 300-lb. watercolor paper. 25" x 19½" (63 x 49 cm). Collection of Frank and Dorothy Crockett.

Once I picked a Canadian thistle to add to my weed collection and discovered a live grasshopper on it. The contrast in texture and pattern immediately interested me, and I made a series of studies. I'd like to do more paintings with insect shapes, but this is the only one I've done so far. Of course, I had to sacrifice the grasshopper for this painting, but he's in a jar in the studio, ready for future use. Before I began this painting I tacked up a value study I had made of the grasshopper, using an oil wash on beige Stonehenge paper, with opaque white highlights. This was the first time I painted a thistle head enlarged to such a degree.

With the paper held vertically on the easel, I used a 2" Hake brush to apply a very wet wash of transparent watercolor, leaving untouched the areas where the thistle heads are to be. The shadow side of the thistle heads were brushed in using cerulean blue, followed by a loose application of raw sienna, burnt sienna, and cerulean blue. In a few places, this warmer wash broke through the first blue wash on the shadowed side, producing some interesting accidental effects.

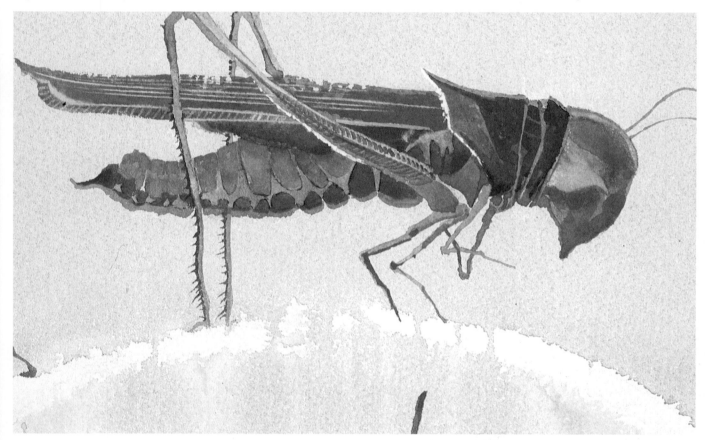

Detail 1. After the initial background wash of raw sienna was dry, I sketched in the grasshopper with a 2H pencil. I painted in the insect with a ¼" (.64 cm) single stroke sable, using predominantly burnt sienna and cadmium red light transparent watercolor.

When dry, I made a stencil using 1½" (4.8 cm) wide masking tape. I pressed it over a particular part of the insect, where I wanted brilliant color. Then right on the painting itself, I carefully cut out the areas I needed with an X-Acto blade. This is possible because the masking tape is actually translucent and I can see the drawing underneath the tape. With a clean damp toothbrush, I scrubbed off the paint, blotting it up with tissue, until the white paper was exposed. When this surface was dry, I lifted off the stencil and applied brilliant touches of cerulean blue, emerald green, and cadmium red light transparent acrylic with a small round synthetic. Because transparent watercolor lifts off easily, it's the natural medium to select for the stencil process.

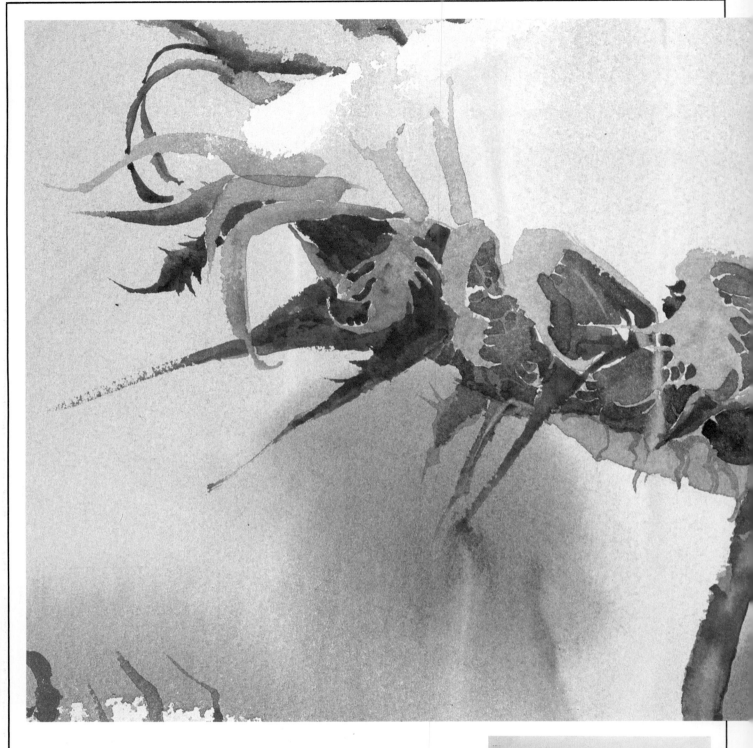

Detail 2. With the paper in a vertical position, I outlined the contour of the thistle with a light pencil. I saturated the paper, leaving only the upper edge of the thistle dry, using a 2″ (5 cm) squirrel hair brush. I then washed on cerulean blue watercolor on the underpart of the head, then applied a wash of raw sienna to the background. The raw sienna ran over the dry white paper and mingled with the cerulean blue here and there and gave some interesting effects.

When this dried, I taped the head of a thistle right beside me in order to have it handy for close reference as I painted. Slowly and deliberately, each area of the thistle was painted in with various colors of transparent watercolor, using a variety of single stroke sables, ranging from ¼″ (.64) to ¾″ (1.9 cm).

When the watercolor was dry, I cut three small circles out of masking tape and masked the lower-right side of the thistle. As before, I lifted off the color with a damp, clean toothbrush and tissue, exposing the white paper and removing the stencil when the surface was dry. Transparent green acrylic was painted into these small circles to give a little visual contrast, using small round synthetic brushes. Finally, a few accents of cadmium red light acrylic were added to the underside of the thistle for additional texture, color, and interest.

EVENING SUNFLOWERS

Watercolor and gouache on Crescent illustration board. 20″ x 26″ (51 x 66 cm). Collection of Earl and Marge Deacon.

When a painting wins a prize, or sells quickly, it's tempting to the artist to repeat it. That's why the American painter John Sloan was opposed to awarding prizes in exhibitions. When an artist repeats a painting with only slight variations, he stops growing, and the painting becomes a cliché. The subject of this painting is very popular with the public, but I paint it only once a year or so, when the theme recurs naturally, because I don't want it to become hackneyed. Evening light is a favorite subject of mine. There's a kind of magic to it, especially when there is moonlight, which is part of this painting, even though the moon is out of the picture.

First, I mixed a large quantity of transparent Prussian blue watercolor for a wash. My illustration board was on a slant and saturated with clear water. With a 2″ squirrel hair brush, I applied a graded wash, gradually lightening it as it fused downward. This first five minutes was critical. If the wash wasn't perfect, I would throw out the board and start over. The essence of the painting was contained in this first evenly graded transparent wash.

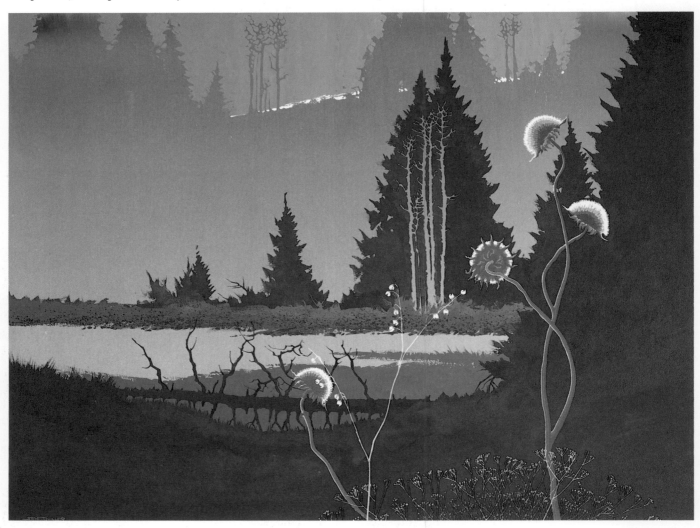

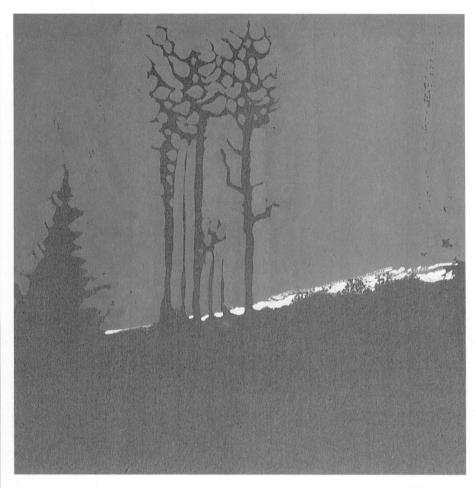

(left) Detail 1. This is an example of a unique visual effect I find very pleasing. First a transparent graded wash was applied, and when it was dry, a lighter mixture of opaque Prussian blue and zinc white gouache was used to paint around all the spruce and aspen forms, creating their forms by painting around them in the negative space. When this was dry, I painted a very light mixture of opaque gouache along the ridge, going around the forms. This further enhanced the effect of a moon shining out of the picture and added light and interest to this upper area.

(right) Detail 2. Here again the Prussian blue transparent watercolor provided the undertone. I mixed a middle value of opaque blue gouache and created the base for the middle-ground forms, and the same tone was used for the area below the open passage suggesting water. When this was dry, I covered everything but the base of the middle-ground forms and applied a darker shade of blue with a controlled spatter and other brush strokes to suggest rock forms. When dry, I used pure opaque Prussian blue gouache to paint the fallen snag and the spruce in the foreground.

The sunflower was done using opaque gouache working from dark to light. I began by using a round #5 sable and opaque burnt umber gouache. When dry, I applied burnt sienna over the burnt umber, leaving the dark brown showing only in the central and lower portion. Then a mixture of raw sienna and burnt sienna was applied, leaving the red brown showing only in the lower part. I used raw sienna next, gradually creating the illusion of three-dimensional form by adding more white to the color as I developed the shapes. All of this detail work was done with small, round sable brushes.

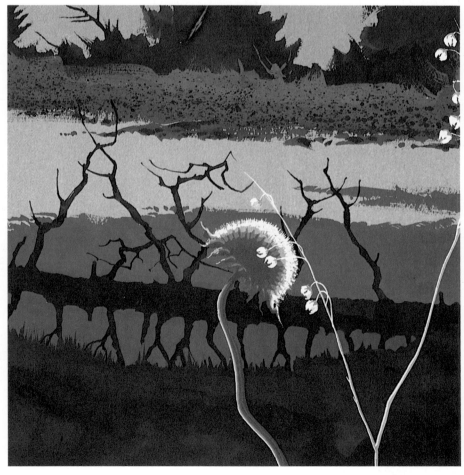

MILKWEEDS

Acrylic and casein on Crescent illustration board.
20½″ x 30″ (52 x 76 cm). Collection of
George and Maybelle Gilfillan.

One autumn, I stopped to collect a group of milkweed pods, and found myself admiring the soft shades of greens and browns as well as their delicate shapes and contours. So I decided to do a painting in pastel tones for a change. Because I wanted a warm underglow, I chose transparent acrylic in golden orange tones as a base. As I wanted a soft matte finish, I decided to use opaque casein for the rest of the painting. Because the palette is so different from what I generally use, it provided me with an entirely new experience. I worked in the background loosely in order to enhance the arrangement of the foreground milkweeds.

First, I washed transparent cadmium orange acrylic over the entire board. When this dried, I developed the soft pastel passages of the background, alternating tones of violet, gold, and green casein. I used large "bright" synthetic brushes and lots of thick pigment in an oil painting manner. While the marks of the brush show, the texture isn't intrusive, and it's in keeping with the overall soft tonality.

Between these juicy passages, I left occasional open areas to let the transparent acrylic show through. The lighter lavender color was a mixture of alizarin crimson, cobalt blue, and titanium white casein, and the bush forms on the horizon were done with a darker tone of the same color. I created the weed forms in the middle distance by painting around them into the negative spaces using lighter gold opaque casein, leaving the darker gold, transparent acrylic to shimmer through.

I painted the weeds directly from the group in front of me, in the natural light of the studio. I worked very slowly, constantly referring to the forms. The soft greens and golds are fairly accurate to the plant itself, but the lavender is not. I used it to relate to the rest of the painting.

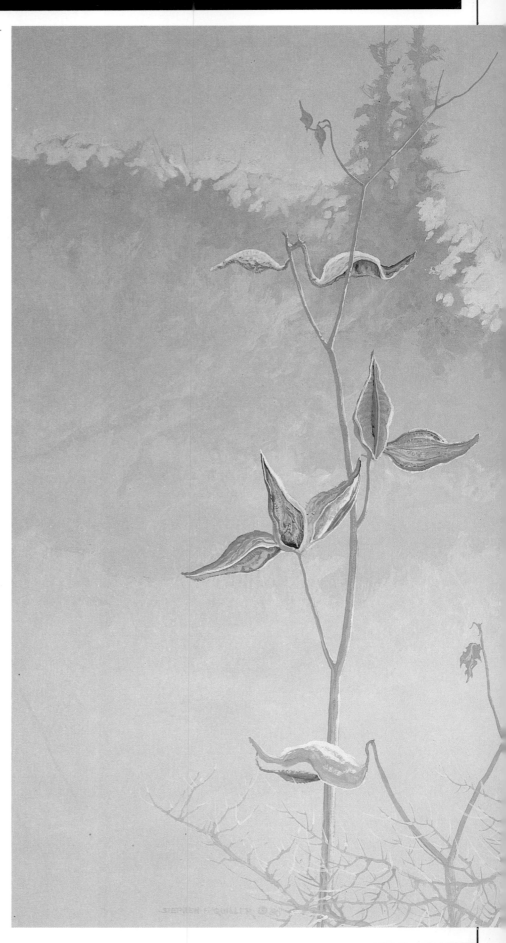

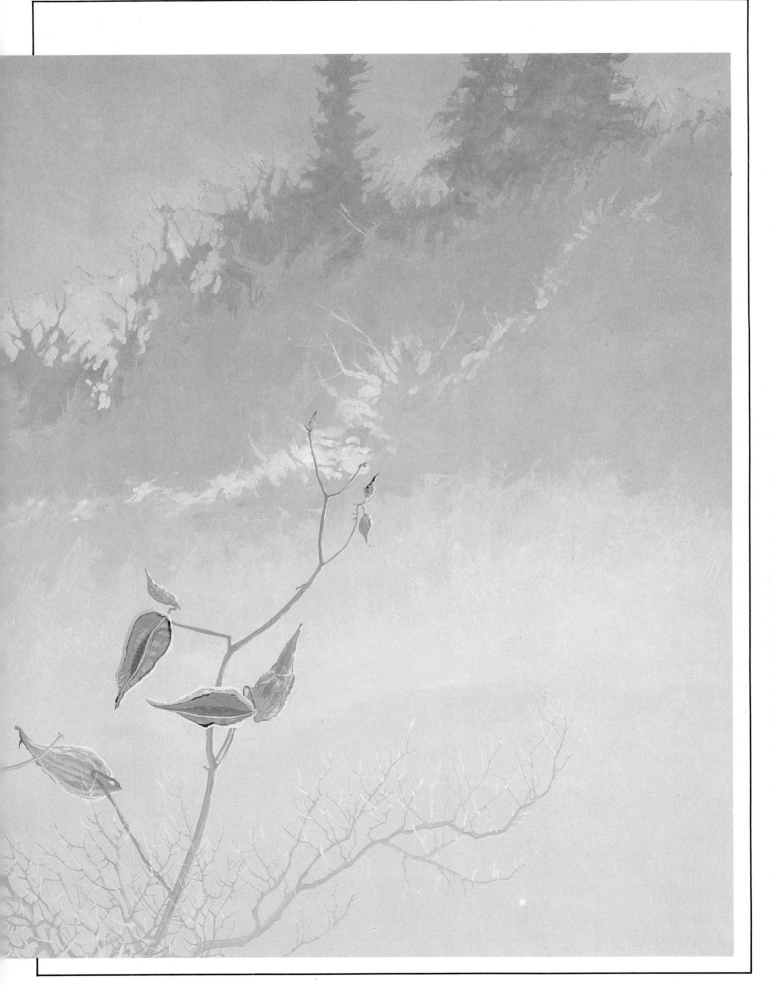

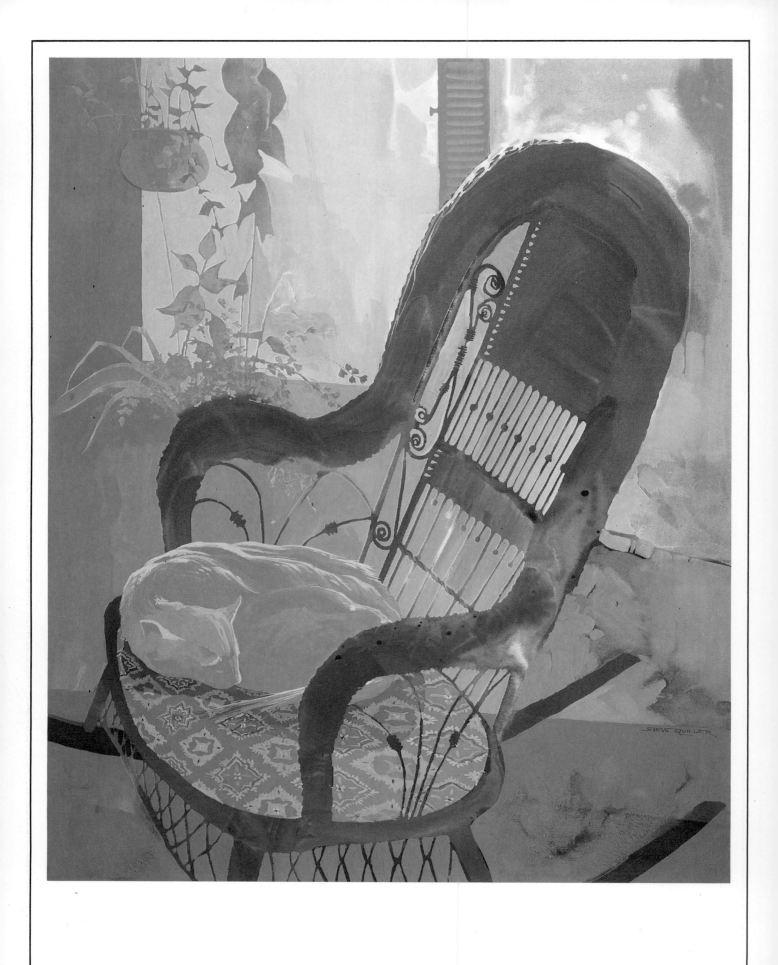

CAT AND WICKER ROCKER

Acrylic and casein on Crescent illustration board. 25″ x 20½″ (63 x 52 cm). Collection of Charlene Quiller.

This is one of the first paintings I made to explore the possibilities of combining the water media. It's also an exercise in defining forms by painting the negative spaces. While I work, I look directly at the rocker; there's no preliminary drawing on the board. The cat is an obliging model, and I frequently enjoy sketching her.

First, I washed warm tones of transparent acrylic over the entire surface of the board, working wet-in-wet, using a 2″ squirrel hair brush, and loosely suggesting the form of the chair. When this dried, I started developing the graceful curves of the rocker by painting the negative spaces with translucent and opaque casein. This painting was done in sections as the forms are complicated. The color is arbitrary and non-naturalistic in order to carry out the warm-cool color relationship I'm interested in.

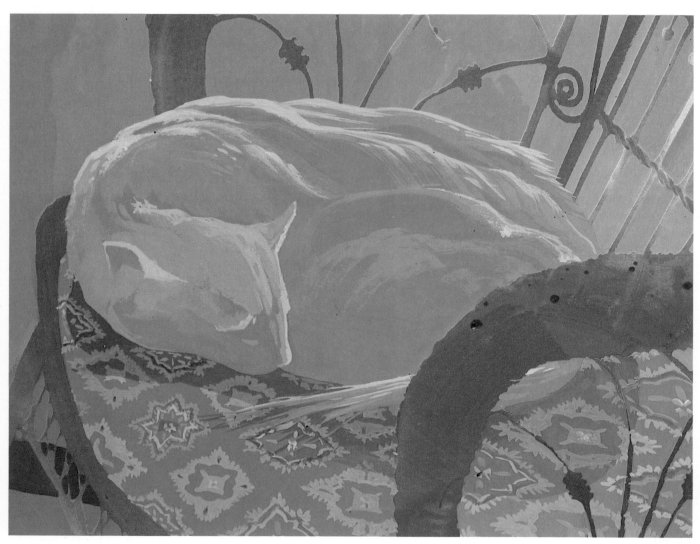

Detail. This area is worked from transparent to opaque. First I washed on transparent warm orange and brown tones of acrylic. Then, I painted mixtures of opaque blue-green casein, creating the wicker forms by painting around them. The chair seat and the cat were painted first in darker tones of blues and greens, using larger synthetic single stroke brushes. As I built up modeling and detail with lighter shades of green opaque paint, I used smaller, round synthetic brushes.

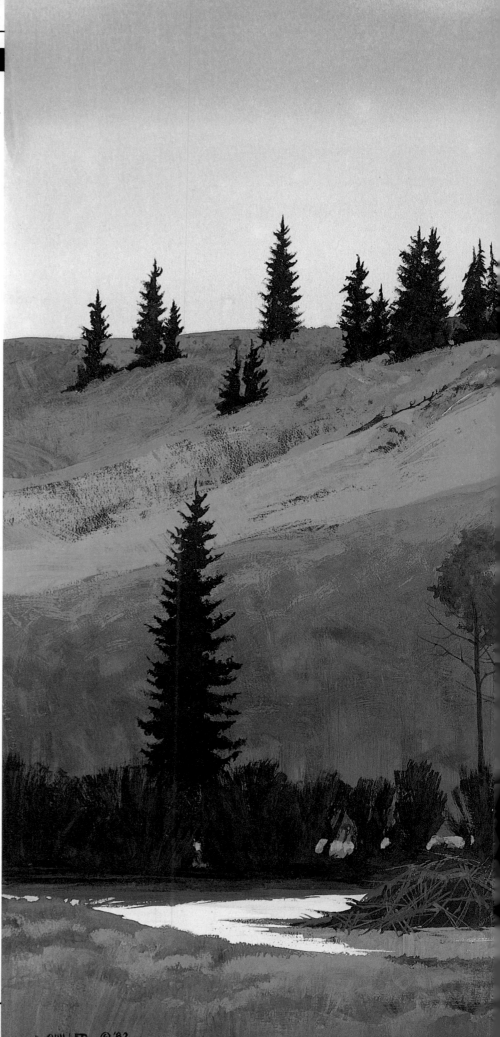

TWILIGHT ELK

Watercolor, gouache, and casein on Crescent illustration board. 24½″ x 24½″ x 30″ (62 x 76 cm). Collection of John Bruce and Carole Hennan.

Twilight is the time of day I most enjoy painting. I'd been observing a nearby beaver pond, and this painting progressed from a series of sketches. This is a summer evening, when there's little value change, but color can still be seen. The brown earth takes on a reddish cast, and greens are more intense in the rosy afterglow.

I wet the entire surface with a layer of zinc white gouache, followed immediately with washes of warm tones of watercolor applied with a 2″ squirrel hair brush. This created an effect quite unlike any other combination of media, and is just right for a luminous sky. The rest of the painting was done in opaque casein.

No matter how familiar a medium becomes, each painting offers a different challenge. There aren't any formulas, and I keep learning all the time because things never go as planned. Three-quarters of the way through this painting I was totally frustrated because the colors weren't working together right; but I kept struggling with it, making changes, and finally I felt good about the results.

S. QUILLER © '82

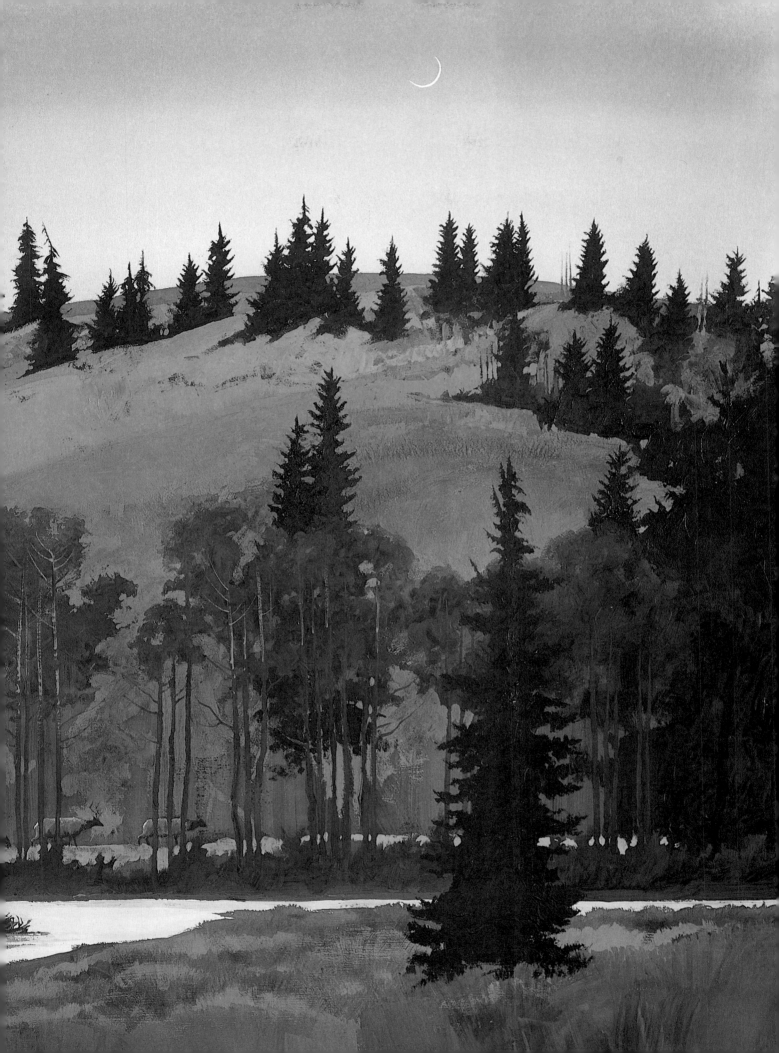

(below) Detail 1. When the underlying gouache and watercolor tone was dry, I painted this area with opaque alizarin crimson casein. When this was dry, I used various combinations of blue and green casein, brushed on with ''bright'' brushes to create the hill forms. I allowed some of the warm underpainting to show through. The lighter blue diagonals are pure cobalt blue, and the spruce were painted with a mixture of Shiva green and alizarin crimson. Later on in the course of the painting, some of the blue-green passages were lightly scumbled with a lighter tone of red, letting the green show through.

(below) Detail 2. It's easy to see in this detail the contrast between the translucent gouache mixture and the opaque dark casein. First, the white gouache was mixed with alizarin crimson and ultramarine blue watercolor and applied wet-in-wet to the surface in a translucent manner. When this application was dry, using synthetic ''bright'' brushes, I applied casein in various blues and greens in a juicy, opaque manner, giving subtle color changes to the area. I used a mixture of Shiva green and alizarin crimson to paint in the spruce trees with small ''bright'' synthetic brushes.

(left) Detail 3. Here's a good example of how casein can be used in a thick, oil paint kind of way. I first developed the foliage of the tree forms in various shades of green. I painted in the lighter blue around these tree and foiliage forms, to create the ridge directly behind them. A light mixture of mostly alizarin crimson was used to scumble across the top of the ridge, and some of this color was used to make pockets of color in the tree foliage. I mixed various shades of darker and lighter casein and developed tree trunks and branches with small "bright" and small round brushes.

(right) Detail 4. The foreground, background, meadow, trees, and pussywillows were done using opaque mixtures of blue and green casein. The water had been formed by the undertone of translucent gouache and watercolor, but I didn't like the way it related to the surrounding area, so I painted it over with the same color of opaque casein. I painted the beaver house using opaque casein, working from dark to light, and using single stroke synthetics for the broader areas and smaller round synthetics for details. At the very last, I painted the elk in between the trees, keeping the warm opaque casein colors very low in key so they would not be too obvious, but would blend in with the rest of the composition.

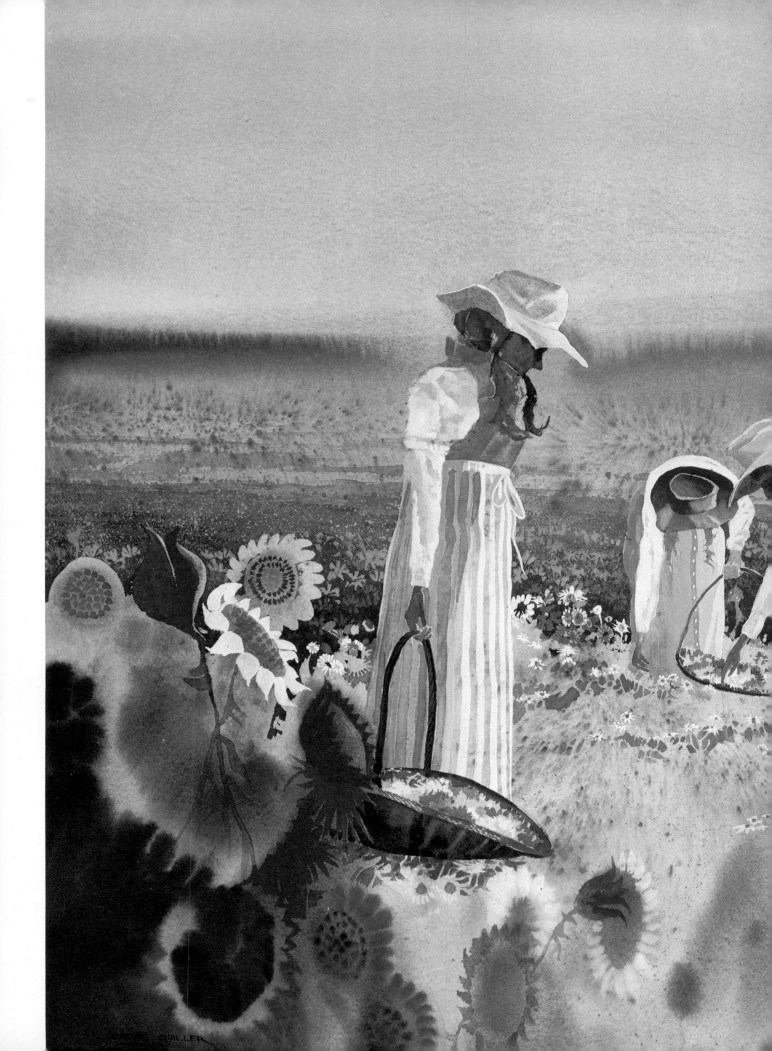

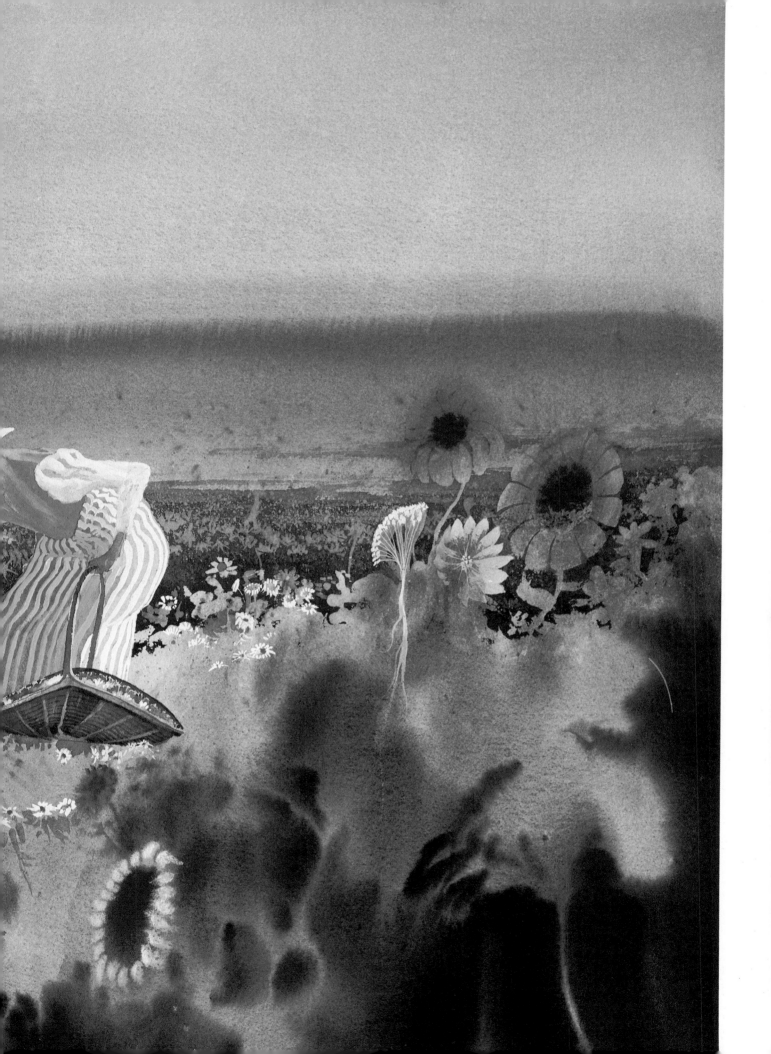

FLOWER GIRL FANTASY

Watercolor and gouache on Arches 300-lb. watercolor paper. 21½″ x 29½″ (54 x 75 cm). Collection of Charlene Quiller.

At one time I lived in a flower-growing area of California, one of the largest such areas in the country. In the spring, the fields became a random pattern of brilliant colors. Crews of people wearing big hats and bee veils would be working—pollinating, weeding, or collecting seeds. Years later, after I had moved back to Colorado, this theme haunted me, and I made a series of paintings based on it.

For this painting, my wife, Charlene, posed for me, dressed in a costume borrowed from our local theater. I made a series of sketches of her posed in different positions. Three of these poses were used in this painting, and the flower theme was developed around them.

This painting is one of my early experiments combining watercolor and gouache. At the time this painting was completed, I was very excited and pleased with it. It was a new direction for me, and one of my better pieces. But now I can look at it and see some areas I'd like to improve. Mostly because I don't think the figures work as well as they should with the rest of the composition. They seem just a bit "cut out," and some blending and the use of soft as well as hard edges in their forms would help the painting.

(above) Detail 1. This detail combines the use of transparent watercolor, masking fluid, and opaque gouache. First, I washed pale yellow-orange transparent watercolor over the wet surface. When this dried, I masked out the figures and some of the flower forms with masking fluid. A somewhat darker orange wash was then applied, and when this dried, I painted in small flower patterns with the masking fluid. This process was repeated, using a darker wash, more mask and another, even darker wash. When dry, the masking fluid was carefully removed leaving the open area for the figures and the patterns of the background flowers. I built up the figures using transparent watercolor, and when dry, I applied various shades of translucent and opaque cerulean blue and permanent white gouache to develop the hat, blouse, and skirts using a small, round sable brush.

(left) Detail 2. These flower forms were shaped by using masking fluid, the batik approach, and some white gouache. I applied a transparent yellow-orange watercolor wash; and when this was dry, I painted in the large foreground flowers with masking fluid. I then developed the flowers in the background using the same batik technique described in detail 1. When everything was dry, I removed the mask carefully, so as not to smudge the color. I developed the pattern in the flower head and the petals with transparent watercolor and used permanent white gouache to form some of the petals in a controlled, opaque manner.

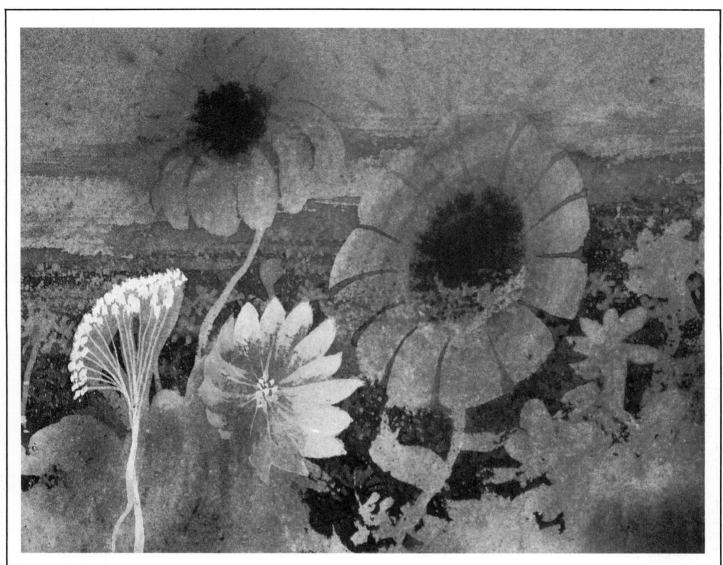

(above) Detail 3. This area of the painting is done in exactly the same way as detail 2, using alternate applications of masking fluid and gradually darkening watercolor washes. The size and complexity of these flower forms balance those on the left side; I made them in a great variety of shapes to add interest to the composition.

(right) Detail 4. All of these flowers were painted using wet-in-wet transparent watercolor, and were done at the very beginning of the painting. First, I applied a yellow-orange transparent wash, followed with transparent applications of orange, red-orange, and deep red. I used a variety of sable brushes, using a large flat wash brush first, progressing to medium and small round sables as the work became more detailed.

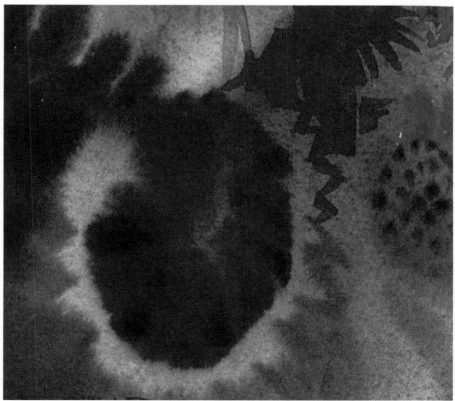

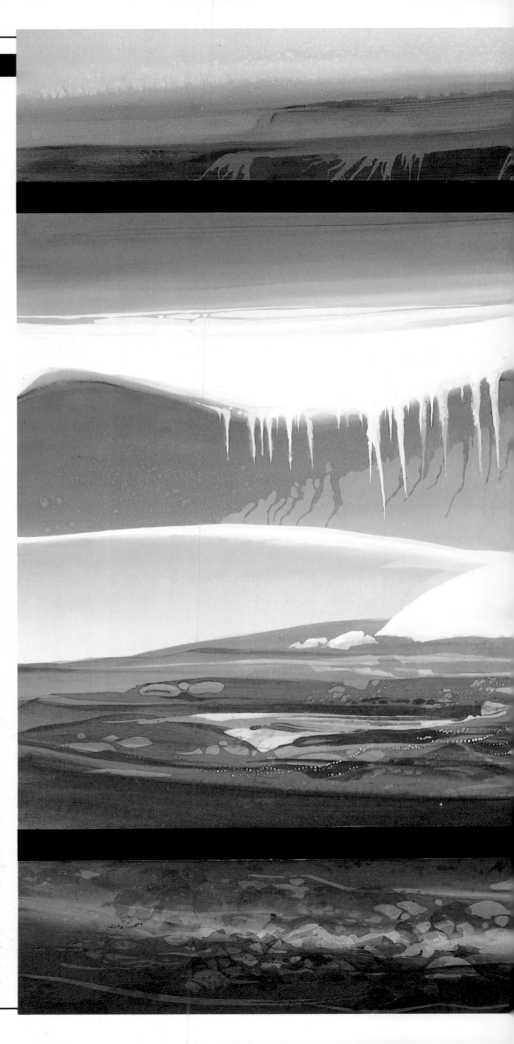

ICE FLOW TRIPTYCH

Acrylic and gouache on Crescent illustration
board. 30¾″ x 40″ (78 x 101 cm).
Collection of the artist.

For the past several years, I've been
working on ice flow themes, explor-
ing the possibilities in both hori-
zontal and vertical formats.
Recently, I thought it would be a
challenge to do some in two or
three sections, not to merely paint a
continuous scene that was broken
up, but rather to use related mate-
rial in each section, and still have it
work together compositionally.

I began this triptych by using an
idea that had worked for me before,
expanding it and elongating it as the
subject for the central section. I
planned to show hanging ice and
snow in the upper part, and the
lower part would be a snow bank
essential to the composition.

First, I made a pencil sketch of all
three sections. As I worked, the up-
per panel changed into related ice
forms that were low in key and
moved the eye from right to left and
then down toward the ice forms in
the central panel. The lower panel
changed from a snowbank into re-
lated water and rock forms. It also
would be low in key, but would
have a lighter value sweeping up on
both sides, moving the eye toward
the central panel. Once I got these
ideas resolved compositionally, I
began work on the painting.

Starting with the central panel,
I washed on transparent acrylic in
light blue tones. When this was
dry, I applied masking fluid in sec-
tions of the water, and also in some
areas of the upper part, beginning
the process that I call the "batik ap-
proach." When the mask was dry, I
washed on a darker blue. When this
paint was dry, I applied more mask-
ing fluid, allowing it to dry, and ap-
plying another darker wash. After
repeating this process once more, I
let the paint dry thoroughly and
gently rubbed off the masking fluid,
exposing the patterns that result.
The white of the snow and the
icicles were painted with trans-
lucent and opaque gouache with
the merest hint of cadmium red
added to the white.

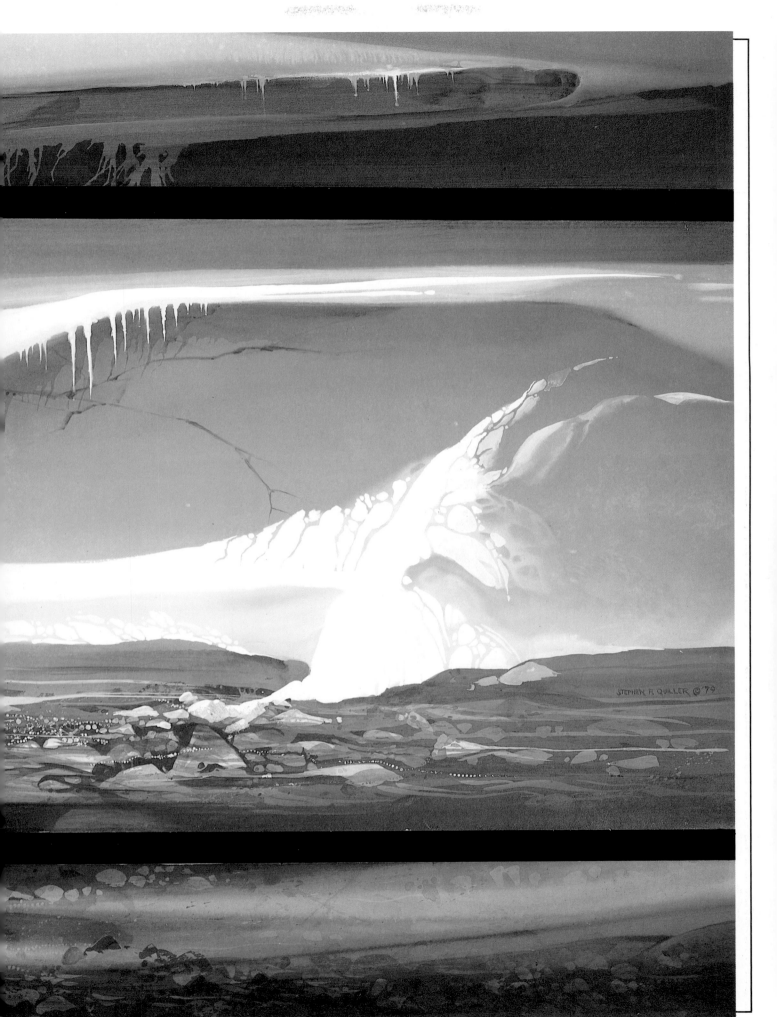

RAIN FOREST

Acrylic and watercolor on Arches 300-lb. watercolor paper. 21½″ x 29½″ (54 x 75 cm). Collection of Charlene Quiller.

This painting is one of a series I've done inspired by the rain forest along the Oregon coast. I kept this one for my own collection because I like the color, and the patterning, and the contrast of hard edges with disappearing shapes, like the figure to the left. At first you don't really notice this figure, but it's a key element in the composition. The figure is based on sketches I've made of the many older women in heavy coats and scarves who frequent the rainy beaches.

I began the painting by wetting the tilted paper with a 2″ squirrel hair brush, then applied a wash of subtle acrylic colors, done very loosely, leaving untouched some selected areas. I chose acrylic for the first wash because, once dry, I could paint over it many times, wet-in-wet, without disturbing it. This gave me more than one opportunity to work a given passage. After the acrylic wash dried, the remainder of the painting was completed using transparent watercolor. The crisp, negative white shapes that create the fernlike plants were not masked out first; instead, I painted around the shapes very carefully.

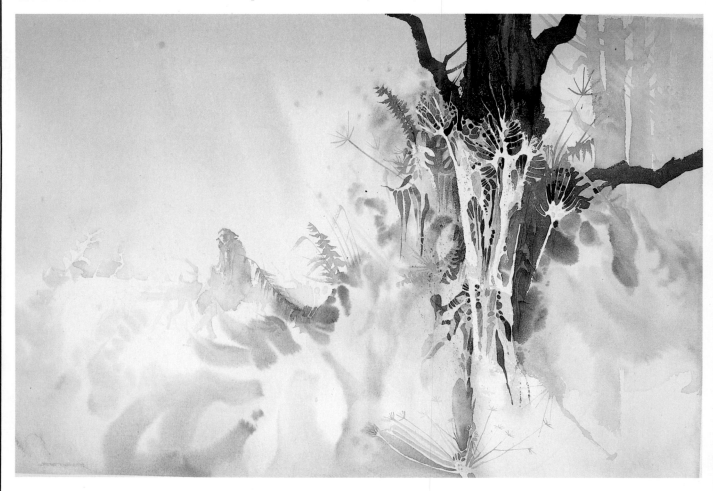

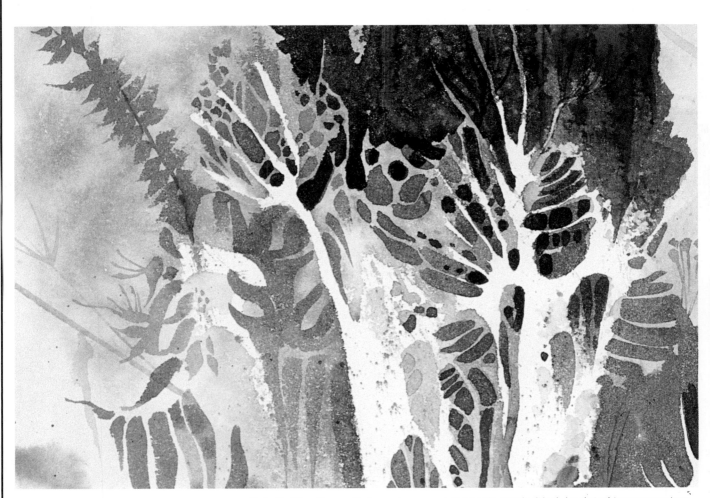

Detail. After the preliminary transparent acrylic wash dried, I painted transparent watercolor in greens and browns around the white forms to suggest leaves and plants, using a ¾″ (1.9 cm) single stroke sable and smaller brushes for more intricate shapes and darker details. I painted the darkest area—the tree trunk—last, using a mixture of burnt umber, raw sienna, and alizarin crimson, which I carried into certain areas behind the foliage shapes. To suggest texture in the trunk, I used a palette knife like a squeegee.

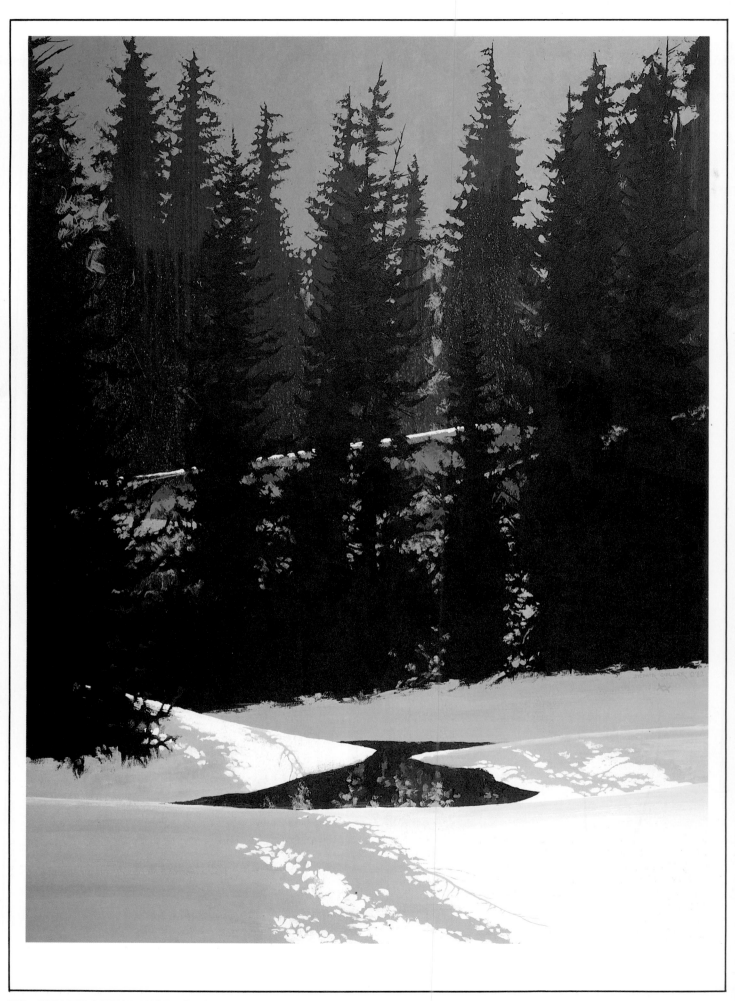

EARLY SPRING, SAN JUANS

Acrylic casein on Crescent illustration board. 34″ x 26″ (86 x 66 cm). Collection of the artist.

It's always exciting when you break out of what you've been doing and begin something entirely new. That's the case with this painting, the technique of which was inspired by looking at nineteenth-century American paintings. Many of these paintings have an underlayer of warm color that shows through in areas. I began this painting with a general composition in mind, but I wanted the warm underpainting to be the deciding element.

The board was held vertical on the easel, and, using a big brush, I applied large washes of transparent acrylic in warm shades, using a mixture of cadmium red, Acra violet, and some burnt sienna. These colors became the majestic, somewhat fantasylike trees in the background. While this initial wash was still wet, I came in with some transparent Hooker's green and burnt sienna acrylic in selected areas and let it fuse downward. This paint ap-

plication provided a maze of warm colors that I allowed to dry.

Next, I applied an opaque acrylic spatter of orange, brown, and blue in the middle area. The sky was painted with casein, and the nearly black tree forms in the middle distance were done in opaque acrylic. Visualizing what I saw through these tree forms, I used casein in opaque blues, golds, and siennas to suggest the forest floor, finally adding the dramatic white stroke.

Detail 1. Here's an example of how I make snow shadows. First, I cover the area with a tone of cerulean blue casein, using a large, single stroke synthetic. When this was dry, I used a small, single stroke synthetic and opaque white casein to form the intricate pockets that are the sunlit areas of snow between the shadow forms.

Detail 2. This detail shows the various paint applications used for the upper tree areas. First, I washed on warm shades of transparent acrylic; and while this was still wet, some transparent Hooker's green and phthalo blue were added. When this dried, I added opaque spatter in both warm and cool tones for a little texture. Light blue casein was painted over this transparent underlying color to form the background trees. I painted in the foreground spruce using opaque phthalo blue and Hooker's green acrylic. When this layer dried, I painted the ridge behind the dark spruce trees, using casein in both warm and cool tones, finishing the passage with a highlight of pure titanium white.

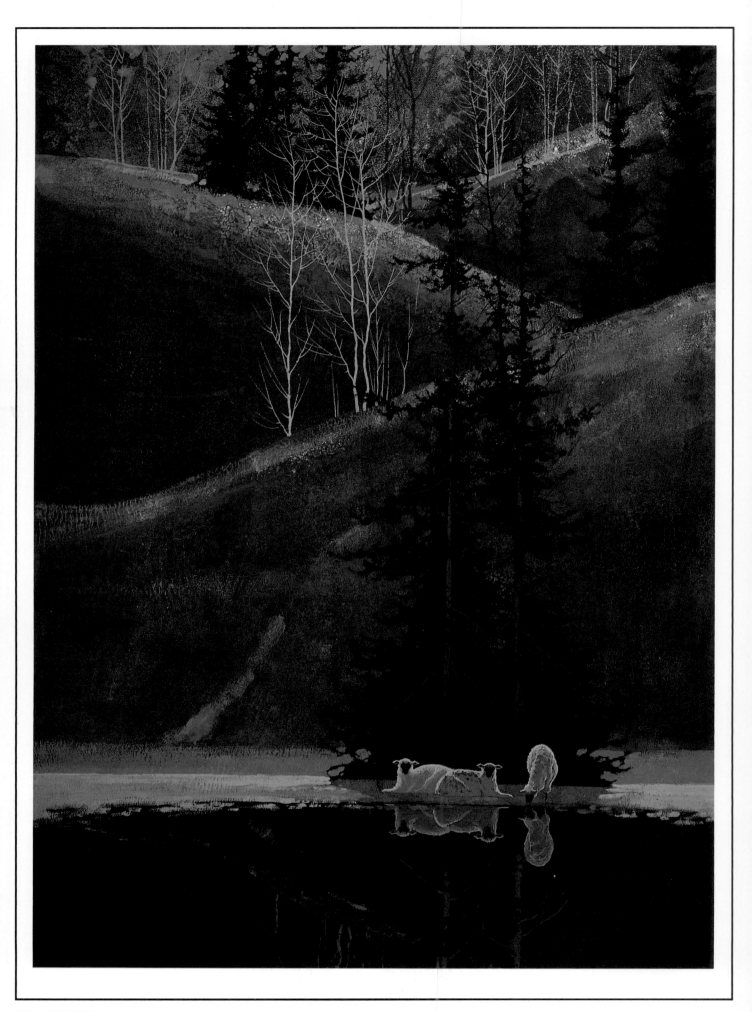

AUTUMN REFLECTIONS

Acrylic and casein on Crescent illustration board. 30″ x 21½″ (76 x 54 cm). Collection of Jerry and Joan Hix.

Although this painting has a group of sheep in it, and I've been working with images of sheep for the past several years, what really interested me in this painting was the texture that the mountains have when the leaves are gone. During the Indian summer days of October and November, the landscape takes on a beautiful warm glow.

Using a brayer, I applied a thick coat of titanium white acrylic all over the illustration board, producing different interesting textures. Here and there I made strokes with a coping saw blade for greater variety. After this dried overnight, I put the board up on the easel and stroked on warm transparent washes of casein, letting the pigment run down over the rough texture and settle in here and there. Every painting is experimental and unpredictable, and I let the result of this first application of paint determine the actual composition. In this way, although I have a general idea in mind, I can make use of the areas of greatest visual excitement.

Detail. I applied thick white acrylic paint with a brayer for texture. When this was dry, transparent glazes of warm sienna tones were applied with a large, synthetic single stroke brush. The warm colors flowed down over the white textured underlàyer. When this layer was dry, I painted the ridges, leaving the upper part untouched. I then applied translucent and opaque tones of burnt sienna casein, gradually darkening the color by the addition of alizarin crimson and cobalt blue. When this dried, I put in a few opaque accents of cadmium red extra pale casein, using a #16 ''bright'' synthetic. The thin aspen trunks and branches were painted with a small, round synthetic brush and a mixture of titanium white and Shiva violet casein.

QUESTIONS AND ANSWERS ON WATER MEDIA

The following list of fifteen beginners' questions—and my answers—has been compiled over the years from my teaching experiences. I keep these questions in mind when I am introducing my workshops. So I'm including them here for your additional reference; some of them are bound to concern you, too.

1. *Q.* I'm a purist. Why use water media other than transparent watercolor?

A. Watercolor is beautiful, but it does have its limitations. The color becomes lighter when dry, and it is meant to be used transparently. You can always use transparent watercolor exclusively if the painting calls for it, but using the other water media in combination will give you a wider range of visual possibilities.

2. *Q.* Why mix the water media?

A. When combining two or more media, each medium can be used to its best advantage, and visual effects can be obtained that otherwise would be impossible.

3. *Q.* If I mix the media, can I enter my painting in watercolor shows?

A. There are still a few exhibitions limited to only transparent watercolor approaches. However, the majority of water media exhibitions will accept all approaches that use water media on a paper surface.

4. *Q.* My acrylic washes streak. What can be done to prevent this?

A. When using acrylic in transparent, translucent, and opaque wash techniques, work the brush and paint together thoroughly on the palette for an even consistency before applying the wash.

5. *Q.* I've worked only with watercolor and want to try some opaque techniques. What medium should I try first?

A. I recommend gouache. It handles the same as watercolor; you can use the same brushes. Start small and experiment.

6. *Q.* Which of the water media works best for outdoor sketching and painting?

A. Although all of the water media will work, gouache and watercolor can be carried about in an enclosed palette. The color will stay fresh and the paint tubes can be left at home. Also, you can wait until you get back home to clean out your brushes.

7. *Q.* How can you tell the difference between a finished gouache and a finished casein painting?

A. There are differences on the finished surface, but they are very subtle. The main difference is in the handling characteristics, which determines which medium is selected in preference to another for certain applications and approaches.

8. *Q.* Don't you have trouble coming up with ideas?

A. A single idea can be expanded and expressed in many different ways with the various water media. While I work on one painting, I get an idea for another. The more time I spend painting, the more ideas come.

9. *Q.* Which medium do you use for opaque detail?

A. Far and away, the best is gouache. It is the most opaque and flows evenly on the brush.

10. *Q.* I have a hard time when my paper buckles. What can I do about this?

A. If a thinner paper is used, presoak it for fifteen to thirty minutes. Staple it to a board, and when dry, tape all four sides with 1½″ masking tape. Or use 300-lb. paper or a heavyweight illustration board.

11. *Q.* Is there any combination of water media that doesn't work well together?

A. I have found that gouache, when applied over casein, does not bind well. As the gouache dries, it flakes off. The oils in casein seem to resist the gouache.

12. *Q.* Do you like working on an easel or do you prefer a table?

A. It depends on what I'm doing. If I'm working very wet, I work on the table with the top of the painting board raised four or five inches. The majority of my work is done on an easel, as I can stand back and study my progress more easily.

13. *Q.* How do you know which medium to use?

A. It depends on what direction I want the painting to take. If I want stimulating visual contrast, I may choose transparent acrylic and opaque casein. If I'm after a subtle mood, I may use transparent watercolor and gouache.

14. *Q.* What are the limitations of water media?

A. The variations in technique are limitless. By learning how to handle and combine watercolor, gouache, acrylic, and casein, you can pursue virtually every direction in two-dimensional art.

15. *Q.* I never seem to improve. How can I make some progress?

A. Read and study about other artists who are working today; study the old masters; attend water media shows and find out what other people are doing; go to art museums; paint constantly and experiment; and you will grow.

CONCLUSION

After a time of practice and exploration, these techniques I've demonstrated will become familiar, and you'll have them at hand to use when you need them, almost without thinking. Technique is a means to an end. That end is to create a painting that says what you want it to say, in a style that is uniquely yours. If you study the paintings of the great watercolorists, you'll see how they combined transparent, translucent, and opaque paint and how they gouged and scraped at the surface if they felt the need to do so. The most important thing for them was to make the painting do what they wanted it to; the next most important thing was knowing how.

You can learn about technique and composition by seeing the work of other artists in museums and galleries. You can learn by working from books such as this one. You can learn by carrying a sketchbook with you at all times as I do. This is where I put my initial ideas, wherever and whenever they come to me.

Many times, while doing something completely unrelated to painting, such as driving, hiking, or fishing, my subconscious takes over, and the ideas begin to come. Then I stop, take out my sketchbook, and make a quick sketch or jot down some written notes. I keep a list of these ideas posted in my studio. Some of these don't have enough energy to live long enough to make even one painting; others are so vital, they become a recurring theme that's repeated in several paintings. And the more I paint, the more I see there is to do.

If you like someone's work, it's only natural that your own work will go in that direction. But don't become a pale copy of someone else. Pick out what you like in that other artist's work, absorb it, but keep pursuing your own direction. Then the things you like about the other person's work will become incorporated into your own. Never stop growing.

Be honest with yourself and with your work. Paint what you know and what you respond to. Paint in the combination of media that suits your temperament and that actually seems to add greater power to your work. For me, the answer is WATER MEDIA.

SELECTED BIBLIOGRAPHY

Barbour, Arthur J. *Painting the Seasons in Watercolor.* New York: Watson-Guptill, 1980.

Betts, Edward. *Master Class in Watercolor.* New York: Watson-Guptill, 1975.

Doerner, Max. *The Materials of the Artist and Their Use in Painting.* New York: Harcourt, Brace and Co., 1949.

———*Painting Techniques.* New York: Harcourt, Brace and Co., 1962.

Kautzky, Ted. *Trees and Landscapes.* New York: Reinhold. 1952.

———Ways with Watercolor. 2nd ed. New York and London: Reinhold, 1963.

Kortlander, William, and Bowles, Jerry. *Painting with Acrylics.* New York, Van Nostrand-Reinhold, 1973.

Mayer, Ralph. *Artist's Handbook of Materials and Techniques.* New York: Viking Press, 1957.

Pellew, John C. *Painting Maritime Landscapes.* New York: Watson-Guptill. London: Pittman, 1979.

Sloan, John. *The Gist of Art.* New York: Dover, 1977.

Taubes, Frederick. *Painting Materials and Techniques.* New York: Watson-Guptill, 1967.

Torche, Judith. *Acrylic and Other Waterbase Paints for the Artist.* Sterling, 1969

Woody, Russell O. *Painting with Synthetic Media.* New York: Reinhold, 1965.

INDEX